NEW WAYS OF GRAVURE

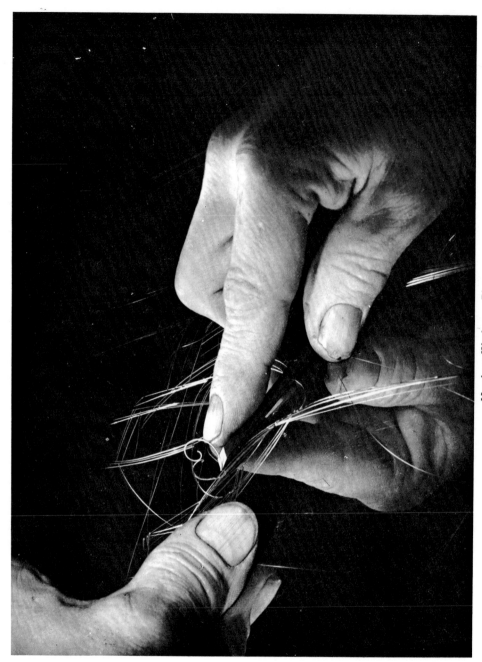

Hands at Work on a Plate.

NEW WAYS OF
GRAVURE

S. W. HAYTER

With a Preface by Herbert Read

134 Illustrations

LONDON
OXFORD UNIVERSITY PRESS
NEW YORK TORONTO
1966

Oxford University Press, Ely House, London W. 1

GLASGOW NEW YORK TORONTO MELBOURNE WELLINGTON
CAPE TOWN SALISBURY IBADAN NAIROBI LUSAKA ADDIS ABABA
BOMBAY CALCUTTA MADRAS KARACHI LAHORE DACCA
KUALA LUMPUR HONG KONG

© *Oxford University Press 1966*

The first edition of this book was published in 1949
by Pantheon Books, Inc., New York
and Routledge & Kegan Paul, Ltd., London

PRINTED IN GREAT BRITAIN

PREFACE

BY HERBERT READ

AMONG contemporary artists Stanley William Hayter has a wide influence which is due to two distinctive features. In the first place he has revived the workshop conception of the artist—the artist, not as a lone wolf howling on the fringes of an indifferent society, but as a member of a group of artists working together, pooling their ideas, communicating to one another their discoveries and achievements. In the second place, he is an artist with a philosophy, a philosophy that assigns a particular function to art in life, and to the artist in the life of society.

He has selected as his main medium of expression the Cinderella of the arts—the process of gravure, including in that generic term all forms of art which get their effect from the incision of a groove on some resistant material. It thus includes dry point and mezzotint, burin engraving, and all forms of etching. Gravure in this sense was not always a neglected medium—the stature of Dürer, Rembrandt, Goya, and Blake, to mention only four great artists, would be sensibly diminished if we were to exclude their engraved work. But, for reasons which Mr. Hayter investigates in the second section of his book, the art fell on evil days—it began to be regarded as a means of reproduction rather than as an original medium of expression. With the introduction of mechanical methods of reproduction in the nineteenth century, even this use of the medium fell into decay.

It is true that during the second half of the nineteenth century the art of etching revived with Seymour Haden and Whistler, and I am sure the author of this book would be the last man to despise the skill of etchers like Cameron, Muirhead Bone, and Zorn. They lacked, however, what he calls 'an adequate motive' and this brings us to Mr. Hayter's philosophy.

In the long historical perspective of art one truth emerges clearly: skill is not enough. One hears that today there is a slump in the market

for etchings—meaning the market for Frank Short and William Strang, Fitton and Haig, Burridge, Brangwyn, and Bone. There is no slump in the market for Rembrandt, Goya, or Blake, and the reason does not lie in the superior skill of these artists. It lies in their philosophy, which led them to believe that art was something more than a reflection, however subtle, of the phenomenal world—that it is in some sense epiphenomenal. We can say that art is a criticism of life, and the etchings of Rembrandt are criticism in that sense. But Hayter goes beyond even this degree of the epiphenomenal. In common with the great masters of the modern movement in art—Picasso, Klee, Moore—he believes that the objects of art constitute a distinct order of reality. 'I want to distinguish the pursuit of reality from the pursuit of objects,' he writes, 'to combine immediate experience with experience of the imagination'; and imaginative experience, he realizes, has depths and dimensions that extend beyond the individual, that are racial and archetypal and only to be expressed in symbolic form.

All this Mr. Hayter himself makes clear enough in the pages that follow. He also makes clear another point which cannot be too frequently emphasized—the point that the artist, in his pursuit of reality, is using certain instruments, certain materials; and that the success of his pursuit depends on his exploitation of these means. There has always been an intimate connexion between the functioning of the plastic imagination and the manipulation of the plastic means. Poetry is not born ready-made; it is made in the process of birth, and the images spring from the plastic stress itself, from the wrestling with words. The same is true of music and painting, of any art. From this point of view one might say that the art of gravure, before the foundation of Atelier 17, was an art that had never realized half its potentialities. Hayter and his pupils have discovered new processes and new possibilities in existing processes; they have added new 'values' to the art— values of texture, of dimension, one might even say of colour. These are all clearly described in this book—described with a technical enthusiasm and precision of detail which will inspire those who have never engraved before to acquire the necessary equipment, and those who are already practised in the art to develop new phases of creative activity.

CONTENTS

HISTORY OF THE TECHNIQUE

LIST OF ILLUSTRATIONS

COLOUR PLATES

ACKNOWLEDGEMENTS

THE author thanks the following institutions for permission to reproduce prints from their collections: The British Museum; Victoria and Albert Museum; Buchholz Gallery (Curt Valentin), New York; The Chicago Institute of Art; The Frobenius Collection, Frankfurt a/M.; M. Knoedler & Co., New York; The Metropolitan Museum of Art; Museum of Modern Art, New York; Museum of Natural History, New York; The National Gallery of Art (Rosenwald Collection), Washington, D.C.; The New York Public Library; Paul Rosenberg Gallery, New York; State University of Iowa; University Museum of Philadelphia, Pa., and George Wittenborn Inc., New York.

He also thanks the following artists for permission to reproduce their prints: Fred Becker, Serge Brignoni, Anthony Gross, Sue Fuller, Richard Lacroix, Armin Landeck, Mauricio Lasansky, Helen Phillips, Prinner, A. Krishna Reddy, Karl Schrag, Gail Singer, Yves Tanguy, Sergio Gonzales-Tornero, Roger Vieillard, the late Jurgen von Konow, and the late John Buckland Wright; the publishers, Brunidor Editions, New York; the poet, Ruthven Todd; Henri Hecht; and Mrs. Meric Callery.

For most valuable help received during work on this book the author would like especially to thank Mrs. Margery Perret of Geneva, Miss Elizabeth Mongan, and Messrs. A. M. Hind, Karl Kup, the late William Schniewind, and Carl Zigrosser; the members of Atelier 17; and, for their expert advice on colours, MM. René Laraignou and Edelmann of Chas. Lorilleux, Paris and Copenhagen. He is also particularly grateful to Mr. Bernard Karpel, Librarian of the Museum of Modern Art, New York, for compiling the Bibliography.

INTRODUCTION · ORIGINS

ENGRAVING, the act of incising a groove into some resistant material, is found as early as the first traces of human activity. Perhaps before speech had reached the point of development when it could adequately impart command or describe experience, the scratching of lines into bone, horn, and stone served as a means of communicating ideas and recording experience. If we may suppose that the first experience of a line, as a thing to be drawn, as a record of a movement, could have been the trace of the passage of man or animal on a sand or mud surface (Fig. 103), the action of making a groove or a line of pits (as footprints) in a more resistant surface might be one of the earliest methods of recording experience, or obtaining the power to re-live an event. The action necessary to incise a trace in hard material involved, even then, driving a sharp instrument in the direction of the movement—rather than drawing (pulling) it—so that the 'geometric' simplicity of curvature, caused by the product of two factors only, the impact of the tool and the resistance of the material, is found as unmistakably in prehistoric engraving (Figs. 62, 104) as in the cut we make with the burin today.

The viewpoint of this book differs in many ways from the traditional attitude toward the processes of gravure (which normally emphasizes the function of reproduction), not so much as to the fact that a number of identical prints may be made from the plate, but as to its use for reproduction in the sense of a translation from originals created in another medium. Engraving and etching with related processes are rarely used today for the commercial reproduction of works of art (such as paintings), the photomechanical process having proved cheaper and adequate to the popular taste in such matters, yet even in the minds of artists there remains the connexion with reproduction; in recent times the reproduction of a drawing together with his signature has satisfied many an artist as an activity subsidiary to his primary purpose as painter or sculptor. Commercially it has

enabled dealers to put on sale specimens of the hand of the artist, less expensive than original and unique drawings, but which could be considered in some degree as original works of the artist. The distinction between prints invented, executed on plates, and printed by the artist himself and those cut by an artisan and printed by a specialist has been lost to some extent.

My own conviction is that engraving and the related techniques constitute a very valuable medium for original expression. They have many features in common with the arts of design, painting, and sculpture, but possess certain resources of their own, together with certain definite limitations, the latter being by no means those that have been accepted traditionally for the last few centuries. It is, for instance, possible to produce in a print from a plate any conceivable texture, quality, or effect obtainable in drawing with ink, pencil, crayon, wash, or even by means of a woodcut, wood engraving, or lithograph. To what extent this is desirable is, of course, another matter. Beyond these resources of the medium there are countless untried ways of exploiting effects to be produced by the actual methods of preparing a plate: the action of mordants, or acids in etching, the unequal resistance of grounds to attack by acids, the sensitivity of soft wax to pressure, the use of abrasives in effecting variations in the printing surface, besides the action of the cutting, scraping, and polishing tools in dry point and mezzotint work. The etching and engraving techniques have an enormous potential vocabulary of expression, the greater part of which is practically unknown; until very recently only a few exceptional artists have employed it at all, and then only at long intervals.

I hope in this book to indicate the directions in which this vocabulary of expression may be amplified, without pretending to set limits to their extension in the future.

The invention of a method of execution calls mostly for ingenuity, and any generation can produce the appropriate inventions, if the need for them is sufficiently urgent. The development of new techniques of engraving and etching in the last twenty years bears no witness to the real capacities of those concerned in it; the demand was

lacking. Compared with the fantastic growth of techniques in the natural sciences in the last century, their achievement is indeed quite modest. It has been the fashion to divorce the arts from scientific development, but I feel that this is an error. The activity of the artist, like that of the philosopher, embraces every action of the human spirit; the methods by which advances in technique and domination over scientific fact are made are very similar to the methods of the artist. Man rediscovers rather than creates; the unconscious activity of research depends on the recognition of a pattern previously established in the mind of the researcher.

Since the nineteenth century man's increasing consciousness of and power over space (in physics and mathematics) have been reflected in new and unorthodox methods of demonstrating space and time graphically. The 'picture plane', a sort of window (Fig. 1), that theoretical surface behind which one might produce the illusion of timeless and unmoving space, was attacked from several angles. In some cases elements were made to pass through this plane, or to appear before it, such as the cut-out relief forms of Arp, or the collages of Picasso and Miró. In other cases the complete *raison d'être* of the picture was suspended in it; in still others an attempt was made to destroy the 'window' entirely. Attention, which had been concentrated upon the objects and their representation, was transferred to the relationship between the objects and their movement in space. Many properties of matter and space, which had been represented diagrammatically only by the scientist, found their expression in graphic and affective forms. The new aspects of psychology suggested to the modern painter a fresh sense of his relationship to his work, of its function, and of its significance to the rest of humanity.

Particularly in engraving, which is essentially the art of the line, of the line in three-dimensional space, it became necessary to exploit the enormous possibilities of indicating the properties of matter, force, motion, and space. In the methods of etching, the arrangement of transparent webs to define planes other than the picture plane, often no longer parallel to it, of surfaces having tension or torsion,

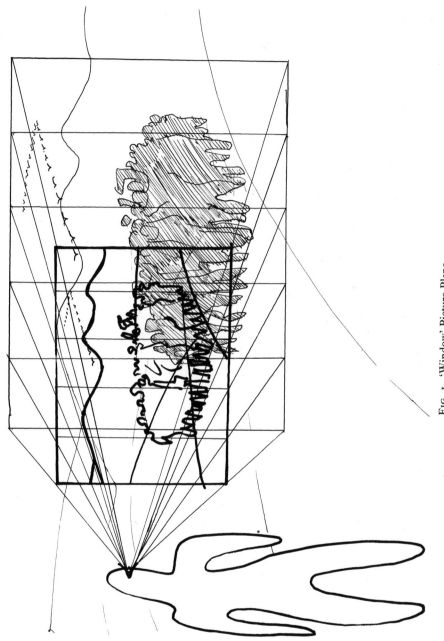

FIG. 1. 'Window' Picture Plane.

FIG. 2. German School (15th Century): Triumph of Chastity. Niello. (Collection, Metropolitan Museum of Art, Bequest of Theodore M. Davis, 1930.)

and the interpenetration of transparent surfaces could more easily be realized than in the usual techniques of painting. By means of the hollowing-out of spaces in the plates (or drilling holes through them) a projection could be made in front of the picture plane of the print, in this case represented by the unworked surface of the plate. Prints made from fifteenth-century plates intended to decorate boxes show in the four corners the white relief projections caused by the rivet holes by which the plate would have been secured (Fig. 2 shows such a rivet hole at the top of the plate); such prints were accessible to artists over a period of four centuries, but it is not surprising that the effect was never used by them. Until the historical necessity for breaking through the picture plane arose, such effects not only were of little value to the artist, they were definitely undesirable. But when it became necessary to use this device for artistic expression, the method to produce the effect was at hand.

In the practical part of this book I propose to describe as exhaustively as possible what is done to obtain a plate which is to produce certain qualities when printed. In that part, however, which deals with techniques of expression and projection (which will inevitably become involved to some extent with techniques of thought and methods of access to the imagination) an assumption will be made which should be defined here. I intend to assume that there exists a general truth, as a common value beyond the control of individual desire or speculation; but that objects, things in the phenomenal world, have an order of reality which is less concrete than the reality of a human reaction to them. And I want to distinguish the pursuit of reality (the reality of the first order) from the pursuit of objects, and to combine the immediate experience with the experience of the imagination, which I should like to consider as the trace or record of assimilated previous experience, not necessarily restricted to the immediate lifetime of the individual.

TECHNIQUES

1

WORKSHOP PLANNING · MATERIALS AND EQUIPMENT · PREPARATION OF THE PLATE

LAYOUT OF THE WORKSHOP

FOR convenience of working in plate media three areas should be allocated in the available space:

(*a*) *Work Room*

Room for drawing, working on plates with needles, burins, and other tools, for stopping-out, &c.

(*b*) *Etching Room*

Space screened off or remote from the room above, equipped with running water and furnished with acids and acid baths near the window or ventilation, heater for laying grounds, and, as far away from it as possible, a cleaning table with a fire extinguisher near to it.

(*c*) *Press Room*

The printing room, with press, hotplate, inking slab, another glass or marble slab for grinding ink, tables carrying wet paper pressed between glass slabs, blotters for drying prints, and a cord for hanging up blankets to dry.

The ideal arrangement would be three separate connecting rooms so that one could pass from the work room to either the etching room or the press room, and, for wetting paper and cleaning plates, from the press room to the etching room. The plan (Fig. 3) has been drawn for a single room with partitions to isolate the etching room from the remaining space, as this sufficiently demonstrates the requirements.

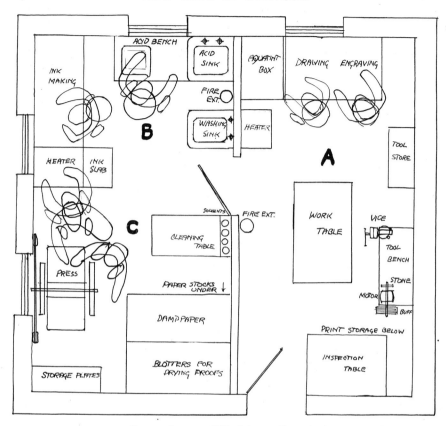

FIG. 3. Layout of Workshop, 18′ × 20′.

(a) *Work Room.* This space must have at least one large, extremely firm table with good light from a window, or artificial light falling upon the working position, from the left side. A diffused light is preferable to avoid any glare from the plate surface, and to make work through grounds more visible. Near to the table, racks and storage space must be provided for tools, stones, brushes, and varnishes. A separate table, not to be used for work, for handling proofs, and a cabinet with deep drawers in which to store prints are also useful.

(b) *Etching Room.* The place where acids are to be used must be well ventilated, as nitric oxide, hydrogen, chlorine, and solvent

vapours are given off during the operations. A draining table leading to a sink is a convenient place for the acid baths. This should be coated with asphaltum or other acid-proof material. A second sink is very useful if much work is to be done; this should be kept scrupulously clean and reserved for wetting paper and cleaning plates and hands. If the cleaning table, preferably glass-topped for cleanliness, is in this section, it should be as far as possible from acids, as the spray from them will affect plates and tools, and from flame or heaters. An open box containing sawdust damped with solvent is effective for cleaning plates. One of the fire extinguishers should be over this table. Storage is provided near the sinks for acid bottles, acid baths, ammonia, whiting, water stone, charcoal, and abrasives. A good light is needed over the sinks for cleaning, to control biting, and for grinding.

(c) *Press Room*. This is so organized that the printer shall use the minimum number of steps while working. The hotplate with the inking slab should be at the right; then, towards the left, the bed of the press, the wet paper, and the blotters for drying prints. It should be possible to reach the bed of the press from the hotplate by turning round and taking no more than two paces. In the arrangements shown, the hotplate, the inking slab and the gauze pads, blotters and wet paper, form, with the press, three sides of a square in which the printer moves, the fourth side being occupied by a window. Thus the light falls from the left while the plate is being prepared. It is then placed on the press, wet paper is laid upon it with clips, blankets are laid down, and the press is turned. Then the proof is lifted and placed in the blotters, and the plate is returned to the hotplate for re-inking. If the exit from the press room is near to the sink for cleaning and for wetting papers, this is convenient. Though light is needed on the plate being inked and on the press for the placing of the sheet, the paper table needs less, as proofs can, if necessary, be examined on the bed of the press. Storage must be provided for inks, ink-making materials, oils, pigments, mullers, and so on, remote from the press; and also for paper, which can be stowed beneath the tables, and for blankets and the cleaning rags for the press.

MATERIALS AND EQUIPMENT

Plates

The plates are of copper or zinc, 16 or 18 gauge, rolled or hammered as hard as possible. Copper which has been recently heated and cooled is soft, and the crystallization of the metal has to be re-established by hammering or rolling. If the plate is hammered, the crystallization is established in all directions, if rolled, in the direction of the passage of the plate. A rolled plate, however, if left untouched for many years, becomes as hard as a hammered one. This crystalline structure is important as it is exposed by certain manners of etching and also affects the cutting of a burin. At one time plates were scraped by hand with a sort of adze which removed a long ribbon of metal from one end to the other; they were then ground level and finished with a buff and jeweller's rouge paste; today they are ground mechanically to a level, often by a machine holding water stones in a device like a human arm with two rods connecting the holder to a single rod moving up and down the plate. Often plates are simply laminated between polished rollers at high pressure.

In France, Atelier 17 once used plates which were slightly dulled as this was found to prevent glare, to give grounds a better hold, and to permit drawing on the surface with a pencil. In the United States, where these depolished plates were not available, we sometimes sponged the plates with ammonia, or etched them for about a minute in Dutch mordant.

Abrasives

Carborundum powder, No. 150; used for roughing up the surface of a plate and, with a flatiron, for the carbograph method as mezzotint; also used for roughing glass slab for ink grinding, and for resurfacing the muller when it becomes too smooth.

Rotten-stone powder, for repolishing plates.

Water of Ayr stone (Scotch hone), used with water for replaning the surface of the plate.

Snake-stone, used as above, leaving a smoother surface.

Willow charcoal, used after or instead of the snake-stone as the second stage of repolishing a plate.

Emery paper, Nos. 0000 and 000000, used in the final stage of re-polishing a plate, and in repolishing burnishers and scraper faces.

Putz pomade, rouge, and tallow, used with an oil rubber of rolled felt or canvas for finishing a plate to a mirror surface.

Emery wheel and buff, driven by $\frac{1}{4}$ h.p. electric motor, for regrinding and repolishing plates and tools by mechanical means rather than by hand as above.

India oil-stone (Norton list No. 1B64), having fine and coarse sides, for sharpening tools.

Wire brush, for cleaning lines and, in *manière noire* etching and dry point, for scratching plates.

Tools

Files, for bevelling edges of plates.

Sprayer or air-brush for fixative; used in aquatint and bitten-surface etching to stop gradations.

Scraper, triangular section, for removing errors, and producing certain textures on the plate surface (Fig. 4A).

Burnishers, of steel or agate, of spoon or conical form, for repolishing corrections or lightening surfaces in the plate in aquatint, bitten-surface, or mezzotint (Fig. 4B).

Pin vice (to hold tools from 0 to $\frac{1}{8}$ inch), for phonograph needles or other small tools (Fig. 4C).

Hand-vice, for handling plate while hot.

Bench-vice, for tool making.

Needles and points of various sizes.

Echoppe, a needle ground to a diagonal face to give a cutting edge, for re-needling across worked surfaces (Fig. 4D).

Stylus of bone, wood, cactus, &c., for working through soft grounds.

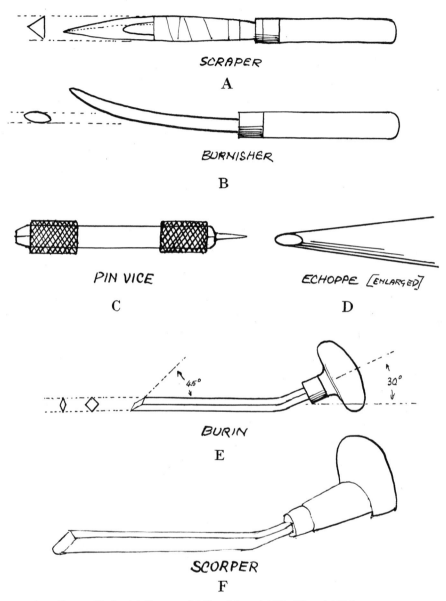

SCRAPER

A

BURNISHER

B

PIN VICE

C

ECHOPPE [ENLARGED]

D

BURIN

E

45°

30°

SCORPER

F

FIG. 4. Tools: (A) Scraper; (B) Burnisher; (C) Pin Vice; (D) Echoppe; (E) Burin; (F) Scorper.

Leather comb and steel comb, sometimes used to work through soft or hard grounds.

Burins, square or lozenge-section, sizes from 7 to 10 (E. C. Lyons' list), for line engraving on copper (Fig. 4E).

Scorpers, half-round and square section, sizes from 54 to 63 (E. C. Lyons' list), for hollowing shapes to print as raised whites on the proof, or to produce certain textures and qualities on the plate (Fig. 4F).

Rollers

Wooden rollers, covered with felt or carpet, used in inking intaglio plates. These should be sealed or kept in linseed oil to prevent them hardening.

Leather-over-felt-over-wood rollers, for laying grounds, separate rollers being kept for hard and for soft grounds.

Hard rubber rollers, used to replace leather rollers in laying grounds, and for certain ways of printing from the surface.

Soft rubber rollers, preferably synthetic rubber to resist heat and oil, also used for inking and for laying grounds.

Gelatine rollers (brayers), for typographical printing.

Dabbers (tampons) of rolled rag, or wash leather stuffed with cotton, used to replace the rollers for both inking and laying grounds.

Press

Blankets, finest pure wool woven roller cloth, of sizes suitable for the plates to be printed, in sets of three or four. One of each set to be very close woven (fine 'swan-cloth'), as it will determine the texture of the print.

Blotters, white, of sufficient size for drying prints, paper for printing, plates, &c.; 24 inches by 40 inches is a good size.

Starched tarlatan, to remove ink from the plate in printing intaglio.

Cotton gauze, unstarched, for *retroussage* in printing.

Wax paper, to protect felts in transferring texture to soft-grounded plates and wrap plates for storage.

Tissue paper, white, to place between proofs in drying and storage.

Glass slabs, preferably 1 inch thick; a box lined with stainless steel or zinc; or plastic sheets for pressing wet paper.

Sponges, for wetting paper.

Brushes, one soft for brushing paper surface, and another for cleaning ink out of lines in plates.

Whiting, in block and powder; block for cleaning hands when wiping plate; powder for degreasing plates with ammonia before laying hard ground.

Inks

Glass or marble slab (or litho stone), for grinding inks. The surface should be ground with carborundum at times to keep a tooth on it.

Glass or granite muller, for grinding ink. Its surface also should be ground at times.

Cone grinder, driven by hand or electrically, at a slow speed. This means replaces the hand-grinding of ink but must be used carefully to avoid heating by friction.

Raw cold-pressed linseed oil, for ink-making.

Plate oil (burnt linseed oil), for intaglio ink. This oil is made by heating raw linseed oil at its boiling point for four to six hours when a violent oxidation occurs during which the oil usually takes fire spontaneously. When cool it is greenish in colour, very viscous, and has a characteristic smell of acrylic acid.

Litho-varnish, slow drying, used to give consistency and transparency to colours in surface printing.

Sun-thickened oil, Venice turpentine, siccative (manganese or cobalt), used in inks for different purposes.

Pigments

Frankfort black, a light pigment with great absorption of oil, made from calcined wine lees, containing considerable iron salts, used in making ink for intaglio.

Noir bouju (French black), a very dense pigment, mixed with Frankfort to make black for intaglio.

Fine vine black, similar to *bouju*, used to replace it.

Lamp black, used in making ink for surface printing.

Various powder colours, for grinding inks for intaglio and surface printing.

Grounds

Stopping-out varnish, a saturated solution of resin in alcohol, used for re-covering the plate in etching.

Asphaltum solution in turpentine, benzene, or lacquer solvent, used for re-covering where a very long bite is needed.

Gilsonite powder (dry asphaltum), used in making grounds and varnish.

Beeswax, used in making grounds and in edging big plates.

Axle-grease or tallow, used in making soft grounds.

Colophony resin (damar or mastic), used in making grounds, in powder for aquatint, and varnishes (see above).

Hard ground, made from asphaltum, beeswax, and resin, for coating plates for etching; often smoked to harden.

Soft ground, made from hard ground with $\frac{1}{4}$ to $\frac{1}{2}$ quantity of tallow or grease, or for certain purposes from wax, resin, and grease only; used for transferring pencil trace, direct drawing with stylus, or impressions of textures for etching.

Solvents

Gasoline, for removing grounds, varnish, or inks from plates and cleaning press, hotplates, &c.

Benzene, turpentine, alcohol, chloroform, ether, acetone, lacquer solvents, kerosene, for removing grounds, &c., and making liquid grounds, varnishes, &c.

Lye (caustic soda solution), for removing dried-in ink from plates.

Syrup, sugar solution, glycerine, gamboge, gum arabic, soap, for making lift grounds; they prevent the adhesion of a ground to the plate and cause it to lift in warm water.

Acids

Nitric acid (HNO_3), mixed with 2 parts (volume) of water and some copper in solution for etching copper, or mixed with 10 to 12 parts of water for etching zinc.

Hydrochloric acid (muriatic acid: HCl), used with a saturated solution of potassium chlorate for etching copper.

Potassium chlorate ($KClO_3$).

Sodium chlorate ($NaClO_3$).

Dutch mordant, a solution of potassium chlorate or sodium chlorate with 10 per cent. hydrochloric acid, for etching very accurate work on copper.

Ferric perchloride ($FeCl_3$), in solution in water, used for etching copper.

Glass- or plastic-stoppered bottles for storage of acids.

Hard-rubber, plastic, glass, porcelain, or enamel acid-baths. The latter will only resist acids if the surface is intact.

Rags for cleaning and polishing.

A few addresses of supply houses both in the United States and Great Britain might prove useful to the student:

In Great Britain the following specialize in supplies:

 C. Roberson & Co.,
 71 Parkway,
 London, N.W. 1
 (tools, copperplates, grounds, &c.)

T. N. Lawrence & Son,
2-4 Bleeding Heart Yard,
Greville Street,
Hatton Garden,
London, E.C. 1
 (tools, copperplates, inks)

Buck & Ryan,
101 Tottenham Court Road,
London, W. 1
 (gravers and tools).

In the United States most tools and materials may be obtained from any artist's material store or jeweller's supply house. The following stores supply materials for the graphic artist:

E. C. Lyons Engraver's Tools,
64 Fulton Street,
New York 38, N.Y.
 (carries everything)

The Cronite Co.,
35 Park Place,
New York 7, N.Y.
 (carries everything, including hammered plates)

John Sellers & Sons,
66 West Broadway,
New York 12, N.Y.
 (hammered plates)

C. G. Hussey & Co.,
140 Avenue of the Americas,
New York 14, N.Y.
 (rolled plates)

Harold Pitman Co.,
1110 13th Street,
North Bergen, N.J.
 (rolled plates).

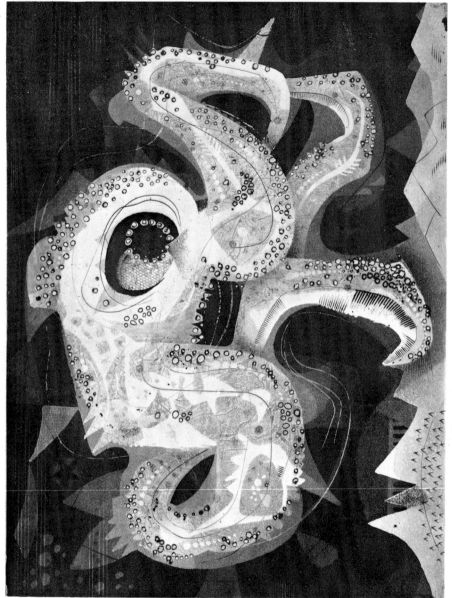

FIG. 5. Jurgen von Konow: Octopus, 1955. Aquatint.

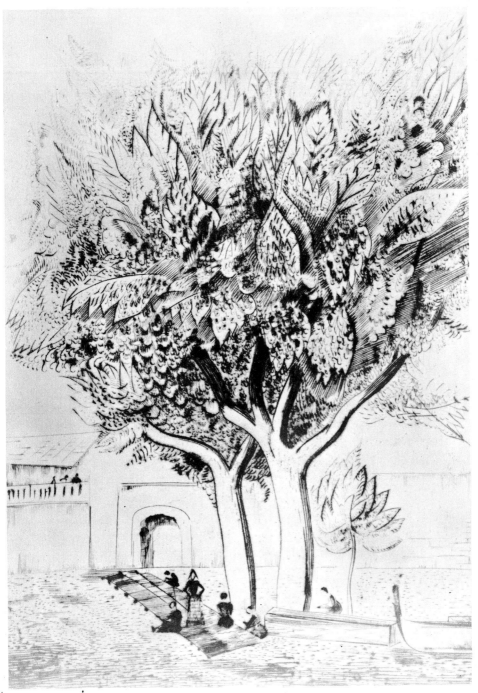

FIG. 6. Joseph Hecht: Collioure, *c.* 1920. Dry Point.

2

DRY POINT AND MEZZOTINT

DRY POINT

PERHAPS because of its apparent simplicity, dry point—the direct scratch of a point on a metal plate—is often the first method attempted by the beginner. The tools and the equipment needed are few and not elaborate: a plate, a point, and the means of printing. As I shall explain, however, the apparent simplicity of the medium is illusory. The degree of manual dexterity demanded is higher than that asked by any method except line engraving, and considerable experience is required before the result of the action as it will appear in the print can be foreseen.

As has been shown in the introduction, intaglio printing is normally made from grooves or pits in the plate so that the ink stands up in relief above the surface of the print. In dry point, however, the actual part played by the groove which the needle makes is insignificant. The burrs, those flanges of metal turned up at the edge of the scratch, are chiefly responsible for retaining ink upon the surface of the plate when it is prepared for printing. Thus, when pressed into paper, the lines will *not* be visible in relief above the surface.

A dry point print can usually be identified under a magnifying glass by the *indentation* made by the burr in the sheet of paper and by the soft colour. This colour is due to the fact that the bulk of ink in the lines is less than it is in engraving, and therefore actually appears less black. Furthermore, where the colour of the etched and engraved line appears cold, that of the dry point line is warm. The printing methods are the same as those for the printing of intaglio prints, but it is impossible to make surface or relief prints from dry point plates.

Copper plates are most generally used, although brass and steel have also been employed. Zinc, which allows the greatest ease in working, is too soft. Possibly the very hard beryllium–copper alloy would provide an ideal plate for dry point.

To make a plate in dry point

The materials required are a steel, sapphire, or diamond point, set in a wooden or metal holder, and a copper plate, scraper, and burnisher, as already described. As in all direct printing methods, the proof will be a mirror image of the plate, that is, reversed from left to right.

It may be found convenient to draw or trace on the plate, using a wax pencil, lithographic crayon, or tracing through carbon paper. If the surface of the plate is not too highly polished, an ordinary soft pencil may serve to mark the traces. It has also been found that a drawing made with a ball-point pen on paper can be transferred to the plate, by wetting the paper and passing it, face down on the plate, through the press.

A scratch is made in the surface of the plate with the firmly held point. If a number of these scratches is examined through a magnifying glass, it will at once be apparent that three quite different lines can be made with the same point and under the same pressure. This is because it is the burr on the edges and not the groove itself which determines the quality and strength of the printed line. The diagram (Fig. 7) shows these three types of line and the characteristic angles between the point and the direction of the line which determines them. To obtain the line shown in No. 3, the heavy, saw-edged burr must be made with the point nearly vertical, otherwise the burr itself will be undercut and removed, giving the line No. 4. The bottom line on the diagram shows how widely the resistance to wear of these different lines varies. The pressure of the press in printing, which is over 100 lb. to the square inch, is carried momentarily by these saw points, so that it is obvious that they will rapidly be bent down or worn away.

The problems involved in making a dry point which will carry out

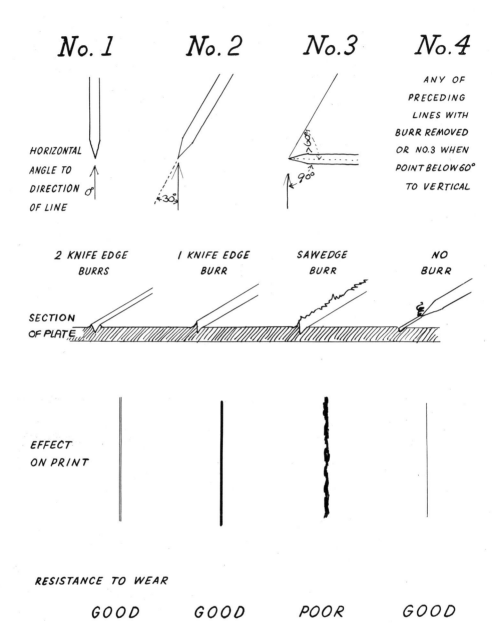

FIG. 7. Four Types of Dry-Point Line.

FIG. 8. André Masson: Le Génie de l'Espèce, 1942. Dry Point.

FIG. 9. S. W. Hayter: Paysage Urbain II, 1930. Dry Point.

the artist's intentions exactly mean that the ordinary action of draw-
ing, with the angle between pencil point and paper continually
varying, must be forgotten. Either the point must be held firmly and
the plate swung to make a curve, or else both hand and point must
swing in the curve to be made.

The last type of line (No. 4) does not print very strongly. Its effect
is rather grey as the trench is shallow. A diamond or sapphire point,
held loosely, gives such a line, making greys like those seen in the sky
of *Paysage Urbain* (Fig. 9). The doubled line (Fig. 7, No. 1) is also
valuable as a means of establishing greys. There is no reason why
rulers, or mechanical devices to rule parallel lines, should not be
employed if needed, but in actual practice I have found no need to
use such helps in cutting a straight line.

The progress of the work can be followed by rubbing a little
printing ink into the surface and wiping it clear with the palm of the
hand. If the plate is examined in a mirror an approximate idea of the
appearance of the plate will be obtained.

It is, of course, possible to make textures by other means than
shading or cross-hatching, although one rarely sees it done. Mauricio
Lasansky, the Argentine master, has perfected a method of driving
the very sharp point, loosely held at an angle against its direction,
which causes it to skip and make short dashes or dots, the intervals
between them being controlled to give a variety of dotted textures.
The more acute the angle at which the point is held, the wider will be
the interval between the dots (Fig. 10). This effect resembles that of
mezzotint, described later, but the textures are variable and are, in
general, much bolder.

Should parts of the plate be found to be too dark, or certain lines
to have been scratched too violently, these can be lightened by
scraping away the burr with the scraper. It is easier to do this when
ink is in the lines, as the effect is then immediately visible. When
a line has to be removed entirely, this can be done with the burnisher,
particularly if no metal has been removed from the plate.

It is advisable to print only when *absolutely* necessary to verify the quality
of the work, as every print made from the plate will alter the plate very

FIG. 10. Mauricio Lasansky: Cradle Song, 1939. Dry Point.

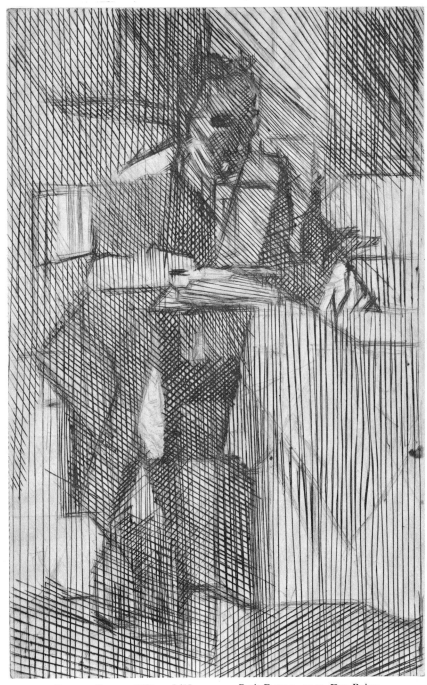

FIG. 11. Jacques Villon: L'Homme au Petit Bateau, 1941. Dry Point.

slightly and *not uniformly*, owing to the different resistance offered by lines of varying character.

A zinc plate which, owing to its softness, begins to change from the very first print, might, on a well-worked print, give ten prints nearly alike in quality. A well-worked copper plate might give twenty or even thirty, but no more. By the use of a steel or chromium facing it is possible to strengthen the burr so that it will stand up to an edition of 50 to 100 prints, but of all the media used, dry point is the one which suffers most in the process of printing. With experience it is possible to make a plate which will produce a desired effect when worn by the first printings and then steel-plated. One should note that no method of printmaking is currently employed with less precision or more uncertainty than dry point, even by the so-called masters.

MEZZOTINT

The mezzotint method of making prints, invented in the seventeenth century, consists, broadly, of roughening the surface of the plate with a tool so that enough ink is retained in the surface to print a uniform black. This effect could be obtained by cutting dry point lines in two or more directions, close enough together to hold ink between the burrs. The tool used, the rocker (Figs. 12, 13), has a curved blade, the underside of which is cut with fine, closely set grooves. When this tool is rocked across a plate the result is a series of fine dots, each carrying a small burr.

To prepare a plate the rocker is held as shown in Fig. 12 and the surface is covered in one direction, each rocked line being worked as close as possible to the previous one. The position of the plate is then changed and it is worked across again in a direction at right angles to the first. Then diagonals and parallels to the sides, four in all, are worked across. This will generally result in a uniform black. To acquire accuracy in attaining this black considerable practice is required.

Another and simpler method of preparing a plate for the same effect is to work over it with carborundum stone in two or three directions. A group in Philadelphia has also employed carborundum powder worked over the plate with a flatiron.

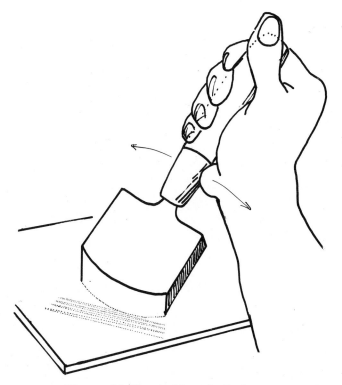

FIG. 12. Working the Mezzotint Rocker.

Then, with scraper and burnisher, the markings are slowly smoothed away, regaining half-tones, various in-between values, and whites. The scraper gives a clear, harsh accent which does not print white unless burnished, while the burnisher alone softens and lightens in a less crude fashion. In the final effect there can be any degree of photographic detail, and it may resemble a charcoal drawing in colour, but it has a certain velvety softness characteristic of the dry point process.

Employed with engraved lines or with previously etched lines, the method has been used by a few modern artists; but on the whole effects which are characteristic of mezzotint are not those which are sought by artists at the moment. Like dry point, mezzotint wears

D

FIG. 13. Rocker and Roulette.

badly in printing and requires to be steel- or chromium-faced before an edition of any size can be printed.

For repairing or replacing tones which have accidentally been lost in working, the roulette (Fig. 13) is used. Roulette work with the burr removed, together with burin lines, was used in making the illustrations for Georges Hugnet's *Ombres Portées*, Paris, 1932.

The method of working the background of the *Apocalypse III* (Fig. 15) could be described as mezzotint, although it was done in a single direction with coarse carborundum over the burin lines. The transparency obtained by the work of the burnisher on the figure is characteristic of this method.

The general principle of working back from a black or dark print surface to the lights is not of course confined to mezzotint, although it is the characteristic of that method. Plates which have been roughened to print black by aquatint, soft-ground textures, or closely bitten lines (see Jacques Villon, Fig. 11) can be worked in the same manner.

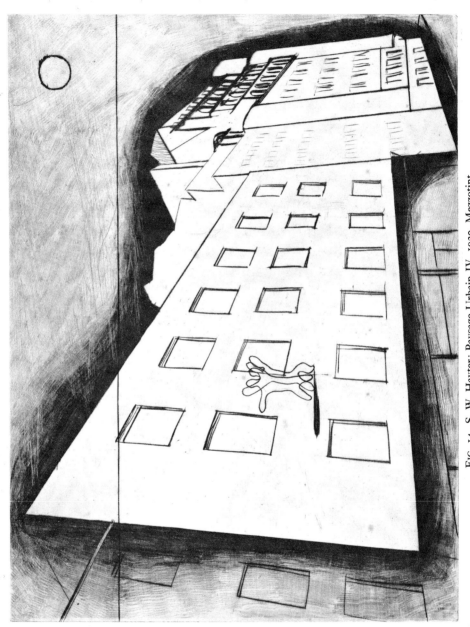

Fig. 14. S. W. Hayter: Paysage Urbain IV, 1930. Mezzotint.

FIG. 15. S. W. Hayter: Apocalypse III, 1931. Engraving and Dry Point.

3

BURIN ENGRAVING

OF all the methods which can be used to produce incisions in the surface of a plate into which ink can be rubbed and then transferred under pressure, perhaps the simplest is the direct cutting of grooves with a burin or graver. It must not be forgotten, however, that no method by which metal is removed in order that a thread of ink shall appear on paper can be considered to be direct and, although the principles are simple, mastery of the method demands the most serious practice.

THE TOOL

The burin (Fig. 4E) is a short steel rod, square or lozenge-shaped in section on edge, the end of which has been cut off to form a facet at an angle of 45° to the axis of the stem; the rod is suitably mounted in a handle. The tool is bent near this handle, to make it easier to lift the point clear of the cut, and the two underfaces are ground perfectly flat and parallel. Process engravers use a tool of which two small facets have been ground off at the point. The same in profile as the artist's burin, this tool produces a broader and more uniform cut, being held at a greater angle of attack than one which has been ground parallel to the axis. A change of angle produces less variation in the cut with this tool than with the burin first described.

The advantage of a tool correctly ground is that inflexions of the line can be produced with very slight variations of the pitch, making possible a very great sensitivity. The burin which is square in section is the most generally useful as it raises almost no burr on straight lines and turns with great freedom. The deep lozenge-section burin, the accurate setting of which is harder, turns with greater resistance and throws up far more burr, and is

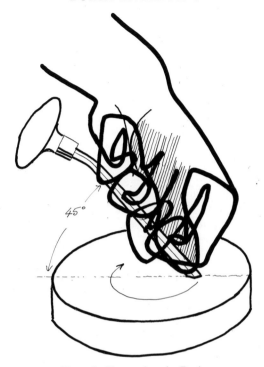

45°

FIG. 16. Sharpening the Burin.

really only necessary when greater depth is desired in extremely fine lines, lines as fine as a hair or even less. With this tool it is quite practicable to employ lines $\frac{1}{3}$ of the width of a hair, laying them 1,000 to the inch.

Sharpening the tool

When a burin is made, the underfaces must be set perfectly straight and parallel to the length of the tool, and the edge between them must be absolutely sharp. This is achieved by applying great pressure to the blade laid flat on a level stone, with the fingers of one hand, while driving the tool diagonally with the other; it must be held in such a position that the blade cannot roll or turn. When perfectly ground, no reflection of light is visible from the edge between the two faces. It is preferable to grind away some of the outer surface as the steel at the core of the tool retains its sharpness longer.

To temper steel, one should heat it to dull red and quench it in water. The surface is then repolished. As the tool is reheated slowly, a succession of colours appears: first, a pale 'straw' colour; then, with an increasing temperature, a darker straw colour is followed by a dark blue (first blue), a second 'straw' colour, and a second and lighter blue. If the metal is quenched rapidly at the temperatures indicated by these changes of colour, the steel will become progressively harder but more brittle. Finally, at a temperature corresponding to dull red heat, the metal becomes 'glass hard'. The best temperature for our burins corresponds to 'second straw', which makes the steel sufficiently hard but not too brittle.

The end facet is then ground to an angle of 45° with the length, the tool being held by the shaft, as near the point as possible, and rotated on the level surface of the stone (Fig. 16). (If the wrist is rigid while this is being done the surface will be ground flat; if, however, there is movement of the wrist a spherical surface will result.)

The angle of 45° has been found by experience to be the most generally useful for all purposes. The longer point, set at an angle of 30°, which is used in wood engraving, breaks too easily and will not turn freely without raising a burr on the line. The shorter point, at an angle of 60°, is useful for stippling or for dotting, where it breaks less frequently, but in lines of any length it has a tendency to rise out of the furrow with a consequent loss of control.

Unless the burin is extremely sharp, it will not make very fine lines (that microscopic tetrahedron of metal which should cut will be missing entirely), and the characteristic responsiveness and flexibility of the tool cannot be appreciated. The keenness of the point should be such that, when rested upon a plate, the mere weight of the burin will make an impression.

THE PLATE

For burin engraving copper is always used, in plates of 18 or 16 gauge, preferably with the surface slightly dulled. Thinner plates are awkward to handle and can cut the fingers while being manipulated in the process of printing, while thicker plates offer no advantage and can strain or burst the paper under the pressure of printing.

If the copper has been prepared by hammering, or if it has been left undisturbed for many years, the crystallization of the metal is estab-

lished equally in all directions, thus hardening the plate. This is a definite advantage in cutting. Hammered plates cost at least three times the price of rolled copper. Commercial rolled copper is decidedly softer in one direction than the other, the metal crystallizing in the direction in which it is rolled. More burr will be raised on lines cut in the softer direction, and the diminished resistance in that direction results in a tendency for the burin to run away on a curved line, the hand, controlled to cut the harder metal, losing that restraint on unexpectedly encountering the softer. Sources of rolled plates in the United States and Great Britain are mentioned on pages 12–13. Hammered plates seem to be unobtainable at present.

Zinc plates should never be used for burin engraving, as the metal is soft and crumbles when pressure is used on the tool. Brass and soft steel are no longer worth using, as they lack the flexibility of copper, and the endurability desirable for the printing of enormous editions can be obtained by depositing a steel or chromium facing on a copper plate.

To avoid the glare which is responsible for so much eyestrain among engravers, one can work on a slightly dulled plate, which also has the advantage of allowing one to draw on the plate with a soft pencil. The surface of a highly polished plate can be dulled by scrubbing with water and fine pumice powder in a rotary movement. Ordinary kitchen scouring powder will serve for this if it is not too gritty.

As in all printing processes, the work on the plate will be reproduced in reverse upon the print. A drawing on thin, strong paper may be made over carbon paper with the face upward; the reversed drawing will then appear on the back of the sheet. Then, to transfer the drawing to the plate surface, this may be pinned face down over the plate, backed by a sheet of white transfer paper. The lines are then followed with a hard pencil or burnisher.

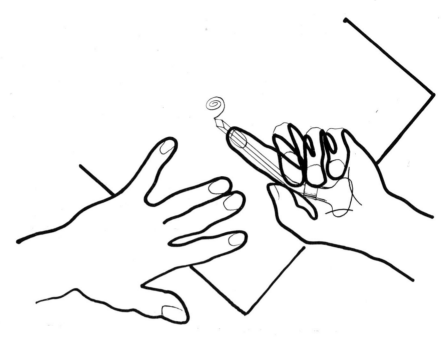

FIG. 17. Hands and Burin on Plate.

THE CUTTING

The burin, prepared as described, should be held between the middle finger and thumb, the handle lodged in the palm of the hand, the forefinger resting *lightly* over the point (or beside it on the plate); the other fingers should be curled up to avoid interfering with the vertical movement of the tool.

In cutting, the axis of the tool should remain vertical. One sits facing the table diagonally, so that the right elbow rests upon it, the plate being on the edge of the table, under the eye. The fingers do not need to be contracted, the pressure coming entirely from the palm of the hand or from the thrust of the plate moved by the other hand, so that there is no need to grip the tool with any degree of force (Fig. 17, and Frontispiece). When the hand is relaxed, the result generally is more sensitive and expressive.

It is most important that *no* pressure be exercised by the forefinger. Forcing the tool down into the furrow increases friction, and the consequent increase in the force needed to cut destroys the sensitivity of the line; it is, in fact, like driving a car with the brake on.

In engraving it is utterly unnecessary to strain the eyes. The process engraver's habit of working with a watchmaker's glass in the eye is pointless in the case of original engraving. In the design, the line cannot be seen as it is being covered up by the hand, owing to the angle at which the tool is held, so there is no reason to strain the eyes by attempting to follow it. It is preferable to work with unconcentrated eyes, the direction and depth of the line being controlled by the touch alone, a far more sensitive and accurate control than that of vision. A difference of about 1/100,000 inch can be distinctly felt, although such an interval would be quite invisible to the eye.

To begin, the point is engaged in the copper surface with gentle pressure applied to the handle, the angle of attack being decreased until the burin moves freely. An increase of the angle while moving will cause a broadening and deepening of the line. Always cut slowly: in the case of heavy incisions, extremely slowly, so that although a shred of copper $\frac{1}{32}$ inch wide is being removed comparatively little force is applied. Any other procedure will result in the loss of the sensitivity and flexibility of the line.

If the burin is perfectly sharp it will be possible to thrust boldly against the resistance of the metal without restraint.

Curves are produced by rotating the plate, the burin hand moving very slightly. It is immediately noticeable that where a certain pitch, say 5°, is needed to produce a straight line of a given force, a greater angle of attack, say 7°, will be needed to give the same strength on a curve, and perhaps double the angle or more for a very close curve, otherwise the burin seems to run away. At first the beginner will not realize how much he has to rotate the plate to make a curve; he will tend to flatten and stiffen his forms. Since much of the burin work seen has been executed by people who have never developed their skill beyond this point, burin work is often assumed to be characteristically stiff and awkward. It is advisable for the beginner to exaggerate both the lightness and the depth of lines and the boldness of

Fig. 18. Enlargement of the Print of a Burin Line.

curvature, to avoid the sameness which is the mark of an inexperienced burinist.

At this point, particularly if the furrows have been cut freely without following a trace made previously on the copper, the peculiar characteristics of the line of the burin should be considered by the beginner. In almost every method of making an image except sculpture in the round, the execution of the work is carried out by the hand moving independently (or, in certain cases, the fingers alone) at arm's length, the work being surveyed from a certain distance, as though dissociated from the artist, and the characteristic muscular action is that of pulling, or, as one says, *drawing*. Now the line which has just been engraved was not *drawn*, it was driven: the sensation of the engraver in making it was one of travelling bodily with the point forward in the direction of the design. Then, owing to the rotation of the plate, another quality is felt. The artist, identified with the moving point, must orient himself in relation to the changing positions of his design, just as a traveller orients himself with relation to a position shown on a map. A further peculiarity of the burin cut is the sensation of the engraver, not of tracing upon a surface, but of cutting into the substance of the copper, breaking through the surface, to which he *almost* but never quite returns in the finest of his lines. This sensation is not illusory for, as the line when printed is definitely above the surface of the paper, the depth of penetration into the metal actually involves a corresponding displacement of the line in relief above the sheet (Fig. 18). Thus a wider and deeper cut, crossing a shallower and narrower cut, will print with the former raised above the latter. A photograph of an uninked plaster cast of an engraved plate demonstrates this clearly (Fig. 19).

It might appear that this provides a method of constructing a positive three-dimensional space without ambiguity, but the reality is less simple. A little experimentation will show that while a definite *separation* always remains, it is about as easy to see this in reverse as it is to see it directly. That is, the finer line can be seen as well in front of the heavier line as behind it (where, of course, it is). So our means of expression still retains the alternation, the ambiguity which is found in most of the 'intaglio' processes. There

exist, however, methods of *cancelling* this separation in space: a round dot, for instance, marking the intersection of two lines of unequal depth seems, visually, to knot them together in the same plane (Fig. 105).

The line to be cut may be entered strongly, the burin attacking the plate at a high angle, and then being lowered until movement commences; or it may be entered with a very fine trace, with the burin almost horizontal, so that it is hard to define where the cut starts. Where the line crosses another a slight nick from the spine of the burin is made. (See Fig. 19, upper left-hand corner.) If necessary this can be removed with the burnisher.

Lines may be ended in three different ways:

(*a*) by withdrawing the tool from the cut, and removing the thread of metal from the end with the scraper; this results in a square-ended line;

(*b*) by lifting the tool vigorously from the furrow, leaving a short pointed end;

(*c*) by depressing the handle slowly so that the line becomes progressively finer until it ends imperceptibly; in this case, as the resistance of the copper is diminishing progressively, it becomes necessary to hold back the burin hand cautiously to avoid slipping.

When looking at a print it is always possible to see in which direction a line has been cut. In engraving, even more than in etching, the treatment and direction of a line have great importance in relation to expression. This must be decided (deliberately, or when the tool is familiar, almost automatically) with a view to the purpose of the work. The most elementary cut proceeds from fine to deep, the next one is uniform in force, and the third moves from fine to deep to fine again. They may be employed to give a simple straight line, simple curves of uniform or regularly increasing curvature, and then more complex curves. Thus, if it is wished to isolate an object in white in an apparently dark hollow form, the procedure adopted resembles the action of a sculptor in cutting away background to a line in carving, although, considered physically, the relief of the surface of the print is in reality the reverse of what is perceived.

It is obvious that as soon as any number of cuts are made in a plate,

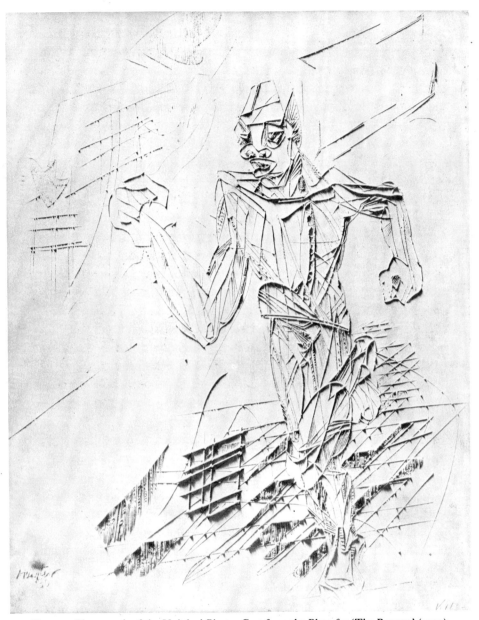

FIG. 19. Photograph of the Uninked Plaster Cast from the Plate for 'The Runner' (1939) by S. W. Hayter (Collection, Museum of Modern Art, New York).

they will assume a relationship which will modify their separate effects. In a form of which 50 per cent. of the surface has been cut into, the reversal just referred to will always occur, that is, the impression will no longer be of a series of black lines on white, for the blacks will predominate. Moreover the balance between them will seem more important than that between the actual cuts, and the whites will appear to be in front of the black. Even when much less than 50 per cent. of the total area has been engraved, if the black lines are connected and tend to surround or isolate a white form, that form will solidify at the expense of the surrounding black. This is an example of the *Gestalt* alternation of object \rightleftharpoons background.

It is possible to make very short cuts which will function like dots. A clean triangular dot is made by driving the burin into the plate at an obtuse angle and removing the shred with the scraper. The *flick* dot, a two-pointed lenticular form, is made by engaging the point and jerking upward and forward. A round dot is formed by rotating the plate; a larger dot by rotating the plate against the burin leaning to one side, almost the only occasion upon which the axis of the burin is not kept vertical to the plate. It is also the only time when it might be desirable to use a burin with an end facet blunter than 45°; since dotting subjects the point to extreme stress, some engravers keep a tool sharpened at 60° for this purpose alone, but one could well use the point of a scraper.

The infinite combinations of dots and lines of differing length and thickness permit the elaboration of texture in the print. Equivalents of colour can be obtained by these textures, as by the use of etched lines and transferred textures in etching. Where it is wished to end a series of cuts in a previously made line, a slight raising of the heel of the burin at the last moment before reaching the line will cause the point to click into the furrow, without any risk of travelling beyond it. Where it is wished to traverse a line already made, a very slight depression of the heel will permit the cut to pass without deflexion. One method of making a closely linked line of arrow-head dots consists of dotting firmly in the furrow of a line already cut, then burnishing the spur-shaped burrs forward in the direction in which the dots

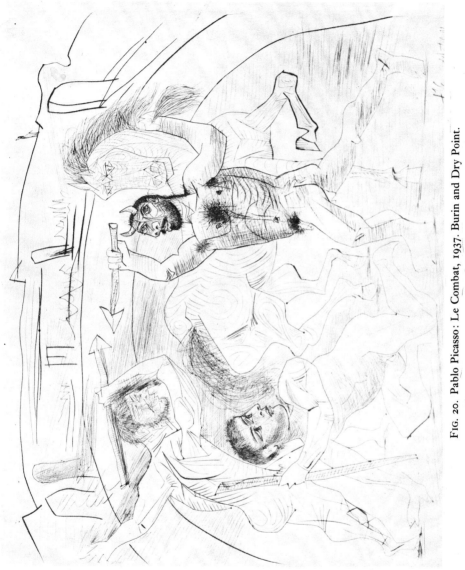

FIG. 20. Pablo Picasso: Le Combat, 1937. Burin and Dry Point.

were made so that they will, to some extent, seal up the furrow. This is valuable as a method of destroying a too persistent line. It enables the engraver, also, to fill the end of a line that has been carried too far; though, of course, $\frac{1}{16}$ inch is about the maximum possible by this means. Systematic use of this device permits a white line to be made through a black line already engraved.

As soon as the main design is established or a small portion of the plate has been worked out (whichever method is adopted), a print should be made. Just as many of these working prints, 'states', as they are called, should be made as are needed to follow the progress of the work. There is no fear of wearing out the plate as a well-cut burin engraving will print 500 impressions without steel facing.

At this stage serious errors may be found in the plate. It is very simple to correct them, and every engraver should know how to do this. Otherwise he will be at the mercy of every accident that may occur.

Joseph Hecht (Fig. 21), in my opinion one of the greatest burinists, had the gentle habit of inviting beginners at the first lesson to take a burin and make as deep a cut as possible in the plate. In their enthusiasm they would often break a point. He would then require them to remove the gash so that he could not detect where the correction had been made; they often spent a week in obliterating that first jab. This may well have been planned to test the fortitude of the aspirant, but, actually, corrections should not take so long.

Very fine lines may sometimes be removed by burnishing in the direction of the line until the copper has closed over the place entirely. The procedure, in the case of deeper lines, consists of marking with callipers on the back of the plate, very accurately, the position of the section to be removed. Then the plate is hollowed out with the scraper until the lines disappear, and the back is hammered up until the face is level. This is done more rapidly by gumming one or two thicknesses of paper to the back and passing the plate, covered with paper, once or twice through the press, which will apply enough pressure to push up the metal. Finishing is begun with Scotch stone and water. The marks of the scraper are removed; then, charcoal with water is worked across in the direction that was employed for the stone. When

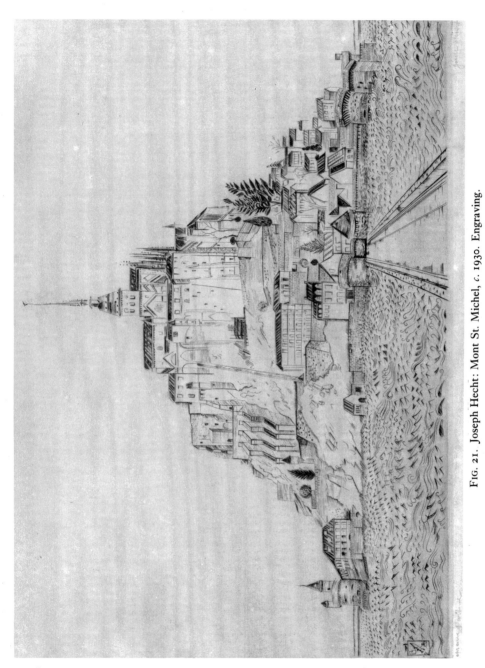

FIG. 21. Joseph Hecht: Mont St. Michel, *c.* 1930. Engraving.

the correction is complete, the slight grey of the charcoal may be removed with jeweller's rouge, very fine emery paper, or any other polishing agent. Each operation *must* be perfectly completed before starting upon the next.

It may be necessary to establish some trace of a project on the plate before starting work with the burin. Although a tracing with white transfer paper may be used, the practice of drawing (pulling) lines on the plate, and then copying them with the driven tool is most undesirable, if the artist is to arrive at any conception of the function of the burin in originating a work of art. When, in a large or complex project, the engraver tends to lose his way as the plate swings into different positions, it may be advisable to have the relationships and the directions mapped out. Otherwise the design may be carried clear off the plate.

Atelier 17 has generally used white-coated paper applied over the plate, drawing the main elements through it. The white traced line which remains on the plate is useful for situating the design but it most certainly should never be *followed*. It is fortunate that the breadth of the trace, sometimes ten times that of the burin lines to be cut, permits free construction of the design with the tool itself. It is possible to draw with pencil on a slightly dulled copper plate, but again it is most essential that the work should originate with the tool and not be transposed from a pencil trace. We have found that a line drawn on copper with a felt-tipped Flowmaster pen resists acid sufficiently to leave a trace when bitten for a few seconds. This trace will remain visible throughout the whole development of the project, but will not show on the print.

At one time, as soon as beginners had mastered their tool sufficiently to engrave lines and dots with some precision, we used to leave them to find further applications of the technique. However, we observed that those systematic elements which would tend to transform the whole field of space were often ignored.

An experiment (see Figs. 15 and 23) was then devised to show the function of linear systems in transforming the whole situation of those objects (as small white on black elements; small constructions

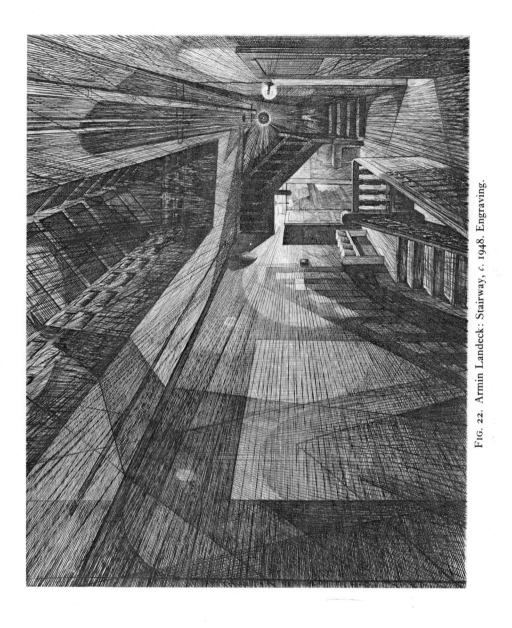

FIG. 22. Armin Landeck: Stairway, c. 1948. Engraving.

FIG. 23. Experiment to show Change of Space by means of a Linear System.

of simple wedge-shaped cuts). Once these are solidly engraved into the copper and seen to lie in one plane, it is not believable that any operation on the rest of the plate can change their situation. Nevertheless, as will be seen from the illustration, when the plate has been covered with vertical, horizontal, and radiating pencil lines and a random mesh established keeping very precisely to the directions of those lines, it becomes impossible at a certain point to avoid using the mesh like a sort of perspective and situating all those previously superficial objects within it when their relations with one another will be seen to be displaced in depth.

Further experiment shows that any coherent line system of this general type will necessarily become the frame of space within which all previous or subsequent work will be articulated. These webs are to be understood as special cases of arbitrary line systems rather than 'perspective' with its connotation of 'right' and 'wrong', as all of them can be shown to function with the same degree of conviction. The beginner is thus introduced to one of the big general means of transformation and not left to struggle with the detail exploitation of objects and textures.

The first artists we know who made use of the burin were goldsmiths who worked primarily for the appearance of the metal rather than for any consequent print. Although we work now with an eye to the print rather than to the metal, if the plate develops beauty in itself, the print also will probably be satisfying. It does not necessarily follow, however, that a plate which is not in itself handsome will fail to give an interesting print, but this is exceptional. Armin Landeck's print *Stairway* (Fig. 22) is an example of a plate worked first of all for the copper and then for the print.

4

ETCHING I
BITTEN LINE · SOFT GROUND
LIFT GROUND

THE BITTEN LINE

Preparation of the ground

THE first step in making an etched plate is to obtain a coating on the surface of the zinc or copper plate which will resist the action of acid. This coating should allow a point to penetrate it without undue resistance (that is without undue pressure on the point), but at the same time it should not crack or flake off in closely worked passages and it should, further, be able to stand up to the action of the acid for many hours if necessary. It is an advantage to have protective films that do not crystallize, harden unduly, or crack when stored, as it is sometimes necessary to prepare plates and keep them for years before exposing them to acid.

Attempts have been made to combine all of these qualities in the various products used for this coating. Actually, few possess them all. The preparations come in two forms: liquid varnishes and solid lumps. The most generally used composition consists of 1 part resin, 2 parts bitumen, and 2 parts beeswax. In certain colourless grounds a greater proportion of resin is used in place of the bitumen. The most commonly used resin is colophony, but Damar resin can also be employed in preparing a ground.

The grounds used in the seventeenth century were much harder than those used today; they were often mixtures containing heavy linseed oil, *burnt* on to the plate, which gave them an almost enamel-

like hardness. The tools used to work through these grounds were sharp cutting tools of the type of the echoppe (Fig. 4D), and the whole process of etching was looked upon as an easier and more rapid method of obtaining the effect of burin work. These grounds, however, had the disadvantage that they were less resistant to strong acids than the softer modern compositions. Grounds dissolved in nut oil were also applied in liquid form and the volatile oil was driven off by heating the plate. The surface of some of these grounds was sometimes covered with a coating of white lead, applied over the acid-resistant film, so that the mark on the plate would appear in black on white, rather than as the bright metal against the black of the bitumen.

If a ground contains too large a proportion of bitumen the resistant coating cracks easily; if there is too much wax, it softens under the hand while working and its resistance to acid is decreased. When, as happens in very rapid biting, the plate becomes warm, the edges of the coating may bubble or allow the acid to underbite. With liquid grounds, if the drying is extremely rapid, there is a tendency to crack; when the drying is slower the grounds are often sticky, and have more time to pick up dust particles which weaken their resistance to the acid.

Preparation of the plate

The plate, preferably slightly dulled, is cleaned with a paste of ammonia and whiting, or with acetic acid or alcohol to take away any traces of grease, and then the cleaning substance should be removed with running water.

The water will spread over the whole surface of the plate in a film which will only break where grease spots have been left. If the surface of the plate is not perfectly clean, the coating will not adhere and, when the plate is placed in the acid, it will lift off it, exposing the dirty places.

The plate is dried by heating it without touching the surface with the fingers, since traces of grease persist on the hands even after washing.

A small quantity of the ground is melted on to the heated plate. For this the upper surface of the block of wax is used, as any foreign matter which has found its way into the block during its preparation

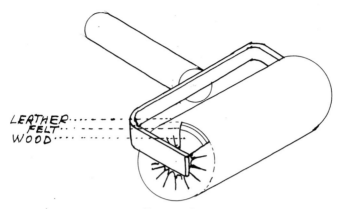

LEATHER
FELT
WOOD

FIG. 24. Grounding Roller.

will have sunk to the bottom. It is usual to keep the ball of ground wrapped in fine silk so that any particles of grit which were in it will be retained by the material. The outer surface of the ball must also be kept free from grit or any other impurities.

Next the leather roller (Fig. 24), free from dust, grit, or fibres, is passed over the plate, becoming coated with the wax and distributing it over the surface. At this point the plate is too hot to finish; in a ground applied at this temperature it is inevitable that bubbles of air are left under the surface. At this juncture the plate surface appears shiny. By moving the plate to the cooler end of the hotplate, it is brought to a temperature which is just bearable to the fingertips, applied lightly below the edge of the plate. The plate rolled at this temperature is covered with an even *mat* surface of a definite brown colour, free from holes or bubbles. Rolling must be continued until this coating is satisfactory.

If the plate cools too much during this operation the wax comes off the roller in blobs. Reheating will be necessary to take these up again on the roller. If too much heat is applied the ground will start to burn, as will be seen when it smokes.

The hand-vice is then clamped on one corner or in the middle of one side of the plate, as is convenient, and the plate, still hot, is passed,

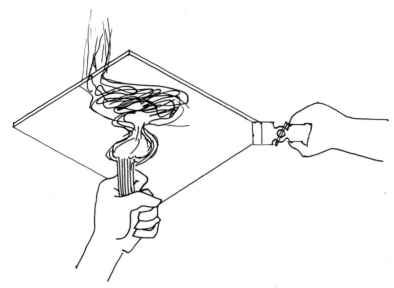

FIG. 25. Smoking Hard Ground.

with the grounded side down, over the flame of a taper (Fig. 25), care being taken not to touch the surface with the wick or to keep the flame too long in one place where it may burn the ground. The soot will blend entirely with the ground, leaving a brilliant black surface which becomes dull black on cooling.

During the whole process care should be taken to prevent dust, fluff from the sleeves, hair, and so on falling on the plate as the weak points created by such particles in the surface of the wax will allow the acid to penetrate. It is well worth while for the beginner to spend a few hours thoroughly learning this process as it can be carried out very rapidly once the right temperature has been found and it has been realized that the first essential for a clean plate is a good ground. The dabber, described on page 9, may be used instead of a roller, but with the dabber it takes longer to prepare a plate of any size and the coating deposited is thicker and more irregular and so more liable to crack.

There are many liquid grounds similarly constituted. The materials, the same as those in the solid grounds, are dissolved in ether, chloroform, or petroleum-ether. The simplest method of laying these liquid grounds is to pour a quantity of the filtered liquid over the plate, letting it drain while

pouring the excess back into the bottle through a funnel. Dust on the surface of the plate or in the liquid must be avoided. I have never found liquid ground as satisfactory for all purposes as the ground laid with the roller, though the plastic base varnish used by process block-makers is very resistant. This, however, also offers great resistance to the point in working.

A pencil drawing of the subject on hard-surfaced paper (tracing paper) may be soaked with water, laid face down on the grounded plate, and transferred with the press. For this *less* pressure is required than is used in printing, one blanket being removed. If it is done carefully, the process does not damage the ground. The drawing appears in reverse as a grey line on the black surface, and it can be followed with the point.

Needling

The needle, either a steel point in a wood or cork handle or, more commonly, a gramophone needle in a holder or pin-vice, is held like a pencil, but rather more perpendicular to the plate. In working with the needle the weight of the hand provides sufficient pressure; too much pressure, or too sharp a point, produces a shaky and uncertain line. If one forms the habit of drawing freely from the elbow or the shoulder, rather than with the fingers only in the cramped position of the rested hand, the line will be correspondingly clearer and firmer. As the quality of the line in all etching processes will be seen as if magnified, this quality is of more importance than in drawing. I have found it useful to trail the second finger on the surface of the plate (Fig. 26) as this serves to steady the hand in making long sweeping lines. It is, of course, important to avoid scratching the ground with the fingernail. Many etchers keep a paper under the hand to avoid this, as well as to prevent the wax being softened with the warmth of the hand.

It is desirable to open up the surface of the plate clearly; any method of laying bare the parts of the plate to be bitten will serve. A cactus spine gramophone needle runs very freely and does not cut into the metal; a star wheel such as the tool used for tracing embroidery designs will give a dotted line and a comb or a number of needles held in a clamp can be used to give a series of parallel lines. When the plate is examined after the needling is

completed, the lines should show clean metal. Where they are yellowish or brown, there is probably a trace of the ground still in the groove and they will not start to bite as soon as the clear ones. Often they will open as a series of dots, generally broader than the finest line. Such faulty work will not be conspicuous in strongly bitten passages, but is undesirable where fine lines are wanted.

It is possible to carry out all the work on the plate with the same point, trusting to the acid to produce all the variations of strength desired, but to save time, particularly when producing the deepest blacks, two or more points of different thickness and, for very wide areas, the edge of the scraper blade can be used. This can be seen on Picasso's *Femme au Tambourin* (Fig. 27).

Here it should be noted that, if a groove in the plate is to hold ink so that it will print black, it must have a depth proportionate to its width. A broad line must be bitten deeper than a fine line. If the furrow is too shallow, ink will not be held in the centre where a grey will appear between two black margins, as the walls alone will retain the ink. Such a grey space is known to French etchers as a *crevé*.

Biting and stopping-out

There are two methods of organizing the biting of a plate: all the lines may be opened up at once and different parts of the plate exposed to the acid for different periods by progressively stopping-out first the fine lines and then the heavier ones; or the strongest lines may be marked first and exposed to acid, the next in strength being added, the plate rebitten, leaving the first lines open and so on.

The beginner should remember that stopping-out is a process of sealing lines against the acid and, although he is using a brush to do this, he is not painting. Once lines have been bitten in a plate it may be necessary to varnish over them three or four times, for the first coat sinks into the line, but the second may fill it and the third may be needed to seal the edges at the surface. The use of a transparent resin solution in stopping-out has the advantage that it leaves the finer work visible for comparison with the deeper bitings. When everything is visible, it is like working in the daylight, while using black varnish is like working in the dark.

Where white or lighter effects are wanted in a closely worked passage, it is simpler to ignore them during the needling and stop them

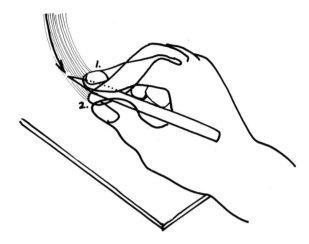

FIG. 26. Point and Position of Second Finger.

out. This permits work in white on black to be done directly. It is obvious that it will be easier to use the second method where fine lines pass across heavy lines, as it would be difficult to stop-out the smaller lines without blocking the others. Similarly, where a contrast of value is sought between broad areas, the first method will be more convenient. In practice both are used according to the requirements of the passage being worked. Without stopping-out it is still possible to vary widely the intensity of the biting in the acid bath. Gradations of strength over part of the plate can be made by tilting the bath, with little acid in it, so that one edge, one corner, or half of the plate is covered (Fig. 29). The plate can be moved at intervals or the acid agitated by blowing or by rocking the bath slightly, so that definite margins are not made. It is clear that gradations darker at the edges, lighter in the centre, can easily be made in this way. However, if a dark centre with a light edge is required, the plate can be covered with water in a bath and concentrated nitric acid can be dropped on the centre: as the acid diffuses in the water less and less action occurs and a dark centre, grading to a light margin, is produced.

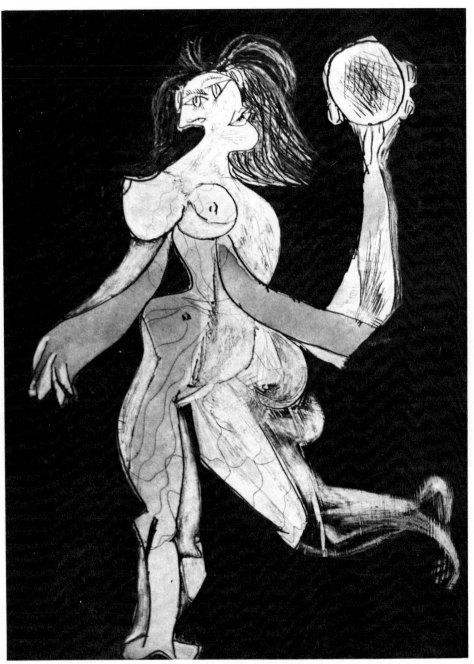

FIG. 27. Pablo Picasso: La Femme au Tambourin, 1944. Aquatint
(Collection, Museum of Modern Art, New York).

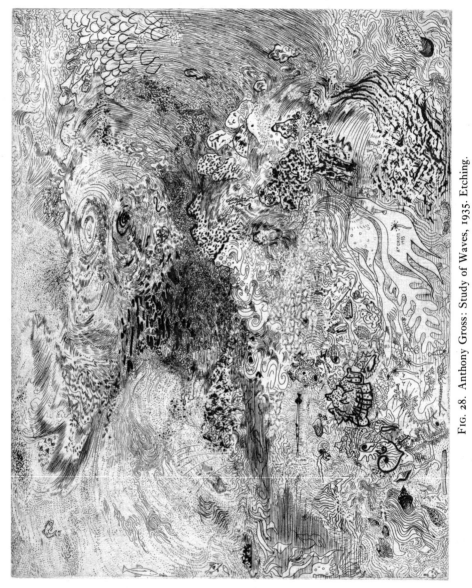

FIG. 28. Anthony Gross: Study of Waves, 1935. Etching.

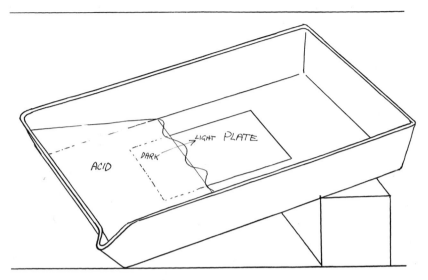

Fig. 29. Position of Acid Bath for a Biting Gradation.

Before the plate is put into the acid, the back as well as all scratches, errors, or possible weak places on the face are covered with stopping-out varnish.

Acid used for zinc: 1 part nitric acid to 12 parts water for a slow bath; it may be strengthened for heavy bitings. Hydrogen gas is liberated during the action of the acid on the zinc.

It is most important to avoid any trace of copper acid in the acid used for zinc, as it will form a coating on the zinc, producing a Zn-Cu couple with an electrolyte between. The electrical current generated will break down any ground so that it finally peels off the zinc plate.

Acids used for copper: 1 part nitric acid to 2 parts water. There should be some copper in the solution or the acid will not bite regularly. Some old acid may be added, or a copper penny dropped in for a few minutes until the acid is coloured blue. Nitric acid reacts with copper to produce bubbles of nitric oxide gas.

Action will commence from centres spreading outward, giving a

F

characteristic granulated texture which we have used deliberately on copper, on zinc, or on steel.

Dutch mordant: 2 parts potassium chlorate, 88 parts water, and 10 parts hydrochloric acid. The salt is dissolved in hot water, then cold water is added to make up the volume, the acid being added last. A stronger mixture may be used if desired. Usually a saturated solution of potassium chlorate is employed: in use this slowly becomes less active, when more hydrochloric acid may be added. No gas is liberated. We have replaced potassium chlorate by sodium chlorate. Owing to the greater solubility of the sodium salt, a faster biting mordant can be made, but it cannot be kept as long as the normal Dutch mordant.

Ferric perchloride: A saturated solution (45° in the Beaumé scale) diluted with the same amount of water. The perchloride also bites without liberating gas, but is less accurate than the chlorate bath. It deposits black copper oxide in the lines which has to be removed for the biting to continue uniformly.

Nitrous acid: May be used in the same proportions as nitric.

Acetic acid: May be used for very delicate bitings. It has very little effect on copper, and stronger bitings require one of the other acids. Its greatest value is for cleaning lines in a plate before biting, when these have been fouled with grease from the hand, for, despite its weakness, it is better for this purpose than the stronger acids.

Biting

The effect of these different acids on the plate is quite distinguishable in the results. Nitric and nitrous acids in biting give off nitric oxide gas with copper, and hydrogen gas with zinc; the bubbles of gas collect in the lines and produce a shallower and rougher-edged line than does either the chlorate or perchloride, which act through the presence of free chlorine in the solution and do not produce gas bubbles (Fig. 30). They cause some degree of undercutting of the edges of lines.

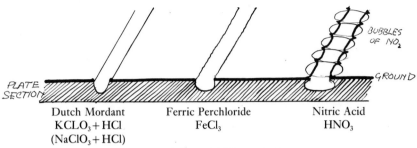

FIG. 30. Effect of Different Acids.

The gas bubbles formed by the nitric acid, if allowed to grow and left undisturbed on the surface, will prevent further action of the acid. Thus in a closely worked passage or on an unprotected plate they may produce a granulated texture, which has sometimes been deliberately sought (see Fig. 31).

This pattern of bubbles will be superimposed upon the pattern of the work. To make the biting as clear as possible, the bubbles are removed at intervals, by tilting the bath which contains just enough acid to cover the plate, thus exposing the plate to liberate the gas. This is preferable to the customary method of removing bubbles with a feather, as it is undesirable to introduce foreign matter into the acid bath.

Instead of the plate being immersed in a bath of acid, the mordant can be applied directly with a brush and manipulated so as to give local variations in the force of the line. Owing to the practice of earlier etchers of controlling the acid with saliva, this method is often known as spit-biting. Another system, used when there is no bath large enough to contain the plate, consists in edging the plate itself with wax or plasticine, leaving a small lip at one corner to make pouring easier, and the acid is then poured directly on to the plate.

When a plate is taken out of a bath it *must immediately* go under the tap to wash away all traces of the acid from both sides. This procedure must become automatic with an etcher: the amount of damage that a single person with a plate dripping acid can do in a studio is surprising.

Before stopping-out the plate must be dried, as a wet surface will not hold the varnish. This may be done with a clean blotter *firmly* applied, without shifting.

FIG. 31. Alexander Calder: The Big I, 1944. Soft-Ground Etching.

The length of time necessary to etch a line varies enormously with the temperature and the proportion of the plate surface exposed. Thus it is almost useless to attempt to control it by timing. A rise of temperature of 10° will almost double the speed of biting. However, it is useful to remember that if it takes one minute to produce a fine line, to double it in thickness and depth will require perhaps four more minutes and to double this again perhaps sixteen more. The extra minutes needed to increase the strength of a line regularly will follow a geometrical progression, so that the intervals in strong biting should always be exaggerated. The best method of control is by direct observation. If the plate is seen in the bath so that its surface reflects a source of light, the lines will appear as black against white, very much as they will print. Where nitric acid is being used, gas bubbles must be removed before observing, otherwise an exaggerated impression of the force of the lines will be given.

When the biting is completed all grounds and varnishes must be completely removed from the back and front of the plate with benzene, gasoline, turpentine, or another solvent. Then a trial proof is made (First State).

Rebiting

It is rare for a plate to be completed with a single ground. Certain parts may appear too strong, others too weak, or detail may be lacking. As the general planning of the plate dictates, overworked passages may be removed by scraping, burnishing, grinding with water of Ayr stone at this time or after further bitings if it is more convenient.

Where new lines are to be added or work rebitten, the plate is cleaned again with whiting and ammonia, and regrounded as before. All old lines are generally filled up with ground.

It is possible, however, to reground with the old lines left open for rebiting. This is done by placing a blank plate of the same gauge alongside the worked one on the hotplate; then, when both have reached the correct temperature, the blank plate is grounded first and the roller is passed from the blank plate to the etched plate, laying the ground without filling the lines. Another method of keeping bitten

lines open consists in filling them with gouache white or whiting mixed with milk, which dries in them; the surface is then polished perfectly clean and regrounded. The filling, dissolving in the water with the acid, lifts off to leave the lines open.

Regardless of the technique employed for rebiting, the lines will never achieve the cleanness and precision of those made directly. Therefore, unless the undertaking would be too involved, it is better to open the lines again with the needle held almost vertically.

Once the biting and rebiting of the lines in the plate has been completed, it is sometimes desirable to work it so that ink will be held not only in the lines but also on the surface between them. It should be clear that if the surface of the plate is exposed unprotected to the acid in these passages, the edges of the lines will be broken down and the spaces between the lines pitted, giving the desired effect (see Fig. 32).

Etching-out

The foregoing description of how an etching is made gives the elementary method of making lines in a plate which is intended to be printed. Some of the errors and accidents noted have become the basis of new methods of working. For example, exposure to acid under different circumstances may make a plate print darker, as described, or the acid may remove or lighten work already established. If the strongly worked parts of the plate are exposed unprotected to the acid for any length of time, the whole surface will gradually take on a granulated grey texture, the tone depending upon the strength of the acid used, and the original lines will slowly become weaker and weaker until they *almost* disappear. The whole surface of that part of the plate will be lowered and, when it is printed, the print being a *cast* from the plate, it will obviously be above the unworked surface. However, when it is possible to regard the totality of all such elements as constituting a background or space, rather than a concrete object, it will invariably appear in the print to be below the original plate surface, an illusion that is strengthened by the black border of ink held in the margins. In this way acid has been used to *remove* or blur the work already existing in the plate.

FIG. 32. Joan Miró: Fillette Sautant à la Corde, Femmes, Oiseaux, 1947. Bitten Surface.

To do this we cover those parts of the plate that are to be preserved with asphaltum, dry it thoroughly, and then etch away the remaining surface with the *nitric* acid bath. As the surface of the plate is lowered the crystallization of the copper along the direction in which the metal was rolled will begin to show as a striation; the bubbling of the acid, particularly if it is a strong solution, will also impose a granulated surface. Any irregularities, lines, or textures already in those parts of the plate will widen and soften so that, after a long biting (perhaps as much as nine hours), they will print like the weathered trace of a crack in a wall. The background of the print, if bitten out, will appear from a distance to be below the surface of the untouched plate, as has already been explained. But by inspection in a parallel light it will be seen that the background is in front of the image, the reverse of what it seems. Thus, if a closed form is etched out in this manner, that form will appear as it really is, in front of the print surface. If, however, the form is an open one which can be regarded as a background, it will appear to be behind. This alternation of the object/background relation (*Gestalt*) and the reversal of apparent positions occurs frequently in etching and engraving, and the borderline cases give rise to an expressive ambiguity which I have found very valuable.

During the summer of 1947, the poet Ruthven Todd and I, with Joan Miró, experimented with the printing processes used by William Blake in the creation of his plates in relief (Figs. 34*a*, *b*). After many tries we worked out the method he probably used. A poem was written in a solution of asphaltum and resin in benzene upon a sheet of paper previously coated with a mixture of gum arabic and soap. (We had suspected that Blake used a transfer method, as his text, though very perfect in detail, is sometimes not perfectly aligned with the plate.) A clean plate was well heated and the paper laid upon it and passed through the press. The back of the paper was then soaked with water and peeled off, leaving the resist on the copper in reverse. The designs were then drawn with a brush and asphaltum solution by the artist, the back of the plate was protected, and it was bitten in a solution of 1 part nitric acid to 2 parts water for at least 9 hours until the plate had lost about half its original thickness. Printing by a number of different methods followed (see Chapter 9).

FIG. 33. Helen Phillips: Structure, 1962. Etching.

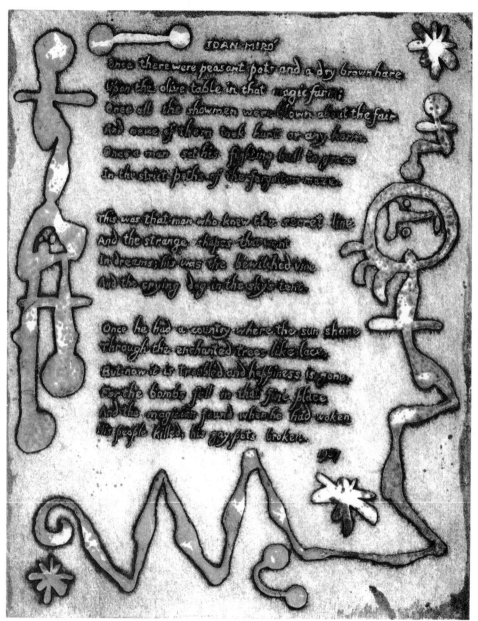

FIG. 34*a*. Joan Miró: Poem of Ruthven Todd with Decorations, 1947. Intaglio Print.

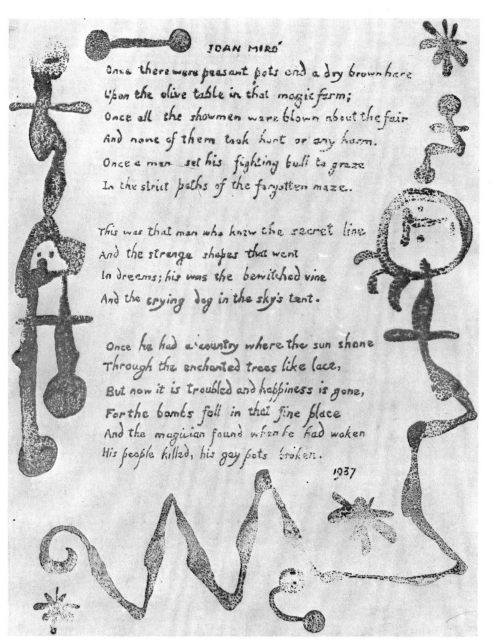

JOAN MIRÓ

Once there were peasant pots and a dry brown hare
Upon the olive table in that magic farm;
Once all the showmen were blown about the fair
And none of them took hurt or any harm.
Once a man set his fighting bull to graze
In the strict paths of the forgotten maze.

This was that man who knew the secret line
And the strange shapes that went
In dreams; his was the bewitched vine
And the crying dog in the sky's tent.

Once he had a country where the sun shone
Through the enchanted trees like lace,
But now it is troubled and happiness is gone,
For the bombs fell in that fine place
And the magician found when he had woken
His people killed, his gay pots broken.

1937

FIG. 34*b*. Same Plate as in Fig. 34*a*. Printed in Relief.

Thus, it can be seen that a ground put on badly so that it is more or less porous, any matter on a plate surface that will cause the ground to lift, and the breaking down of the ground through the zinc-copper electrolytic effect, are all means that have been employed for constructive purposes, but under complete control.

SOFT-GROUND ETCHING

Among the resistant materials which can be used to protect a plate against the action of acid, the soft grounds are of particular interest. An ordinary etching ground heated with grease, vaseline, tallow, or, better, the sticky grease used for axle lubrication, will produce a mixture which will protect the plate but will never dry, so that any object which touches it will pull away the surface and expose the metal. A mixture of 2 parts ground and 1 part grease, or one of about equal parts or anything in between will serve as a soft ground.

Grounding

The plate is heated, as for grounding with the hard ground; the soft ground is melted on and rolled out with a leather or rubber roller in the usual way. There is no need to clean the plate beforehand, as it is being coated with grease. As the melting point of soft ground is much lower than that of the hard ground, the plate is removed from the heater and the rolling completed cold. It should be continued until a brown furry surface is obtained. A pale yellow film of ground on the plate will not be strong enough to resist the acid, although, as will be explained later, there are times when a weak film might deliberately be used.

Work on the plate

The traditional method of using soft ground is, with a pencil or a stylus, to go over a drawing pinned down on the grounded plate, or to draw on a blank sheet of paper laid over the plate, in either case the drawing being in reverse—the mirror image of what is required in the print. When the paper is lifted, its underside will have picked up the ground and exposed the plate wherever the pencil touched it (Fig. 35).

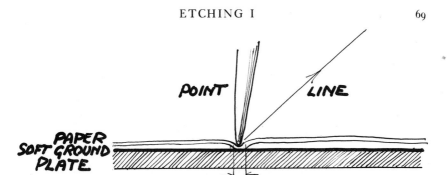

FIG. 35. Drawing on Paper over Soft Ground.

If we analyse what happens we see that the thickness, the texture of the paper, and the degree of pressure exerted will modify the result. Thus, the width of the trace on the plate is the breadth of the pencil point plus about twice the thickness of the paper. The trace has the character of the pencil line on the paper as the texture of the underside of the sheet is impressed upon the wax. The amount of ground which has been lifted depends upon the pressure applied, and not upon the blackness of the pencil trace on the paper. In all these methods it is important to try to visualize the mechanical process of making the object, the metal plate, with its capacity for holding ink; confusion with the concept of drawing should be avoided. The consequence of each operation is then clear.

Biting

The back of the plate and all errors or imperfections in the coating must be covered with stopping-out varnish. At this point it is possible to draw with the stopping-out brush elements in white through any strongly worked area. The plate is then bitten exactly like the bitten-line etching previously described, so that of the lines established in the plate some may be so little exposed to the acid that they are barely visible as greys, while others may become black and stand up in relief in the print. As with bitten-line etching, the separating into elements of varying strength may be done by the addition of new work after biting, or by subtraction by means of partial stopping-out at each stage. When biting is completed the plate is cleaned with benzene or another solvent and printed like a bitten-line etching.

Plates covered with soft ground must be handled by the edges as the surface is sensitive to any pressure. Also, before stopping-out, the plate *must* be allowed to dry, a process which may be speeded up by the use of a hot-air drier. However, it is unwise to heat the plate as this can soften the ground and cause it to close up over the opened lines.

Plates made by this method have somewhat the character of lithographs or pencil drawings (Fig. 36). As, in place of the furrows in the bitten-line method, they have microscopic pits which hold the ink, they present an enormous resistance to wear in printing.

It seems strange that, given a plate prepared in this manner, artists would not have done the most obvious thing, which was to draw directly through the ground with a wooden or other stylus, or to press fingers, textures, and so on into it. Yet, until recently, this seems to have been little done. Some examples are: fingerprints in Fig. 37, textile in Fig. 39, textile and leaf in Fig. 47, canvas in Fig. 48, skin in Fig. 49.

Beginners, starting work in Atelier 17 (see Chapter 16), are generally given a plate prepared in this way, and invited to draw freely, scribble even, upon the wax surface. As the hand cannot be rested on the surface they are compelled to draw freely. Generally, before anything is fixed by acid in the plate, a score of attempts have been made and obliterated with the roller. In this way two useful qualities of the medium are appreciated at once. Up to the time at which biting is started there is an infinite possibility of change but, while the spontaneity of touch will remain in the final print, a definite decision must be made at some point.

Even with this method it is possible to map out the design to be used. A pencil trace made on the plate before grounding will be visible through the ground and can serve to orient the design.

The method has also been used, with very exaggerated biting, to produce forms from which white relief could be printed (Fig. 123). Other uses of this coating on a plate is described in Chapter 5 (Aquatint, Bitten Surface).

LIFT-GROUND ETCHING

To evade difficulties of etching, a number of devices have been used at different times to enable the artist to draw directly what is to

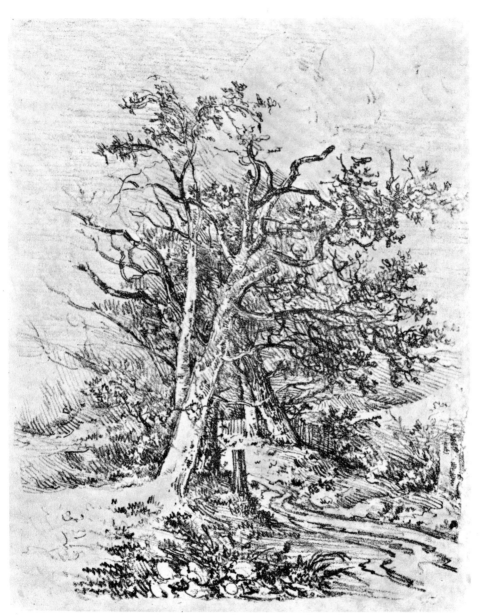

FIG. 36. John Crome (1768–1821): The Tree. Soft-Ground Etching from Drawing.

FIG. 37. Marc Chagall: Femme Violoncelle, 1944. Soft-Ground Etching
(Collection, Museum of Modern Art, New York).

FIG. 38. Jacques Lipchitz: Minotaur, 1943. Etching, Engraving, and Liquid-Ground Aquatint.

appear on the print. Known as the 'pen method', the 'sugar method', and by other names, they depend upon the same principles. Some substance is used to draw directly on the plate or even, in certain cases, on paper whence the drawing is transferred to the plate by pressure, so that the reversal of the design in printing is avoided. The plate is then coated with an acid-resistant film. When it has been soaked in water or acid, the ground breaks down where it covers the preparation used so that the part drawn upon is bitten. It should be obvious that this is only the illusion of a direct method. Any method which involves the use of a substance that will cause the coating to lift, exposing the lines to the action of the acid upon the metal, and which then requires the application of ink and finally pressure to transfer that ink to the paper can hardly be considered *direct*.

Most of the mixtures are made of substances that do not dry completely (such as glycerine, gum arabic, sugar solutions, corn syrup, gamboge, &c.) and thus render porous the film of ground covering them. In Atelier 17 since 1929, India ink mixed with about the same amount of syrup has been employed.

Other mixtures which have been found very effective are 2 parts ink, 2 parts syrup (sugar in solution), 1 part tincture of green soap and a trace of gum arabic, or 1 part gamboge, 1 part gum arabic, 1 part soap solution, and a trace of glycerine. The soap in these mixtures prevents bubbling on the copper plate, and causes the ground to lift more easily. Ordinary gouache has been used as a lift ground, but it has been found uncertain in its action.

In Atelier 17 it was noticed that the patterns made by the whiting in cleaning a plate were exciting and a plate with such markings was sprayed with fixative, lifted with acetic acid, and then etched. The *décalcomanie*, used by the surrealists, can be done on paper with lift ground, transferred wet to the plate by pressure, grounded, lifted, and etched as described.

The drawing is made upon the clean surface of the plate with a pen or brush using one of the mixtures described. The plate is then dried by heating and coated with liquid ground or with resin dissolved in alcohol. This is done by placing the plate in a tilted bath, pouring ground into the lower end, then tilting the bath the other way so that the liquid flows over the surface. The plate is then removed and stood

up to dry. When dry it is soaked in warm water or, better, vinegar or
acetic acid, until the ground detaches over the work.

In this state the plate may be bitten as described, or aquatint may
be laid; we have even laid a soft ground over the opened design and
pressed in textures such as silk, gauze, or crumpled paper (Fig. 39).
In actual fact most effects obtainable by this means (Fig. 37) can be
done more readily with the soft-ground method described, although
Roger Lacourière has employed the lift ground with excellent results
in the preparation of his prints for Picasso (Fig. 40), Georges Rouault
(Fig. 44), Braque, and Paul Éluard, the poet.

FIG. 39. S. W. Hayter: Palimpsest, 1946. Lift Ground, Three Colours.

FIG. 40. Pablo Picasso: 'The Lizard' from Buffon's *Histoire Naturelle, c.* 1937-8.
Aquatint (Collection, Museum of Modern Art, New York).

5

ETCHING II
AQUATINT · BITTEN SURFACE
MANIÈRE NOIRE

UNDER the above heading have been classified all the methods in which whole areas of a plate are attacked with acid to render them capable of retaining ink in pits or irregularities of the surface. These are distinct from the methods of bitten-line and soft-ground etching already described, in which lines only are exposed to the mordant, the remainder of the plate being protected by the ground. They give the effect of wash drawing rather than of pen line.

When an area of plate, without previous preparation, is exposed to acid a slight irregularity is produced in its surface as the attack commences which will print as a slight grey. If the action of the acid is sufficiently slow, the grain developed in the surface represents the crystallization of the metal. If the bubbles of gas given off by the acid are not removed, they protect the surface under them from the action of the acid, so that ring-shaped patterns of deeper biting develop. This has been exploited to give a granular surface of varying intensity according to the strength of the acid (see Fig. 31). Further attack, however, will not give a generally darker tone; it only causes the edges of the hollow, as it becomes deeper, to retain a wider and wider margin of black, leaving the centre of the area unchanged in value. This area will print quite strongly in relief on the paper. Such spaces, known, as we have said, to French etchers as *crevés*, often occur in strongly worked passages in line etching, where the intervals between the lines have been allowed to bite out (see Chapter 4).

These areas can be employed in etching to give certain effects: the

black margins obtained in this way give the effect of relief to an un-
worked area which they surround. There is also a certain ambiguity
in such areas. If the print is seen illuminated from one side, the
portion that appears to project on account of the values of the black
can be seen to be in reality lying at a lower level than the parts bitten
away, the paper being a cast of the plate.

When, however, it is desired to bite a series of values of grey to
black on a plate, it is necessary to use some device to protect points
all over the surface, or to produce a tooth which will retain the ink in
printing, so that as the acid deepens the hollows between them a tone
will be produced, increasing according to the depth until black is
attained. One method of achieving this is known as aquatint. It was
invented about the middle of the eighteenth century, but was little
employed as a medium of original expression until Goya used it in
combination with bitten lines at the beginning of the nineteenth
century (Fig. 41).

RESIN-GROUND AQUATINT

The zinc or copper plate is cleaned and polished and fine resin
powder is deposited on it. The layer of resin dust may be applied in
a situation sheltered from draughts, by shaking a silk bag containing
the crushed resin over the plate. The cloud of dust settles on the plate
and, after a little practice, it is possible to get a fairly even coating.
The plate is then heated until the resin melts and adheres to the sur-
face. Many artists prefer the effects produced in this way to the more
mechanical tone obtained by other methods, as it permits intentional
variations of grain, and even of values in the plate. Thus, if the
amount of dust in one part of the plate is sufficient to melt together
when heated, a white will appear in that part, fading to grey as the
grain becomes more open (Fig. 42). Interesting textures have been
produced in Atelier 17 by using very large irregular pieces of resin,
the coating sometimes being applied in two successive stages.

For larger plates or where great uniformity of grain is required
another method of depositing the resin is to employ a box in which a

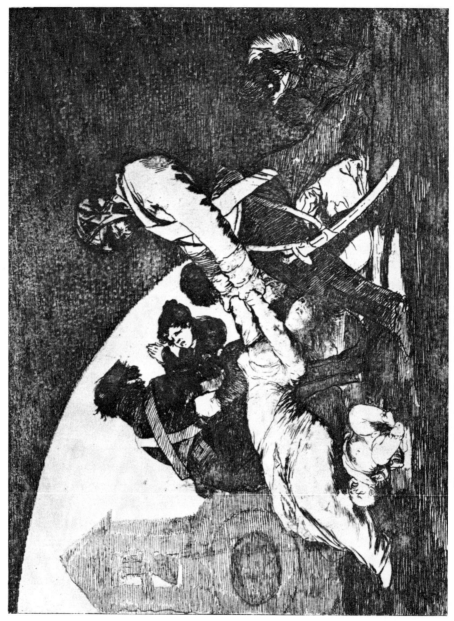

FIG. 41. Francisco Goya (1746-1828): Desastres de la Guerra. Aquatint.

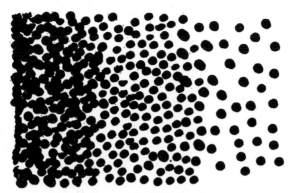

FIG. 42. Resin Ground.

large space above the plate is filled with a cloud of dust which slowly settles on the plate in an even coating. One type (Fig. 43) is a zinc-lined case with a drawer near the bottom in which slides a tray of wire netting to carry the plate. Through a hole a pair of bellows is inserted and a cloud of resin dust is blown up with the drawer closed. After a moment, to allow the heavier particles to settle, the plate is put in rapidly and the drawer is closed. At the end of a few minutes, a regular deposit of resin dust has settled, the amount depending upon the length of time the plate remains in the box. The plate is then removed, great care being taken to avoid disturbing the deposit, and is heated until the points of resin melt and stick. The plate must not be tapped against anything as the jarring will cause the grains to clot, and it must not be too strongly heated, otherwise the resin may be burned off. Very elaborate boxes are made for process engravers in which the cloud is obtained by means of fans, with grinders for resin and graduated sieves to control the size of the grain. These, however, are not really needed for original aquatint.

The quantity of resin needed depends upon the grain being sought for in the work. Too little resin will give a coarse grain, leaving per-haps 90 per cent. of the plate unprotected; the ground will be weak mechanically and will wear after one or two pulls, showing the poor quality of a *crevé*. As the quantity of deposited resin dust increases,

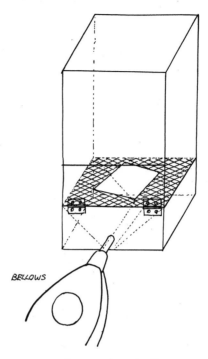

BELLOWS

Fig. 43. Aquatint Box.

the grain becomes progressively finer up to a certain optimum where perhaps only 60 per cent. of the surface will be exposed to the acid. This point can be determined only by experiment. Beyond this point, more resin will result in the clotting of the specks and, when more than 50 per cent. of the area is covered, the grain will be coarser again. In this case, as with sand grain etching and soft-ground collage methods, points are being bitten into the plate, leaving the greater part of the surface intact to withstand the pressure of printing. Such a plate will have an enormous resistance to wear. It is for that reason that the original plates of Goya, where the resin grain is of this type, were printing almost as well, when I saw them in Madrid in 1937 after one hundred years and several badly taken editions, as when they were made.

When the plate is cool the portions which are to remain white are

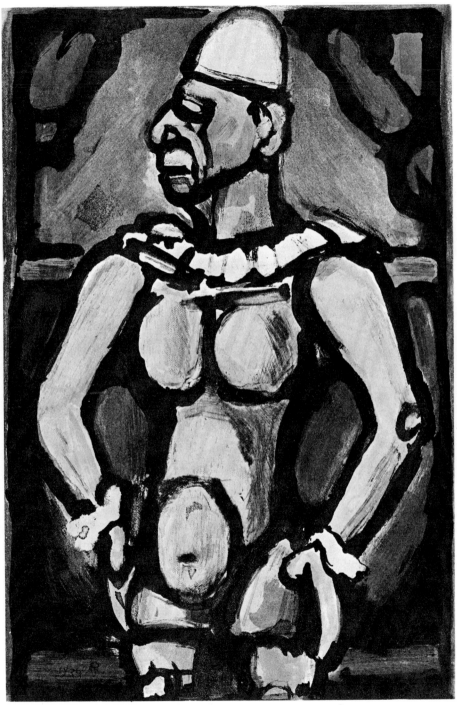

Fig. 44. Georges Rouault: 'Weary Bones', from *Le Cirque de l'Étoile Filante*, 1934.
Colour Etching (Collection, Museum of Modern Art, New York).

FIG. 45. Yves Tanguy: Rhabdomancie, 1951. Etching.

covered with stopping-out varnish. The colourless solution of resin in alcohol, recommended in Chapter 1, is excellent for this purpose if used carefully, as it enables the values of different bitings to be compared in the acid. As the varnish is only just visible, great care is necessary to avoid leaving holes in it, which may in the end print not only grey but even black. Many beginners use a careless stroke of the brush in stopping-out, being under the impression that they are painting and that the boldness of the stroke will give boldness and simplicity to the result. They are *not* painting. In practice a strong bold effect is generally the result of extremely accurate and meticulous stopping. Between the careless strokes of the brush innumerable tiny triangular openings may be left which, far from giving a bold effect, show a certain meanness and detract from the effect sought by the artist.

Aquatint obviously lends itself to the use of white line effects on grey or black. These effects are very precious yet they are seldom employed. Stopping can be done with a dry brush or lithographic crayon to give an effect like chalk drawing, and carbon paper has been used to give a white traced line on aquatint in the same way.

It is unusual to see aquatint employed alone on a plate as it is very difficult to find the position of the elements of the design on the plate. The line that mixes best with the quality of the aquatint is perhaps the soft-ground, although bitten line or even burin line are sometimes used. In the absence of such lines it is convenient to transfer a drawing on to the plate with chalk applied to the back of the sheet, as this will show strongly enough to guide the brush in stopping-out and is removed by the action of the acid. In any case it is so easy to forget elements in stopping-out that it is well worth while preparing a drawing in which the areas of tone are numbered from 1, white, to *n*, black, and which can be used to verify them before each biting.

Biting

The action of the acid resembles that in the case of bitten line already described but, as far more surface is exposed to acid in proportion and as far less depth of attack is required, it is prudent to use

weaker acids and watch the action very closely. For zinc it is recommended that no stronger acid should be used than 1 part nitric to 12 parts water; for copper, Dutch mordant, or dilute ferric perchloride should be used. The last of these, which deposits black copper oxide on the bitten surface, is preferred by some etchers as showing up the values immediately in the bath.

Again the degree of biting can only be estimated after some experience of the method, for the time varies so widely according to the temperature and other circumstances that it is of little value as a guide. A general rule, as with bitten line, is that the intervals for a tone increasing regularly in value will follow a more or less geometrical progression as 1:2:4:8:16, &c. In the earlier stages of biting, the plate shows, in the acid, *more* difference in intensity than it will really print, while in the latter stages the difference in the print will be greater than it appears in the acid. Thus, for the concluding stages, the difference between dark grey and black is best estimated by feeling the depth between points with a needle, as hardly any difference is visible while the plate is in the bath.

An imperceptible increase of tone across an area can easily be obtained by tilting the bath, placing one edge of the plate in the acid, then lowering the bath and letting the acid progress slowly towards the lightest part. A hard edge is avoided by keeping the liquid in motion by blowing gently on it. If a number of such variations of tone are needed in one plate, it is necessary to reground it for each one, everything else being stopped out each time. Spotting and variety of tone can also be produced by applying the acid to the plate with a brush, and, if a very soft gradation is required, the plate may be wetted first.

It is possible to rebite an aquatint if a very fine ground is laid the second time. This should, if possible, be closer in grain than the first. If the second ground is coarser than the first the points will show for each unit of surface the lowest common denominator of the number of points per unit in the two grounds. Thus, bad *crevés* may appear and a value may bite lighter instead of darker following the removal of the original points. I have rebitten an aquatint by regrounding it with hard ground applied with the roller, as has been described under bitten-line etching, but this is only possible where the area

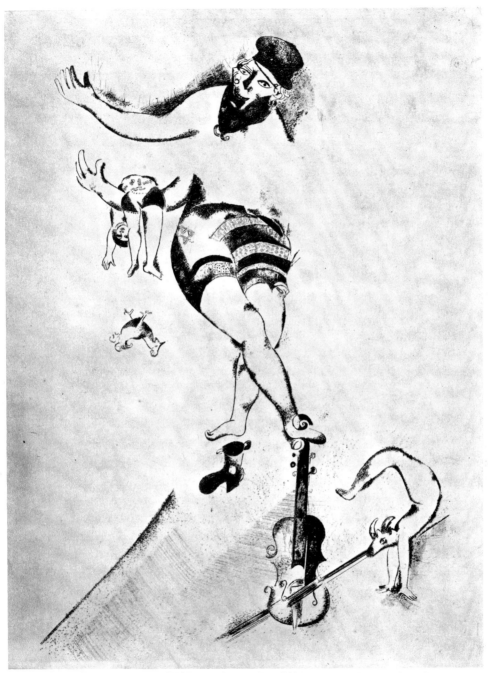

FIG. 46. Marc Chagall: Acrobat with Violin, 1924. Etching and Dry Point
(Collection, Museum of Modern Art, New York).

has already been strongly bitten in the first state. For slightly worked areas it is necessary to reground with the resin. Aquatint plates are in most cases fragile and one should try to arrive at the complete result with as few trial prints as possible, having the plate steel-faced before printing the edition.

LIQUID AQUATINT GROUNDS

Another method of producing the porous ground required for aquatint consists in coating the plate with a very dilute solution of resin in acid. The saturated solution of resin which is used as stopping-out varnish, if diluted with about ten times its volume of alcohol, will dry on the plate leaving a very regular granulation. It is possible to vary the size of the grain by using different dilutions of the solution, and the nineteenth-century reproduction etchers could get very fine and regular grain by this process. A mixture of the solution with water will dry to a coarse grain. Asphaltum has also been used in the same way as resin. It should resist acid perfectly but would, I should imagine, tend to flake off more readily if carelessly handled.

SAND GRAIN AQUATINT

Instead of leaving the surface of the plate open and reserving points to hold ink in it, the surface of the plate may be protected with hard ground, as for bitten-line etching, and an infinite number of pin holes opened in it, for the acid to attack and enlarge, thus darkening the tone. The usual method of doing this is to pass the grounded plate with a fine sandpaper over it through the press with a light pressure. As the finest sandpaper is still coarse in grain compared to the scale of the work, it is usual to pass the plate two or three times, changing the position of the paper each time, to multiply the number of holes. Biting and stopping-out are done exactly as in the case of the resin-ground aquatint, except for the difference in biting due to a smaller percentage of the plate surface being exposed. It is difficult to estimate the values of sand grain aquatint. The method has the definite

1. S. W. Hayter: Pelagic Forms, 1963.

disadvantages that, unless great care is taken, the whites are blurred owing to the sand grains being forced into the plate and it is hard to achieve precision in stopping-out. The plate, however, is extremely robust and will give fifty prints without steel-facing. A method which produces very similar results is that described by Stapart (Paris, 1773), in which salt is sifted on to a thin ground kept fluid by heat. On cooling the salt can be dissolved in water, leaving a porous ground. A very slight cloudy tone, dissolving to white at the edges, has been made by sifting finely ground sulphur on to a plate, heating it and removing the sulphur with a solvent. It is possible to increase the depth of such slight tones, which are due to the formation of copper sulphide, by exposing the plate after heating to a very weak solution of hydrochloric acid, when the copper sulphide is etched out without affecting the copper outside the area. Again a paste of sulphur and oil has been left on the plate overnight with a similar result.

BITTEN SURFACE:
IMPRESSIONS OF TEXTURES ON SOFT GROUND

A method we have applied for purposes similar to aquatint, or to collage, or for purposes referred to in the last section of this book, is the application of a tissue or other texture to a soft ground (see Chapter 1, Materials).

When, under pressure much lighter than that needed for printing, a plate coated with soft ground and covered with a layer of any material with an irregular surface is passed through a press, the ground will adhere to the texture and will be removed by those parts of the texture where the pressure was greatest. This use of quite flexible materials obviates the risk of marking the plate as with sand grain. The choice of materials is wide. We have used silk, net, gauze, lace, wood veneers, leaves, bark, leather, crumpled paper, cellophane, skin, the hand, and innumerable other substances (Figs. 47, 48, 49). It is quite possible to assemble on a plate, one by one, a series of contrasting textures bitten grey to black according to the length of time each area was exposed to the acid. White lines can be drawn through such areas before biting, and black lines be cut through them by

H

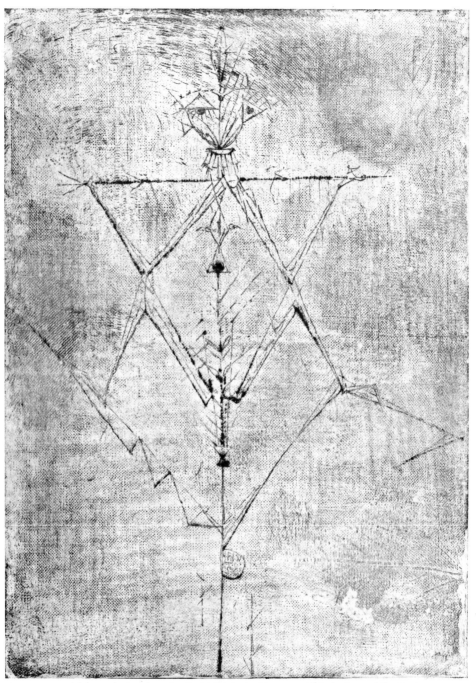

Fig. 47. André Masson: Le Petit Génie du Blé, *c.* 1942. Soft-Ground Etching
(Collection, Museum of Modern Art, New York).

Fig. 48. James Gillray (1757-1815): Caricature. Etching with Textured Background.

FIG. 49. S. W. Hayter: Oedipus, 1934. Engraving and Soft-Ground Etching.

etching or with the burin before or after biting. These textures will
be transparent, as they leave unattacked more than 50 per cent. of the
surface they cover, which thus remains available to take further
textures. Three or four of these textures can be seen one through the
other as if they were overlapping transparent films. Furthermore, at
each stage all previous work is sealed up by the ground and conse-
quently not attacked. The limit to the multiplication of such layers is
reached when one arrives at black, that is to say, when no unbitten
surface remains to take further impressions.

As with all other uses of soft-ground etching, the ground must be allowed to dry each time before stopping-out. The hot-air drier of the sort used by hairdressers is useful to save time.

Even after the impression has been made on the soft ground the effect can still be varied by the treatment of the plate in the acid. Thus a texture of the sort obtained by pressing crumpled paper into the ground contains every variation from open surface to completely sealed surface; that is, from black to white in the proof pulled after biting. Rapid biting with strong nitric acid will develop the open traces very strongly but will not attack the very delicate half-tones at all, while slow biting with Dutch mordant will develop very delicate shades of difference in the texture. Thus, from the same transferred texture it is possible to produce a thread-like black web seen over white or a full texture like a membrane, according to how the plate is bitten. Similarly, when very soft ground is used in a thin layer, every least variation of pressure will take effect, but the whole range of values over the texture will be grey and uniform, and the difference between dark grey and black will almost disappear. When a harder ground is used, only the stronger impressions will take effect, but they will be clearer and less blurred. Negative textures can be made by pressing a sheet of paper on to the ground through the original texture, and then rolling this paper on to a blank plate.

To obtain a ground for the same purposes as aquatint, that is, to bite in a series of values, I have replaced the soft ground by a hard ground passed, while warm, through the press with a silk texture. If the texture used is fragile, it is wise to heat the plate gently to remove the tissue. The final result is a solid ground that can be handled freely and dried between bitings and stoppings with a blotter if required. All these processes have great advantages over the resin-ground aquatint. They produce a plate that has a greater capacity for withstanding wear. The values are transparent in comparison with those produced by the resin-ground, and the resources of texture which, in a black and white medium, replace those of colour in painting, are far wider.

A somewhat similar method of obtaining an open surface on a plate

is to open an enormous number of lines in one direction on the grounded plate with a wire brush, and then to proceed with the biting as in aquatint (Fig. 15). The effect will be a series of greys with the direction of the original striations passing through everything.

THE MANIÈRE NOIRE

This method in general principles resembles those already described, but the execution is more regular. Closely set parallel lines are ruled on a grounded plate in at least four directions, vertically, horizontally, and diagonally. The plate is treated like an aquatint and bitten in any series of values desired. The effect is much harder than that of ordinary aquatint and it is remarkable that it is not more often employed.

All of these methods permit of drawing in white on black, or grey on black, as the term *manière noire* describes the last of them. They are, unfortunately, often used to produce night scenes, as, equally unfortunately, dry point is used for snow scenes or fog effects.

For making a series of plates to print in colour, either as surface or intaglio prints, Fred Becker devised a very ingenious method of transferring a very complicated image to all the plates so that they register correctly. The image is cut with burin, point, or scraper into the surface of a sheet of celluloid, plastic, or scratch board. All the plates are coated with soft ground and the impression of the sheet is taken on each. Then, by stopping-out on the different plates, the required colours and forms can be made to appear where they are needed (see Chapter 8).

It is sometimes useful to stop by means of a cut profile rather than a painted-out form. We have cut out forms in thin *celluloid* (or an acid-resistant plastic) and laid them on the soft-grounded plate with the texture over them. If the soft-ground coating is heavy enough they adhere to it and act as stopping, permitting the texture to take effect only outside the area they cover.

Another method by which slight aquatint tones with extremely fine texture have been bitten in a zinc plate was tried. Used Dutch

mordant containing copper in solution (or old nitric acid containing copper) was applied to the open surface of the plate, with a brush as in the 'spit' fashion described and the plate was also placed for a short interval in the bath. The very fine granular deposit of copper upon the zinc gave an aquatint tone; but an attempt to carry the biting further in a zinc bath failed as the electrolytic effect of the zinc–copper couple removed the grain, resulting in a *crevé*. Thus, though the system could be used like the sulphur method for light tones, it is not practicable for strong bitings. Steel plates have also been treated by the same method.

It seems that an extremely fine electrolytic deposit of chromium or nickel on a copper plate might be used to establish a grain finer than that possible with the resin powder which would resist the action of the acid to any required degree. In this case the grain would be too fine to be perceptible to the naked eye.

6

ETCHING III: NEW METHODS
COMBINED TECHNIQUES · DEEP ETCH,
OPEN BITE · IMPERMANENT RESISTS
SCRAPED AND CARVED PLATES

Combined techniques

ALL of the methods described in the foregoing chapters can be combined in one single plate, although the necessity to employ all of them will rarely arise. As we understand the economy of means in etching and engraving, it is desirable to use the fewest and simplest operations in view of the result to be found; yet where the projection of an idea leads to the accumulation of stages of different techniques, then that procedure must be followed. In such cases, however, a certain succession of events is preferable, based on practical convenience involved in applying the method. Thus (as in the experiment described in Chapter 16) a line, etched or engraved, is easier to trace on an uninterrupted surface; for a texture to be applied through soft ground, again a smooth surface is desirable: hence these operations will be among the first to be carried out. Aquatint, however, can be applied at any time to any surface and may come later; deep bite, the exposure of areas of the plate to the direct action of the acid, being almost impossible to correct, will be reserved for the last. These general rules which embody the easiest procedure must give way if it should happen that for the development of the idea the last operation has to be in sight before what would normally be the first one can be done. Thus, if a linear element should arise in a work only as a consequence of deeply bitten passages, it would be necessary to do these at an earlier stage in spite of the mechanical difficulty to be

overcome. In practice it is seldom possible to organize the successive stages of technique in the most convenient order; thus in the execution of the *Cinq Personnages* plate described in detail (Chapter 11) the cutting of the hollows to print as white reliefs would have been more convenient in the first stage; however, as all of the engraved and etched elements had to be present before these forms could be understood, it was necessary to make them at the last moment when a slip would have been impossible to correct.

Deep etch, open bite

As the method of open biting of a plate, first employed by Arpad Szenes in Atelier 17 in 1931, has become very widespread, it may be worth while to give some account of it. If parts of a plate are covered with a resistant material and the plate is exposed to acid for a long period, the open hollows (once known as *crevés* and considered as blunders) will not retain ink throughout in printing. They will hold ink in the edge of the forms but in open parts will show a grey with, in some conditions, a texture due to the bubbling of gas, or again due to the crystallization of the metal. Earlier work on the plate which has been bitten away will still be seen but eroded to a shadow-like quality, almost as if seen through water. The treatment of the whole surface of a plate in this way was suggested to us by an experiment made by Max Ernst in the 'thirties. A soft-ground zinc plate which had received the impression of cut-out cardboard forms (toys) was put into very strong acid intended for copper; all the ground was removed by the violent action of the acid and the effect now known as 'open bite' appeared.

Impermanent resists

All of the methods of preparing a plate to be etched which have been described so far depend on the use of grounds, varnishes, or resins which resist the action of acid indefinitely. In the 'forties we used a drawing on a plate with a felt-tipped pen (Flowmaster type), first for fixing a preliminary trace on a plate to be engraved, and then later bitten to a relief sufficient to print in intaglio or to take colour.

This Flowmaster ink (and other diluted bitumen and resin varnishes), when used in very thin coatings, broke down under the attack of the acid, to produce a striated band in the plate which would print rather as a charcoal line; meanwhile heavier coatings, made by drawing with heavier pressure and slower movement, resisted the acid completely. Such traces printed as a white (or coloured) line on the grey of the deep-bitten background. Hence we had a means of drawing on to a plate a line which passed from white to black according to the speed of movement of the hand. The effect in the print was a line which appeared to pass through the plane of the surface, giving a sense of free movement through the third dimension. Materials used as resists in this way were Flowmaster inks, Bitumen varnish diluted with benzene or xylol, various plastic solutions, wax crayons or sticks of hard wax, &c.

Once a plate had been prepared in this way it was placed in an acid bath and watched very closely. During the biting the plate would change slowly (though not uniformly all over) so that the image would develop rather like a photographic negative: when the result which was wanted appeared, action could be stopped.

Plates made by this method have been found very valuable as sources of colour, particularly when printed as a completely saturated field of colour by the system described in Chapter 8. The first experiments in this manner were undertaken to discover what would be the result of an action similar to the author's gesture in painting, when carried out on a plate and printed in multiple colour. As one might have suspected, it was different from the effect of the painting but, as it was the consequence of a consistent action, it possessed a logic of its own and became a new means of expression. Like certain other situations which occur in other combinations of technique, intervals arose in which the whole image was, as it were, in a fluid state of suspense, from which the action of the artist can determine a crystallization in one direction or another. It appeared to us that if one can assume any real act of creation, it is in such situations that it is feasible.

Scraped and carved plates

The peculiar quality to be found in work in a plate that is bitten away (see above) or scraped away (where the characteristic vibration of the tool does not entirely hide the trace of earlier work) had already been observed and applied in the 'forties. But it was Sergio Gonzalez-Tornero who first undertook to make a plate entirely with the scraper, sometimes grounded and rebitten with acid and again scraped so that the final appearance of the metal was like hammered silver. The maximum relief of these plates would not be more than 0·5 mm., but inking with the hard roller in colour (see Chapter 8) would reveal a powerful image, the direct consequence of the action of the engraver yet concealed from him until that moment. When such action followed bitten textures or forms in relief previously established in the plate, those forms remained visible but as if seen through running water. The method has opened up possibilities of expression in printing from plates in colour and in black and white which were not previously suspected. Its application to problems of expression by means of a modulated or inflected field of continuous colour should be obvious.

Another technique which is perhaps beyond those already described is the exemplary approach employed since 1950 by Pierre Courtin. Following the hollowed out and deeply bitten forms used by Negri, Brignoni, myself, and others in the 'thirties, Courtin carves into the soft metal to make a matrix from which, with slight general inking, a relief of sculptural, even monumental, character is formed under the press. The print thus becomes a relief in itself, the cast from the hollowed-out plate having the character of carved metal rather than the pictural quality of most printmaking. Sculpture in the round was made in Mycenaean times by pressing clay between two hollowed-out blocks, a procedure followed by the sculptor Moissey Kogan, who perished during the War. It was he who pointed out to me that further work 'in intaglio' in these moulds created a progressively more ample form; a consequence seen in the prints of Courtin. No line as such is used in his expression: the adherence of

some trace of colour to the edges of the relief and the texture like the tool-marks on a sculpture are the only factors of suggested relief that appear together with the actual relief of the pressing in heavy paper.

It was suggested earlier that two general resources of the printed plate had been very little exploited by printmakers: the printing of uninked plates as white on white, and that of heavily worked plates as black on black, almost as a relief in ebony. Although cut-out plates in which the profile of the metal would print as a part of the image had already been made by the late Georges Lecoq-Vallon in the 'thirties, Miró, Soulages, and others in the 'forties and 'fifties, it was left to . a sculptor, Étienne Hajdu, to find a still simpler method of using this device. Assembling in various patterns cut-out forms in metal on the bed of the press, Hajdu simply embossed a heavy paper so that those spaces between his elements are as important in the image as the actual surface indented by the plates, resulting in a relief in paper having sculptural form. The only variant of surface is due to the compression in the impressed hollows which is polished in contrast to the rough texture of hand-made paper; a contrast similar to the polished surface ˙ of marble against the crudely worked stone.

7

PRINTING I
PRINTING FROM INTAGLIO PLATES

BEFORE the result of the artist's work on a plate can be seen at its true value, it has to be printed on paper. Printing from intaglio plates is capable of so many variations and possesses such richness of quality that, if it is not fully mastered, much of the value of the artist's work will be lost.

The quality of the paper, its dampness, the colour, texture, and consistency of the ink, the temperature to which the plate is heated, the touch of the gauze or the hand in inking, and finally the degree of pressure, with the quality and condition of the blankets, are all factors which will modify the results. For any particular plate there is an optimum for each of these factors: to find this will amplify every quality in the plate. Without the correct conditions, a surface which should print as silk will have the quality of chalk, many lines and textures will not appear at all on the print, or they will appear with such poverty of effect that they will no longer contribute anything to the result.

The touch of the hand of the printer, *le coup de main*, is a characteristic of the individual and can only be developed with years of practice. It is easy for the expert to distinguish between two prints of a Méryon plate and declare which one of them was printed by Delâtre, even in the absence of the printer's signature. An apprenticeship of five years is considered necessary for a printer to qualify as a journeyman, and in a big printing shop there is always one master printer to whose twenty years or more of experience the journeymen appeal when something occurs which is beyond their comprehension.

The calm, the economy of gesture, the sureness of hand of an

experienced printer, his care for and organization of tools and materials are all worthy of study and of admiration. Every proof made should be perfectly printed on good paper. There is *no such thing* as a 'rough trial print'. Even to verify two lines on a plate, it must be printed just as well as the final prints which are to be shown.

THE PRESS

The design of the roller press used for printing from intaglio plates (Fig. 50) has not changed essentially since the seventeenth century. It consists of a heavy steel bedplate running between upper and lower rollers in a steel or heavy wood frame. Some means of increasing the pressure upon the bearings of the upper roller must be provided, and, normally, two set-screws are used to supply this pressure, but when no screws are supplied, the pressure is changed by packing in more or less thicknesses of cardboard or fibreboard. The lower roller, made of hollow steel, some 9–12 inches in diameter, turns freely in bronze or hardwood bearings. The upper roller is of solid steel and is at least 6 inches in diameter, its spindle being at least $1\frac{1}{2}$ inches. The surface of the roller is level and perfectly concentric. Even a roller of this size will give 1/1000 of an inch or so, under the pressure used to print, so it should be obvious that smaller rollers or more slender spindles will be quite ineffective. Small presses, with three- or four-inch rollers, made to work on a table, are, in my opinion, toys: even small prints cannot be printed well on them, so that the user is never able to discover the real qualities of printing.

The bedplate must be at least $\frac{1}{2}$ inch thick and perfectly flat. Sometimes it is made with a bevel at one end to make it easier to remove. At both ends stops should be provided on removable screws to avoid overrunning the press. Many printers use a thin sheet of zinc on top of the bed or, better still, chromium or stainless steel to facilitate cleaning. The bedplate is carried on the lower roller.

On many presses the ends of the bed are supported on small rollers and sometimes rollers are fitted to the frame to prevent lateral movement of the bed. Often a central ridge on the lower roller engages with a groove in the underside of the bed for the same purpose.

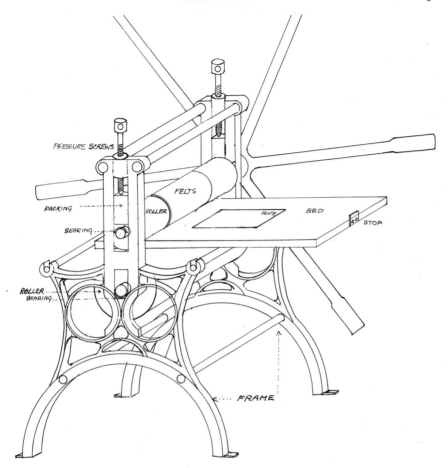

FIG. 50. The Printing Press.

The upper roller may have bars attached to its spindle at one end,
so that it can be rotated directly, or it may be driven indirectly through
a train of gears, so that the crank or wheel turns at about three to five
times the speed of the roller. The pressure needed to print is of a
certain intensity per inch of the cross section of the plate: thus, any
press with a bed wider than 16 inches will need to be geared unless the
printer is exceptionally strong. If we analyse the forces exerted on
the roller, it also becomes clear that a very long roller will show some

torsion when driven from one end only. This would cause slight slewing of the plate and a consequent doubling of the impression if it were passed twice. So, very large presses have a double train of gears to drive the roller from both ends. I have a personal preference for a directly driven press, as the pressure on the plate can be felt when printing.

Before printing can be attempted, the press must be set up and adjusted. No engraver can pretend to know how to print unless he can do this. In Atelier 17 it is our practice to unscrew the adjusting screws so that each printer has to set the pressure for himself before starting work. Once the pressure has been determined, marks with paint can be made on the screw threads and on the frame which, when brought into alignment, will indicate the correct pressure and save time in resetting.

Setting up the press

Once the frame of the press has been assembled, bolted firmly together and stood on a level base, and the bearings have been greased, the first step is to verify the balance of the bed on the lower roller. Releasing the pressure on the set screws, one should sight under the bed to see if any light can be seen between it and the lower roller. If light can be seen, the roller is too low and must be raised before starting to print. This is done by lifting its weight with a beam used as a lever. It is then held up with blocks, while cardboard shims are fitted in the slots under the bearings, and the roller is then lowered back into position. Where rollers on the ends of the frame are provided to support the bed, the bed should be in contact with these rollers at one end *only* and with the large bearing roller but just *clear* of the rollers at the other end. Then, when pressure is applied and the shims are compressed, the bed will be perfectly level, being neither convex nor concave, and borne chiefly by the big roller. If these precautions are not taken, the plate will buckle, the pressure will be unequal along its length, and poor-quality prints will be the result.

2. Richard Lacroix: Brise Marine, 1963.

Adjusting the pressure

The plate to be printed is laid face up upon the bed of the press, covered with prepared paper and with two or more blankets. These blankets, of closely woven pure wool of the finest quality, are extremely expensive, but only the finest should ever be used. They should be treated with the greatest care, as that layer of blankets which actually makes contact with the back of the paper determines the texture of the background. This blanket should be clean, resilient, and of the finest obtainable 'roller cloth', or 'swan cloth'. One or more coarser blankets, or even felts, above it serve to give it resilience. Whenever these blankets become damp or stiffened with size from the damp paper, they must be changed. If they are damp they must be dried, if stiffened with size, they must be washed with lukewarm water and soap or soap powder. A little ammonia added to the water aids in washing them.

Many printers use blotters over the paper which is to take the print, but unless the nature of the paper makes this necessary, I consider it undesirable, as the finest texture for printing is wool felt and not paper pulp.

The press is turned until the roller is on the felts, but not on the plate or the paper. The set-screws are then tightened by *hand* until they seem to have about the same pressure. To verify this, the clean plate is set up on the bed of the press, covered with a sheet of blotting paper and then rolled through the press. When the paper is removed it should be examined with light parallel to its surface, to see if the two edges are exactly alike and if every line in the plate appears white in relief. If any inequality appears, it is corrected by tightening one of the screws. A weakness to be seen in the centre of a big plate can be compensated by sticking a piece of paper to the back of the plate, the thickness of the paper being varied until a perfect impression is obtained on the blotting paper. The press is then ready for use.

PREPARATION OF THE PLATE

The plate is placed on a hotplate, heated electrically or with gas, alcohol, or even hot water, and brought to a temperature on which

one can just bear to place the hand. Ink prepared as described on page 115 is put on a glass, marble, or slate slab and well mixed with a palette knife, oil being added if necessary. The consistency of the ink needed to print a particular plate with the best results has to be determined by experiment. Dry point generally requires a denser and stickier ink than burin, which requires a more liquid ink containing some raw linseed oil. Generally, the mixture should drop slowly from the palette knife when it is held up, but it should never drop in a continuous thread. Ink is taken up on a tampon or roller and is applied all over the surface of the plate. In order to make certain that the ink is driven into every crack of the plate a hammering or rocking motion of the dabber can be used without danger. It is necessary, however, to avoid a screwing or sliding motion of the tampon, for, although every precaution has been taken to obviate the presence of grit in the ink or on the tool, a grain may be present which would scratch the surface of the plate.

The plate now shows a uniformly black surface and, turned against the light, should present no bright and uninked lines. If such lines can be detected, a rag or the fingers worked across their direction will fill them.

Wiping the plate then begins. This requires the use of three pads of gauze. Tarlatan or starched mosquito netting (see Chapter 1) is the best for this purpose. It should be free from grit and not hard enough to scratch the plate. If two degrees of fineness are used, it will make the printing easier. The first pad is one already wet with ink and it is used with some pressure in a rotary movement to ensure all work being filled with ink. At this point no attempt is made to remove ink. The second pad, of open grain, is used in a rapid circular motion, with the *least* possible pressure, until the design of the plate becomes clearly visible through the ink.

Professional printers often use a new pad which they are getting into shape at this point, for no pad used on a plate should be too stiff, nor should it be entirely free from ink. At first it may seem impossible to clear the plate without pressure. However, it is the light pressure that removes the ink. By increasing the pressure it is possible to put ink back on the surface.

The third pad, of finer gauze, should have some ink in it, or even dried ink on it. Using the same rapid motion, with *extremely* light pressure, the wiping is continued until only a slight film of ink remains on the unworked surfaces. At this point the lines should show a slight halo of tone, the film of ink over the whole plate should be uniform, and visible against the light as a bluish or purple film, and it should be free of streaks or spots. If a perfectly clean pad is used the film will show such blemishes and the print will be poor and cheap in quality. Where white in relief is being used, the hollows may be cleaned at this point with a rag, on a stick if necessary.

At this stage a print can be made. It will be a little hazy but very dense and is known as a rag-wipe print. Bitten-line etchings and dry points are often printed in this way. Burin engravings and heavily bitten etched or aquatint plates, where a maximum of definition is required, need to be hand-wiped. This action takes some practice to master (Fig. 51). The dry palm of the hand is passed, rather relaxed, lightly across the plate with a wide sweeping movement, starting and ending clear of the plate. The point where one starts or ends the movement, if on the surface of the plate, will show a hand-print. The commonest error in hand-wiping, as in rag-wiping, is the use of too great pressure, for even the weight of the hand is too much. The sound made by the hand using correct pressure is rather like that made by a stiff broom in sweeping. If the hand bumps on the surface, if it makes a sound like rubber on a glass, or if it whistles, then the pressure is too great.

The plate is rotated during the wiping so that the strokes pass in all directions, rather across than along the directions of the main lines. It should be emphasized that the preciousness of the quality and the texture of the print depend absolutely on the mastery of this action. Again, as in the rag-wipe, a film of ink is left on the surface of the print: this depends for its density on the amount of light oil in the ink, the temperature at which the plate is wiped, and the degree to which the wiping is carried. The effect in the print is modified by the pressure of the press and the humidity of the paper.

Many printers dry their hands with whiting. If this is done the

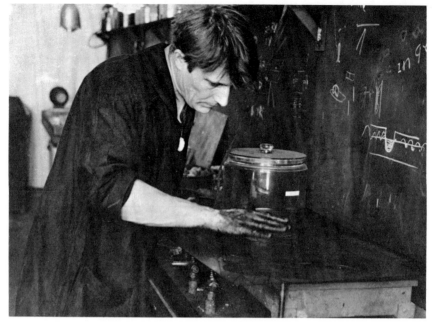

FIG. 51. The Author Hand-wiping a Plate.

whiting should be completely wiped off before the hand touches the plate, otherwise the colour of the ink that is left will be poor. Whiting also has a tendency to remove all the film and leave a blank white background. By using an ink with a considerable content of light oil and preparing the plate as hot as it can be handled with a minimum of strokes in hand-wiping, it is possible to print a clear line on a background dark enough to convince most etchers that the plate has been aquatinted to a middle tone.

It is obvious that these different treatments can be applied to different parts of the plate so that, while certain parts of the work are veiled, other parts stand out in strong contrast. There is no objection to using such treatments, but when, as with a whole school of etchers in England, the underworked plates depend entirely upon such methods of printing, it seems only fair that the proofs should be signed by the printer as well as the artist.

It is possible to combine the two methods of hand-wiping and rag-wiping by dragging a loop of soft gauze, slightly moistened with ink, over the hand-wiped plate, when ink will again be drawn out of the lines. This method, known as *retroussage* in France, is often applied to obtain liquid effects and increase the density of aquatint blacks.

Finally, the outer edges of the plate are wiped clean with a rag on the finger or with the hand.

IMPRESSION

The plate, prepared as described, is placed in the centre of the bed of the press. If it is of any size, the long side should be parallel to the length of the bed. The edges of the plate should have been bevelled before preparation for printing began. If the plate is thicker than $\frac{1}{16}$ inch, or if it is very small, it is wise to place one or two blotters under it. As these compress under the plate they will equalize its thickness to some extent and relieve strain on the blankets.

If water is visible on the face of the paper, it should be dried or brushed lightly until the water has been absorbed. The damp sheet of paper is then placed over the plate, its correct position being determined by lines marked with pencil on the bed of the press. It is important that the paper should be flat and that it should be uniformly damp, as a sheet which is dry on the edges will contract and pleat when printed and a printing fold in a proof makes it unusable.

The blankets are then pulled flat over the whole and the press is turned slowly and without stopping while the plate is actually under the roller. Stopping while the plate is under the roller can cause irregular bands across the proof. The press is turned slowly to give the paper time to take a firm hold on the ink and, for the same reason, the plate is frequently passed twice. Printers making large editions often fasten the blankets back with a cord and weight, so that when the plate has gone through and back they do not have to be handled. In practice it is faster to do this than it is to walk around the press. In running a plate twice through the press, however, it is important to be sure that the pressure is balanced on the two sides and that the

paper does not deform, as any inequality will cause the plate to twist slightly, resulting in a double impression on one edge of the print. This fault is not uncommon in prints, and I have seen Rembrandt First States showing doubling of this kind.

Finally, the print is removed from the plate. This must be done slowly and progressively, as a print pulled carelessly from the plate may cause a thread of ink in the lines to break, or the surface of very soft-surfaced papers to adhere to the plate and tear away from the proof.

Drying the proofs

The damp sheets are commonly dried between blotters; sometimes each proof is covered with tissue paper to avoid offsetting. Generally it is wise to leave the weight of the stack of blotters on the proofs only for 12 hours, after which they can be so loaded that, although the sheets dry flat, the plate impression and the relief of the lines above the surface will not be flattened. Another and more rapid method of obtaining flat prints is based on the fact that all rag and good fibre papers stretch when damp and contract when dry, to an extent of about 2 per cent. in some cases. If the outer edges of the paper are taped down on a board, the contraction in drying will stretch the proof quite flat. Although this is the most convenient method of getting a flat proof in a hurry, it will often remove the plate mark and, when raised whites have been used, they may be so stretched as to lose their relief. The whole procedure of drying and flattening prints is necessary because only that part of the sheet which was actually on the plate has been stretched by the pressure of the press and, if no care is taken, the margins will normally return to their original size and the dried print surface will be convex and irregular. Both methods attempt to equalize the strains in the paper fibre, and, if carried out correctly, result in proofs which will remain flat even if wetted and redried.

The paper will, as a rule, dry in about 24 hours, but the inks we use will not be safe to handle for at least 48 hours and the oils in them will not have entirely ceased to oxidize for a year or so.

Discipline of press room

The elaborate means described to produce clean perfect prints may seem too complicated, but without serious organization of the whole process the work will not be presented at its true value. Wet paper, ink, wiping pads, felts and blotters, solvents, cleaning rags, cleaning table, all must have their places and all must be kept clean. The printer's hands are going to be covered with ink in the printing, yet paper, blotters, blankets, and the bed of the press must be absolutely spotless. Clips, called *les mitaines* in France, are made by folding pieces of 4-inch by 6-inch metal or cardboard over a pencil, giving a clip that springs open. With these clips all paper, prints, and blankets must be handled. Inky fingers must never get inside the clips. As far as possible, too, inking of the hotplate should be avoided and the ink slab, tampon, rollers, and pads of gauze must be kept free from grit. It is recommended that they be stored in a box over the hotplate. Pressure should never be left on the blankets and they should be removed from the press as soon as the work is finished. Then they are either washed or hung up to dry. The ink should be scraped from the saturated gauze after use and that, too, should be hung up to dry, not left in clotted knots.

Sources of error in printing

In spite of all these precautions it sometimes happens that bad or imperfect prints are obtained. A competent printer must be able to identify the source of error.

A print may be wrinkled, puckered, shiny on the surface, or smeared. Lines may be spread or doubled. The wrinkling or folding is generally due to the condition of the paper before printing. A shiny surface on the print shows excessive pressure, which may also be a cause of smearing or spreading of the ink out of the lines. Spreading may, however, also be due to there being too much oil in the ink. Doubling, unless caused by a buckled plate moving or rocking on the bed, is due to unequal adjustment of the pressure screws on the press. Wet blankets or blankets stiff with size from damp paper will also

cause wrinkling, polishing of the surface, and poor prints. The blankets always creep an inch or so as the press rolls, so that a blanket adhering to the paper will finally form a pleat.

The causes of poor lines, interrupted by white dots, are the following: (*a*) the plate was carelessly inked, (*b*) the paper was too dry, or there was grit on its surface, (*c*) the ink was too dry, (*d*) there was insufficient pressure on the press, and (*e*) the proof was lifted carelessly. (*a*) can be identified by examining the plate after printing, when the lines that missed will be seen to contain no ink, (*b*) by the feel of the paper, (*c*) by the presence of ink in the plate, and (*d*) by the fact that the ink still in the plate is apparently wet. Unless it is certain that the paper being used is suitable for intaglio printing, that question also should be examined. Certain papers which are manufactured with resins or hard size in the pulp, the size being fused in the fibre by pressure and heat, are completely unsuitable for printing in intaglio. As the fibre refuses to absorb water, and as only damp fibre can take an impression, such papers will reject the ink. I can recall wasting days with a Japanese Super Nacré paper of commercial manufacture, which had been prepared in this way, although a similar looking paper had previously given excellent results.

Odd lines missing in an otherwise satisfactory print are generally due to bad inking or sometimes to grains of copper or other matter in the lines. With good ink it is very rare that, once in the line, it will be removed by the hand or the pad of gauze.

PAPERS

Any paper which can be completely damped can be used for printing from intaglio plates, but the difference of quality between a print made on wood-pulp paper and one on hand-made pure rag paper is remarkable. Every paper requires slightly different treatment in damping and preparation, and also in the degree of pressure that is needed to obtain perfect prints. It is often more difficult to print well on good papers than on poorer ones.

Hand-made rag papers

Up to the nineteenth century methods of making bad paper were unknown, consequently all papers of the seventeenth and eighteenth centuries are excellent. Though in some cases these were sized originally, that size has disappeared in the course of time. However, it is very rare to find such paper in sheets of large dimensions. Modern rag paper is good or bad for a variety of reasons, such as the quality of the pulp, whether the rag was reduced with the stamp mill or the Hollander machine, the absence of chemical treatment or bleaching, and the skill of the hand that made it. English papers such as Whatman, F. J. Head, Chatham, and Arnold are strong, long-fibred, but often very heavily sized and sometimes very hard-surfaced from hot pressing. Such papers need long soaking under pressure to produce perfect prints. Any paper which is perfectly white has been bleached and will not remain white but will inevitably yellow in sunlight.

Dutch papers like Van Gelder Zonen are excellent, though I have an impression that the best paper was made twenty or thirty years ago.

The Italian papers I know are very poor, short-fibred, cutting easily in the printing, and refusing to take a surface tone from the plate. This last can sometimes be remedied by resizing.

The finest paper I have used was Montval made by the late Gaspard Maillol in France. Some German papers, too, were very fine, though often bleached. A Spanish and a Swedish hand-made paper we used were good. Paper made by hand by Barcham Green of Tovil, Kent, was found excellent.

American hand-made papers, very few of which are now made, are good in texture but somewhat irregular, owing to the way they are made. A few sheets from the Lyme Rock mill in Connecticut, now unfortunately closed, were found to be first rate.

The Chinese papers, of the type of 'India' paper, print excellently but are often loaded with kaolin. They are generally too fragile to be used without being mounted on strong backing sheets.

Hand-made Japanese papers, particularly those made up to twenty years ago, Hosho, Kochi, and so on, which were generally made from

the fibre of the paper mulberry, print perfectly. They require special treatment as they often become extremely fragile when wetted, and it is wiser to damp them very slightly by interleaving them with damp blotters. At the moment of printing the sheet should lie flat, appear dry, but feel cold against the back of the hand. Less pressure in printing will be needed than is required on a laid rag paper. Prints on such paper need careful handling as the surface will wear and fray if badly rubbed.

All these papers are of two kinds, laid or wove, called *vergé* or *vélin* in France, according to the way the wires are placed in the tray or form in which the sheet is made. In wove paper no definite lines can be seen through the sheet as the wires are woven together. In general, linear plates will present well on laid paper but aquatint or textures appear better on a wove sheet.

The machine-made papers can be used where there is no hard size present, but their usefulness depends entirely upon the quality of the fibre they contain. Form-made machine papers are often very similar to hand-made, though more mechanical, as often the texture is obtained by passing the sheet through rollers after making. Wood-pulp paper prints excellently, its only disadvantage being that it is not durable. Papers loaded with kaolin, barium sulphate, and other chemicals are unusable. Ruysdael, Murillo, Troya, and others are good American papers.

The weight of paper used for a particular plate should have some relation to the size of the plate as well as to the texture to be printed. Generally a large plate needs a greater weight of paper (perhaps 120 lb. in Britain and the United States, or 45 kilos in France). Also, aquatint will print more richly on heavy than on thin paper. Lack of weight can to some extent be overcome by backing thin sheets with blotters or other soft paper.

INK

The black inks used for printing are made from a number of different pigments; Frankfort black made from charred wine lees, lake black, French black (*noir bouju*), vine black, lamp black, and other

carbon pigments. They are ground in linseed oil or burnt oil; in commercial inks, stand-oil and varnishes are often used, sometimes with driers or siccative.

The ink we generally use in Atelier 17 is ground from Frankfort black mixed with one-half to one-third the same amount of a dense pigment. When French black became rare we used a synthetic lake black, and later a very intense vine black. The powder is mixed dry, and the plate oil worked into it with a little raw linseed oil until it will hold together. As grinding makes the ink more liquid, it is most important to keep the total amount of oil down to the minimum, or the ink will be too liquid. The mixture is then ground either by hand with a glass or granite muller on a glass slab or by a cone grinder. Machine grinding does not produce so good a result as the heat generated by rapid grinding seems to affect the oil. The consistency of the ink required for the best results has to be determined by experiment: in general, it can be said to work if the ink will drop slowly off the palette knife without running in a thread. No grit should remain in the ink when grinding is finished.

The use of varnishes, driers, boiled oil, or stand-oil in ink is undesirable, though they are used commercially to give gloss to the ink and to cause it to dry faster. The ink, prepared as described, is dry enough to allow for the handling of prints after 48 hours, although oxidation is not completed for up to two years. As the oil used is unbleached, at the end of this time the print takes on a warm colour due to the microscopic margins of brownish oil around the blacks. This causes no loss of intensity. The practice of imitating this quality by mixing colours in the black ink is less successful as it weakens the intensity of the black. It should be noted that the ink we use, unlike some of the commercial preparations, dries to a mat surface.

8

PRINTING II
COLOUR PRINTING FROM INTAGLIO PLATES

THE procedure for printing from engraved, etched, aquatint, or dry-point plates in single colours other than black follows very closely upon that described in the last chapter. Inks in colour, however, do not wipe as easily as black, and the proportion of oil used in their preparation has to be varied to get the best results. With iron oxide reds, or with ochre, for instance, it is necessary to reduce the percentage of heavy oil in the mix owing to the soapy quality of the pigment.

Certain differences arise in planning a plate for colour which do not occur in planning for black. As the contrast between worked and unworked parts of the plate will be red and white, for example, instead of black and white, more violent working will be needed to give an effect of the same intensity. Although all the variations from black to grey to white (except for the slightly warmer or colder tone described in Chapter 2) appear as the same hue, a red will appear almost black in heavy burin passages, then as deep red in strongly bitten textures, and as a series of pinks in light aquatint or in the tone left on the surface. Thus the work will seem to be in a series of three different reds rather than in one colour.

Printing several colours simultaneously from one plate (à la poupée)

This method is used in the production of the tinted horrors known to the trade as 'bedroom etchings'. A bitten and aquatinted plate, sometimes with dry point, is inked in different areas with 'dollies' (*poupées*) of rolled canvas or felt, and is wiped, one area at a time, with gauze and the hand. A separate pad is, of course, kept for each colour.

The effect is a gradation of tints over the lines and the surface of the print. Roger Lacourière in Paris has used the method for printing from multiple plates with very fine effect.

Printing various colours successively from one plate in intaglio

A simple method which has given quite interesting results in the hands of Raoul Ubac, Mauricio Lasansky, Karl Schrag, and others consists of printing in one colour from the plate, then removing the plate from the press, re-inking it in black or another colour, entirely or in part, and reprinting on to the proof with a deliberate slight error in register. As an extension of his experiments in photography, Ubac printed a negative surface-inked proof slightly out of register with a positive to get an illusion of surface in relief. Certain of Lasansky's dry points were printed in cold colour over previous warm colour, giving a peculiar stereoscopic effect. In his *Night Wind* (Pl. 8), Karl Schrag used successive intaglio impressions in green and black about $\frac{1}{32}$ inch out of register to obtain a vibration and density in the represented space, like mist or turbid water, in keeping with the mood of the plate.

Another method which has been very little used is to place, over a plate inked in colour, a stencil as a mask exposing only those parts of the design in which this colour is needed. The plate can then be re-inked with a second colour and reprinted with another mask exposing only those parts in which the second colour is needed (Fig. 52). By this means a very clear definition of colour elements can be obtained, in a way that is impossible by the *poupée* system. From textured, aquatinted, or lightly worked passages in the plate overprinting in two or more colours is possible, particularly if the deliberate error of register is used to avoid fouling. It is clear that with all of these methods a very definite plan of operations is necessary as well as experience of the consequences that can be expected from the association of the various colours.

Simultaneous printing from surface and intaglio

This method has been used by Atelier 17 since the late 'twenties.

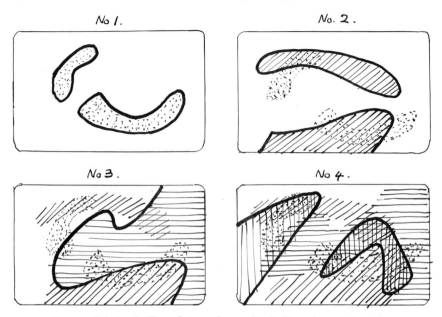

FIG. 52. Printing in Four Colours from a Single Plate through Stencils.

After the preparation and wiping of the intaglio plate in black or another colour, a film of oil colour is deposited on the more or less free surface of the plate, in areas defined by stencils, the fingertips, a roller, or other appropriate means. The whole combination of surface colour and intaglio colour is then transferred to damp paper exactly as described in the last chapter. Thus a single passage through the press is all that is required, problems of register applying only to the placing of the colour elements on the plate surface.

Here several requirements of the medium will be apparent. Inks must be used and colour deposited on the surface in such a way that the colour does not mix with the ink already in the plate. Then, as it is clear that an opaque oily ink between intaglio ink and damp paper would prevent the intaglio ink from adhering to the print, the film of colour on the surface must remain so thin that it is microscopically porous. Thus it will be difficult to super-impose two or more colours, both because of fouling and of the risk of developing too heavy an ink layer, but practicable prints have been made

with three colours bitten intaglio overall. The surface colour being above the intaglio in the plate will, of course, appear underneath it in the print. I consider that certain of the Hercules Seghers prints, generally described as hand-coloured, were in fact printed in this manner. My own *Centauresse* plate (Fig. 53) was printed in this way, using four surface colours through stencils and intaglio red-violet. A further development of this single plate technique for as many as five colours, which was developed in 1945, is described in Chapter 11.

Printing from several intaglio plates in colour

This method of obtaining an image in colour has been applied to the reproduction of works of many modern painters, particularly by Jacques Villon and Roger Lacourière in France. The prints are numbered and signed by the painter and often the buyer does not recognize that they are not, in fact, the work of his hand. Printing follows the procedure already described, but various methods are used to ensure exact register of the plates. As all intaglio printing is carried out on damp paper and as all good papers stretch when damp, it is necessary to control the humidity of the paper so that the sheet will be of the same size at each printing. If register is taken from near the centre of the sheet, the variation will be at a minimum; the possible degree of error increases if control is from the margin.

If the maximum intensity of colour is sought, or if a large edition is planned, it will be necessary to allow each colour to dry before printing the next. Thus the paper will need to be rewetted. To avoid this difficulty many French printers employ a heavy wood-pulp paper which requires little humidity and hardly varies in size, wet or dry. A Japanese Kochi paper that needs only to be placed between damp blotters to prepare it has been used in Atelier 17.

Methods of register

There are three general methods of register in use:

(*a*) In France it is usual to assemble all plates of the same size in which the image is in register, usually ensured by printing back on to these subsequent plates from a wet proof of the key plate, and to drill two small holes through all of them in positions which will not be too

conspicuous on the proof. All the sheets of paper to be used are then pricked through with a needle passed through the holes in one of the plates. When the plate is ready on the bed of the press the sheet is placed by engaging two needles passed through it with the holes in the plate (Fig. 54A).

(b) The method used by Fred Becker (Pl. 7) in Atelier 17 for surface or intaglio printing makes use of a metal mat, having an opening cut to fit the plates, carrying four stops, made by turning up tabs of metal, which are outside the travel of the blankets. The sheets fit against these stops and consequently fall in the same position. Where the printing is done wet on wet, that is without allowing the ink from one printing to dry, and without loss of time in replacing the plates, the method is almost accurate. However, as register is from the margins of the sheet, it is not proof against the varying humidity of the paper (Fig. 54B).

(c) For making trials from colour plates we have also used another system. The position of the plate is marked accurately on the bed of the press. A sheet of paper is cut to allow long margins at both ends and, after the first printing, the sheet is held by one end in the press and turned back over the blankets and roller. If the second plate to be printed has not already been prepared, a damp blotter may be laid over the print to prevent drying. The second plate is then placed very exactly in the marked position on the bed, proof and blankets are laid down upon it again, and the press is turned until the second impression has been made. The sheet still remains pinched in the press by its other end. The process may be repeated as many times as necessary. If done carefully it is accurate to within $\frac{1}{32}$ inch even on large plates, but it is only applicable when printing wet on wet (Fig. 54C).

(d) A method employed by Mauricio Lasansky for printing in two colours from the same or different plates involves printing the first colour normally as described. The second plate is then inked and prepared. The proof, which has been kept damp by covering it with a damp blotter, is laid face up on one blanket on the bed of the press. The second plate can then easily be placed on it, the back of the plate being covered with paper to protect the blankets which are then laid

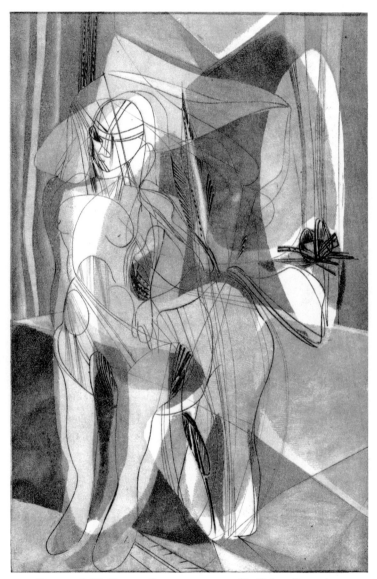

FIG. 53. S. W. Hayter: Centauresse, 1944. Six-Colour Engraving.

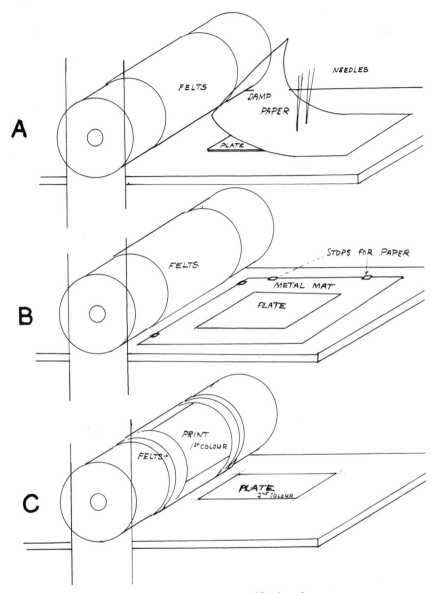

FIG. 54. Three Methods of Registration.

on top. The plate is then printed upside down. The method has the disadvantage of giving a rather poor second printing as there is only a single blanket against the proof instead of the usual three or four, and there is also some inevitable buckling of the second plate under the pressure of the upper roller as the undermost blanket compresses.

In planning and making a series of plates for a print in colour the artist needs to be familiar with the many technical and theoretical requirements of the medium. Zinc plates, unless they have been plated, are undesirable for the printing of pale colours as they give a slight surface grey. Certain colours, as vermilion, cannot be printed from copper as they react with the metal. Strong cutting with the burin is undesirable in a colour plate unless it is the last plate to be printed, as subsequent printings would flatten the relief of the thread of ink on the sheet and, if printed wet on wet, the line would spread. The work done on the plates must be clearly planned with regard to the opacity or transparency of the result. As already mentioned with regard to the printing of surface colour, if too solid a layer of ink has accumulated in one place on the proof, subsequent impressions will fail at these points. Jacques Villon developed a method of printing in transparent colour, even with opaque pigments, by carrying each colour in a system of parallel lines, etched, dry point, or burin, so that no one line of colour will fall on another and white paper will come through the design even in the strongest passages. Roger Lacourière prints reproduction etchings with some dry point and aquatint or mezzotint, inking each plate *à la poupée*, so that even when using ten colours only four actual printings are necessary. From experience of the commercial methods of printing it has been found that the greatest transparency and brilliance of colour is obtained by offset (colour printed from the source on to an intermediate surface and from that on to the sheet); less brilliance comes from surface printing; and no intaglio colour is quite as transparent or as intense in light reflection as either of these.

In the use of colours in printing, as in painting, it is to be noted that there are two possible consequences of employing the same pair of colours. Thus if a red-violet line or point is placed near a blue-green

line or point, leaving between them about the same space as their thickness, in the white interval a yellow will be seen. This colour effect, called subtractive, is that sought by the impressionists in their use of divided colour. But if the two colours are superimposed a blue will appear, the effect being known as additive (see Pl. 3, top centre). Apart from their transparency, all colours from surface or offset will be of the same hue, while colour from intaglio printing will appear, as already described, as if composed of several distinct hues of the colour.

9

PRINTING III
PRINTING ON FABRICS · MACHINE PRINTING
PARCHMENT, HIDE, LEATHER
RELIEF PRINTING · CLASSIFICATION,
NUMBERING, AND PUBLISHING OF PRINTS
RECORDS

Printing on fabrics

IN the sixteenth century patterned fabrics of linen, cotton, and silk were printed from intaglio plates, for instance by Hercules Seghers (Fig. 55), and some of the early engravers made actual prints as images on woven materials.

Hand-printing in colours on textiles was revived in the late 'forties by Atelier 17, working from etched and engraved plates. Fine linen was found to give a very accurate proof, and silk was excellent where the weave was close enough to take a fine impression; cotton and rayon were definitely less successful.

As in practice these fabrics may need to be cleaned, the inks or colours used should be planned to resist solvents. The inks used for fine print-making dry very slowly and if used on fabrics would only resist cleaning after about a year. The ink for fabric printing is therefore prepared as described for intaglio printing, but the raw linseed oil in the mix is replaced by Haarlem (Cobalt Linoleate) or some other siccative. As this ink will dry and form skin rapidly on the slab it is advisable to take a very heavy ink containing only heavy oil and pigment and mix with the siccative to the consistency needed for printing only a small quantity sufficient for one or two prints at a time.

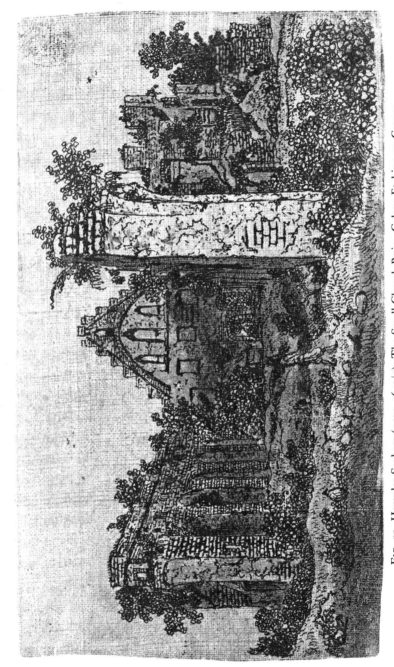

FIG. 55. Hercules Seghers (1590–1640/5): The Small Church Ruin. Colour Etching on Canvas.

In handling silks or other fabrics for printing the chief difficulty arises from the elasticity of the material, particularly when wetted. Hence we have found that using the material dry and laying it on the press so that it is stretched across the plate with uniform tension, then covering it with a damp sheet of paper, was more convenient than wetting the fabric itself before printing. Colours applied to the surface of the plate with roller or dabber over intaglio inking can be printed quite easily if the thickness of the colour film is kept at a minimum (as with printing on paper). This is the only practicable manner of using multiple colour on fabric, as register by hand-printing is extremely tedious and uncertain. Frequently, when the plate is for decorative purposes, the impression should not show a rectangular plate mark. In that case, the plate is sawn out to the profile needed or a cut-out mask is laid over the plate which then prints only the form exposed.

Printing on fabrics by machine from engraved plates

The Atelier has experimented on the possibilities of making rollers for intaglio (solid-deposit) printing on fabrics in large quantities. The roller of copper, or copper on steel, is made sometimes by depositing the copper surface electrolytically, sometimes by shrinking a copper sleeve on to a steel core (somewhat as rotogravure cylinders are made, though the depth of engraving is much greater in the fabric rollers). As these rollers run in wells of liquid ink and are stripped by a ductor blade they have to be perfectly concentric and parallel to within 1/1000 inch; therefore the wide hollows of relief whites used in the flat plates are not practicable. The methods used at present to make such rollers are photogravure, in which a screen is used to break solid tones into dots, and machine engraving by a sort of pantograph. The circumference of the roller determines the interval of repeat in the design, and its length the width of the material. Both of the methods used would fail to give all the detail of the hand-engraved plates; the screen would interfere with textures and bitings, and the traced mechanical quality of the pantograph would not reproduce the flexibility of the trace of the burin.

Experiments were made to see whether it was possible to make a matrix from the required number of repetitions of hand-engraved plates, forming it into a hollow cylinder, and then depositing an electrotype sleeve of copper inside it which could finally be machined internally to be shrunk on to a steel core. The difficulties of the process have to do with the extreme accuracy of the final dimensions of the roller. If successful this method would provide a microscopically accurate replica of the original hand-engraved and etched plate, with the necessary repeats for machine printing. (Of course, unless the printing is done with the greatest possible precision, this quality will not be apparent in the final product; but the consumer is learning to distinguish such qualities.)

Printing from intaglio plates on parchment, hide, leather, &c.

It is practicable to print from etched and engraved plates in intaglio on to any resilient material which will absorb water. Prints have been made on parchment (sheepskin) and on various kinds of rawhide and leather.

The parchment to be printed should be as even in thickness and texture as possible and not only perfectly free from grease but also from the whiting, talcum (French chalk), or other dressing often used to prepare vellum to give it a whiter or more regular surface. If such materials are present the surface may be sponged with clean water containing a few drops of ammonia and the skin immediately stretched on a board either by gummed paper around the edges or, better, with pins at intervals of about $\frac{1}{4}$ inch. Unless this is done whenever such material is dampened, it will contract and deform very violently in drying. But if such treatment is not necessary, it is advisable to dampen the vellum as little as possible; in practice I have found it sufficient to press the material between slightly damp blotters for twenty-four hours. Inks for printing on such material should contain less raw linseed oil than those used for printing on paper as there is less absorption; and rather more pressure on the press should be used. If an imperfect proof has been made it can be cleaned off completely with petroleum ether, benzene, or other light solvent;

the skin is then sponged with ammonia to remove traces of oil and restretched in readiness for another printing.

Hides, leather, and other animal materials are treated in much the same fashion: generally if very soft they require little or no dampening, but if hard they must be softened with water to mould them into the crevices of the plate.

Relief printing from engraved and etched plates

It is obvious that plates made by any of the methods described except dry-point or mezzotint can be printed in relief by depositing the ink upon the surface without filling lines or holes (Fig. 34b). The contact presses used for typography or a screw book-press would provide sufficient pressure, which is less than that used in intaglio printing. Where the work is to be printed with type on a conventional press the plate would have to be mounted on a wood block type-high. Plates worked for this purpose should be engraved and bitten far more boldly than those worked for intaglio printing, for some of the finer lines and textures used in etching cannot be kept clear of ink in mechanical surface printing. Printers sometimes strongly object to printing from such plates, though I think that the quantity of such plates that may be used in the future is unlikely to affect seriously the photo-engraver's monopoly.

Although the roller press is not intended for surface printing, with a little modification it can be used to make such prints. The plate is inked with a gelatine roller coated with typographic ink (not the ink used for intaglio printing) which has been rolled out on a glass slab until it shows a texture which will be found by experiment to give solid colour and keep the hollows of the plate clear. It may then be set up on the bed of the press in a mat of about the same thickness as the plate, a dry sheet of smooth-surfaced paper placed on it. Then, as the elasticity of the blankets is undesirable, a sheet of thin metal or red fibre can be used instead, above which one blanket is laid to counteract possible irregularities in pressure. The press is set to less pressure than would be used for intaglio printing.

The plates made for relief printing in the Blake manner described in Chapter 4 were printed in a slightly different fashion (Figs. 34*a*, *b*). From the small fragment of William Blake's plate of the 'America' poem in the collection of Mr. Lessing Rosenwald in the Library of Congress and from the study of other prints of the same artist I had been convinced that the relief of type and image was insufficient for inking even with hard rollers. With the poet Ruthven Todd, I studied the surface of the prints in comparison with the colour-printed drawings in which the colour is known to have been transferred from the surface of boards coated with paint. As under a glass both showed a similar reticulated surface, we assumed that the inking of the plates had also been done by previously inking another plate or board, pressing this against the plate, separating the two surfaces and printing from the relief plate. The variation of hue from top to bottom in many of Blake's own proofs would be very simple to obtain in this manner. During the summer of 1947 with Joan Miró and others a number of plates were made and printed by this method in black and gradations of colour. Some prints were also made in which the background was printed in intaglio, then colour from a second blank plate was transferred to the surface and printed at the same time. The method has been used by Friedl, Calapai, and Peterdi in the Atelier.

Classification, numbering, and publishing of prints

The European practice of numbering all prints in a limited edition so that each proof bears a figure representing the order in which it was taken from the plate, and as quotient the total number of prints in the edition, is in general use in the Atelier. In the way that prints are sold today (though I would not suggest that this is the ideal way of circulating ideas) the value of the individual print depends to some extent on its rarity (though only if one assumes the existence of a demand). Thus there is no reason why if numbering has to be done it should not be done accurately, until the time comes when we may be able to circulate prints at very low cost in enormous editions.

The progressive working prints taken at different stages in making the plate are marked 1st, 2nd, 3rd, &c., state (*épreuves d'état*); if more than one proof of a state is taken it is also numbered, and it has been my own practice to date these proofs, as the information may be needed later. When the final state is reached, it is usual to take a few trial or artist's proofs (*épreuves d'artiste* in the French sense, though in England and the United States all prints made by the artist are

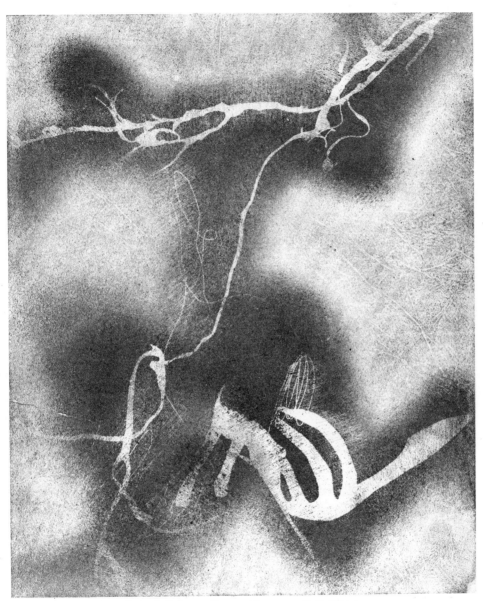

FIG. 56. Prinner: Composition, 1935. Relief Print.

often called artist's proofs), and convention in France limits them to
five—generally numbered in Roman figures or lettered A, B, C, D, E
to distinguish them from the definitive edition. Frequently they are
made on different papers or with different inks to find the best con-
ditions for printing the final edition. It has been the custom for the
artist to retain these prints and the states, or one set of the states, even
when the whole edition is sold to a publisher.

The normal commission for sale of prints by galleries is $33\frac{1}{3}$ per
cent.; where an edition with exclusive right of sale is sold outright
the price paid may vary between one-third and one-half of the face
value of the proofs, depending on apparent ease of disposal and the
dealer's intention of selling either directly or through intermediaries.
Where series of plates are made with a text, arrangements with a
publisher will take into account his expense in paper and printing,
advertising, and making boxes or binding, &c. In these cases two
extra copies, O and OO, are made for legal deposit (Bibliothèque
Nationale in France—Library of Congress in the United States). In
England it is necessary to provide five copies for copyright purposes.
Generally a number of copies marked *Hors Commerce* in France and
not offered for sale are made for the collaborators, as specimens for
presentation and advertising.

Records

Whether the artist publishes his own prints or whether a dealer
handles them, a record should be kept showing dimensions of plate,
description of technique, dates of commencement and termination,
paper used, and dates of printing. Every print made should be
recorded and it is useful to add notes of destination of prints sold,
exhibitions in which shown, prizes, &c. At one time I used to keep
records of plates on failed proofs of the plate, but it is much wiser
to keep all such records together in a book. Of course no further
prints are taken when the edition is completed, though it is sometimes
as well to keep the plate so that a print which has been physically
destroyed could be replaced. Ultimately the plate is cancelled or
destroyed. Recently I have cancelled plates by engraving a signature

recto across a worked passage, impossible to remove without trace; thus if prints are ever made again from the plate they could not be offered as the original edition. This method preserves the plate as a work of art, and as many museums (the Victoria and Albert Museum, the National Gallery, the Chicago Institute of Art, the St. Louis Museum, the Brooklyn Museum, the Museum of Modern Art) have bought such plates, often more beautiful objects than the prints, I do not see why they should be actually destroyed, since the owners of the prints are adequately protected.

10

PLASTER AND CARVING

THE first printers in history, or, rather, before the beginnings of history, were the men who found that a tool or a mould could be pressed into wet clay, leaving an impression or a cast. The Sumerians of 3000 B.C. had a fully developed technique of writing on clay with two simple arrow-shaped tools, one long and the other short, making 'cuneiform' impressions which were assembled in groups as words. The same ingenious people made hollowed-out marks on cylinders to be rolled on the clay (Fig. 63), which were developed from simpler seals merely pressed into it. The hollowing-out was, of course, 'intaglio' as we understand the expression since its first use in the sixteenth century. When an engraving is printed on a roller press with damp paper backed by the resilient woollen blankets a cast is made of the surface of the plate in exactly the same way that the clay was moulded by the carved surface of the Sumerian cylinder seal. Very early in the Western development of printing, perhaps even at its very origin, casts were made, in clay, in wax, and in molten sulphur, from plates which were being engraved. The reversal of inscriptions and details shows that, often, such casts were made from plates which were not intended to be printed at all, but which were designed for purely decorative purposes.

In *A Treatise on Etching* by Maxime François Antoine Lalanne (1827–86), translated from the second French edition by S. R. Koehler and published by Estes and Lauriat in Boston, Mass., 1880, a method is described of making a print in plaster of Paris. In Atelier 17 since 1931 we have elaborated upon this method. It has the advantage of showing the relief of the lines even more clearly than

a print on paper, and it also provides a means of making a print without a press.

TO MAKE A PRINT ON PLASTER

The plate, which may be engraved, etched by any of the methods described, dry point or mezzotint, is inked as for printing on paper.

The ink used should contain rather more oil than that used for printing on paper. When printing on paper a too liquid ink cannot be used as the pressure causes it to spread around the lines. With plaster-printing there is practically no pressure and, as the oil is absorbed by the setting plaster, enough oil is needed so that, after the plaster has set, the thread of ink will not be dry enough to crumble or to adhere to the plate when it is lifted.

When the plate is wiped in the manner described, with gauze and the hand, it is important that a film of oily ink should remain to isolate the plate from the plaster, so it is unwise to make use of whiting in cleaning the hand. If the plate is kept fairly warm on the hotplate during cleaning it will, as a rule, retain this essential film.

The plate is laid face upward on a glass or other clean smooth surface and so placed that the margin is regular; a frame, at least $\frac{3}{4}$ inch deep and large enough to leave a margin of an inch or two around the plate, is placed in position. It is advisable to place weights on the corners of the frame so that it will not float off when the plaster is poured. The plate must be allowed to cool before casting.

Plaster of Paris, plaster cement, hydrocal, &c., is mixed as for ordinary casting, enough being prepared to make a $\frac{1}{2}$ to 1 inch thickness, according to the size of the plate. The usual method of mixing is to sift dry plaster into cold water until it no longer sinks, allow it to stand for a moment, and then stir it thoroughly and allow it to stand again. Some plaster workers tap the bottom of the pan to cause any bubbles to rise to the surface; water that separates is poured off. When the plaster has the consistency of heavy cream and begins to feel slightly warm, it is ready for pouring. We generally pour from

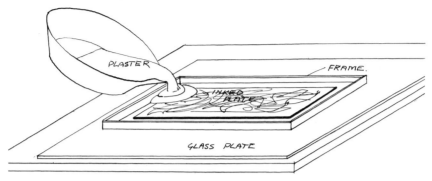

FIG. 57. Printing on Plaster.

one corner, allowing the plaster to creep slowly across the surface so that no air bubbles are trapped in the hollows of the plate (Fig. 57). When the plate is covered, pieces of jute fibre, soaked in plaster, may be laid across in all directions to reinforce the block.

In setting, the plaster heats up, and the plate must not be lifted until the block has become completely cold.

Then, with the plate still held firmly against the cast, the block is slid off the base and turned over. If, owing to any irregularity of the plate or the base, the plaster has covered the edges of the plate, these unwanted excrescences must be cut away cleanly with a knife.

With a large or strongly worked plate it has been found advisable to heat the plate, by placing a warm object such as a flatiron or a can of hot water on it before lifting it. Lifting a plate is also made easier by inserting a point or a knife blade under one corner.

The print should have a surface as smooth as polished marble over the unworked plate surface, the lines should be black, and the even surface colour left by the hand or gauze in wiping should be seen.

Sources of error in plaster printing

If all the lines are grey and broken it is probable that the ink contained an insufficiency of oil. If part of the print is grey, that is generally due to badly mixed plaster; water which should have been poured off the top of the plaster will, if allowed to run on to the plate, cause

this greyness. Bubbles in the plaster are also due to careless mixing or pouring. Lines in the impression which have been broken away are generally due to carelessness in lifting, though, in a big plate which has been heated, the contraction of the plate in cooling can result in such breaks. Overheating before lifting may have the same effect through the expansion of the metal if the plate is large enough. It is definitely much harder to cast from a big plate than from a small one.

CARVING PLASTER PRINTS

Whether the plate has been inked or uninked, the plaster cast is actually a linear relief with a maximum projection of perhaps $\frac{1}{50}$ inch. By carving, the space may be organized into a bolder relief.

The plaster block with the print on it will remain damp and soft for a week or two after it is made, and will then dry and harden. It takes about the same time for hydrocal and the other plaster cements to dry, but they become much harder than plaster of Paris.

In Atelier 17 we have often made plaster prints from plates in early states when only the bigger structures are present, and have combined the development of the theme by carving in actual relief. This has one definite advantage. The volumes to be worked are still large in scale. The scale of engraving and etching, when translated into carving, tends to become extremely minute and tedious. The resultant carved relief block may give most valuable indications of a direction in which the original motif may be developed into the plate for normal printing on paper.

The fresh block is easy to cut, but it is difficult to realize extreme accuracy; it is most convenient to cut away large masses in the fresh block but, where working to a line, to leave about $\frac{1}{16}$ inch to be shaved away when the drying out has finished.

A fine pointed knife of the sort used in woodcutting, a small surgical knife, large and small round gouges, and small flat chisels are the most generally useful tools, though scrapers, drills, and toothed tools may be employed.

In cutting to a line it will be found that a vertical cut crumbles the plaster on both sides; at an angle, only the undercut side will crumble,

L

so it is wise to start a cut near, but not on, a line which is to be left and then shave gently down towards the margin.

The forms used will normally be flat, convex, or concave. As all carving will be below the original surface of the block, a convex form will be within, or partly within, an incised outline. The effect of a concave form in an incised outline is most interesting (see Chapter 19).

Owing to the scale of the engraved print, even if much of the small detail has been cut away, enough will remain to impose a small scale on the whole relief. It is essential to finish the carving with great precision. Surfaces may be worked with tools made by gluing fine sandpaper to sticks and pointed tools, and the most useful finishing material is ordinary wrapping paper which is sufficiently abrasive to polish the surfaces.

Ways to work

Consider the block, illuminated from above diagonally, and then carve the surfaces to show light, shadow, recession, volume, or hollow in relation to this light. A plane turned towards light appears to come forward, turned against it, to recede. The consistent practice of this method is, as a rule, dull.

The actual volumes may be considered: a round where volume is required, or a hollow, or a slope-back where a recession is wanted, cut forward from the incised line where the projection would be needed. The results of this system are also rather dull.

In fact, the only counsel one can offer an artist investigating the medium is to try it, following a more or less instinctive organization, and see what happens. Examples of work in the medium are my *Laocoon* (Fig. 58) and Ferren's *Composition* (Fig. 59).

Colour may be applied to the reliefs after carving. A curious effect is given by incised volumes of colour, the original uncarved surface being left uncoloured, for the systems of coloured volumes organize themselves in a more or less complete composition seen through the plane of the remaining surface elements. Either tempera colour, with an egg or casein base, or oil colour can be used, but only those pigments which can be used on lime in fresco painting are safe on

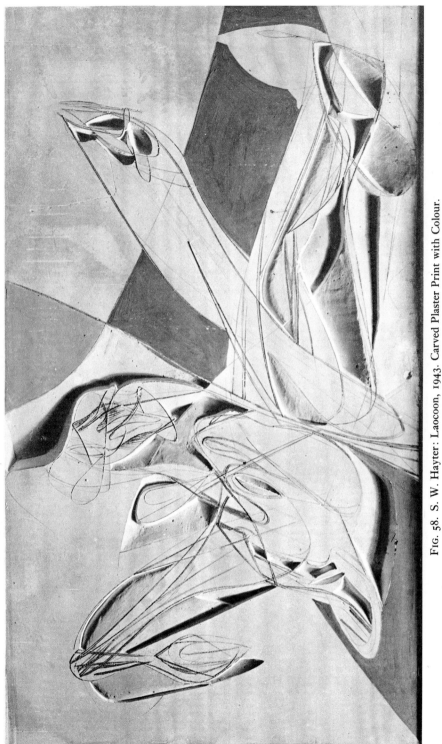

Fig. 58. S. W. Hayter: Laocoon, 1943. Carved Plaster Print with Colour.

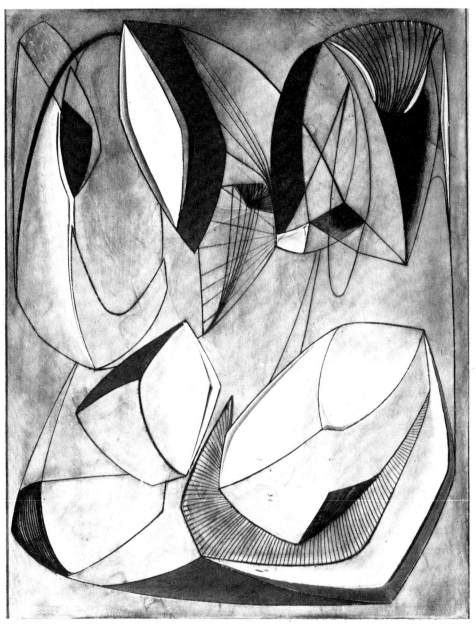

FIG. 59. John Ferren: Composition, 1937. Carved and Coloured Plaster Print from Engraved Plate (Collection, Museum of Modern Art, New York).

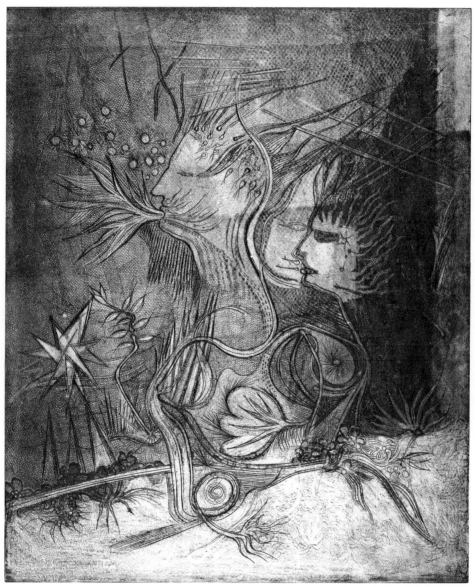

FIG. 60. Serge Brignoni: Les Aquatiques, 1953. Burin and Soft-Ground Etching.

plaster, and oil pigments may show margins where the oil has penetrated the plaster. Printing on plaster may also be done from a surface-inked plate, where the unworked surface of the plate appears in black or in colour.

Plasters have been printed even by such complicated methods as the intaglio and three-colour offset from screens described in Chapter 8.

From the practice of carving relief prints we were led to experiment with clay pressings. For these we used pottery clays, such as terra cotta, which could subsequently be fired. An ink was prepared by grinding potter's underglaze black with the burnt oil used in making ordinary printing ink, and the pressing on damp clay made from a plate inked with this compound was fired. The result, which so far we have only been able to realize on a small scale owing to the special equipment needed for handling clay, was a ceramic proof of great permanence, having the intensity and surface relief of a print on plaster. There is no reason why such tiles should not be glazed or carved before firing, when an extremely durable relief would be made. For bigger prints it would be necessary to use dry kaolin and a hydraulic press to form the tile.

11

CINQ PERSONNAGES: DESCRIPTION OF EXECUTION FROM DRAWING TO FINAL PRINT

FOR a description of the inception and development of a particular work to make some sense to a reader, it is necessary for him to be able to connect it up with a direction, a method perhaps, in any case with its place in a complete series of works by the artist. Some sort of confession of faith is also involved. To describe an act without its motive will limit its value to those who are already familiar with the subject.

Although, for personal reasons, I am no longer an active member of the Surrealist Group, the source of the material in all my works is unconscious or automatic. That is to say, an image is made without deliberate intention or direction. The impulse to make an image is definite, but no particular image is sought consciously. This may give the impression of a completely formless and unplanned method. However, as the following pages show, the execution of a project in a very indirect method—a method of making a print in colour not, so far as I know, previously attempted—involves a great deal of forethought. In practice, the use of colour and the organization of the space were found to have much in common with those already experienced in earlier work.

I will try to explain this apparent contradiction. In the first project, a drawing perhaps, no conscious selection of form is exercised, although, as with a print, the proportions of the plate selected and the sort of colour to be used had been present in a nebulous state in my mind for a year or more. The hand which made the first study was,

however, trained by twenty years of practice in line-engraving, the
mind had assimilated all the mechanical processes involved in making
the work until they became 'instinctive', and the areas of the imagina-
tion which are provoked by the use of such means had been exercised
for years.

Thus, if the source of material for such a work is irrational, its
development and execution has to be strictly logical, not with the
mechanical logic of imitation, but in accordance with a sort of system
of consequences having its own logic. At the different stages of de-
velopment of the work, a choice is exercised, but with extreme
precaution against the application of pedestrian common sense when
inspiration flags. As Paul Klee says, 'to continue *merely* automatically
is as much a sin against the creative spirit as to start work without
true inspiration'.

The plate *Cinq Personnages* (Pl. 3) was commenced at the end
of December 1945. From the start I planned to employ six com-
ponents, all of which had, in some form, been used previously. These
were: (*a*) engraved line; (*b*) transparent bitten textures in the plate
itself, printed in intaglio black; then three elements of colour:
1. opaque orange; 2. transparent red-violet; 3. transparent green;
finally the white relief in the plate itself, planned to pass through the
other five elements. In the manner planned the composition would
not be complete until all six components were present.

The first drawing, on a white sheet full size right to left as in a
print, not left to right, mirror image, as in a plate, was made with
pencil and red chalk to represent colour and texture, and contained
only the structure of the design. The loop-shaped interval on the left,
the position of the head of the standing figure on the extreme left,
the flow of space in the left panel and the interruption by cross
structure on the right, and the position of the plunging figure were
complete at this point. A small plate of the elements of the latter
figure was made at this time, December 1945. There were only a
few geometric indications of the recumbent figure at the lower right,
and the figure itself was not shown.

The main plan from this drawing was redrawn in reverse on the

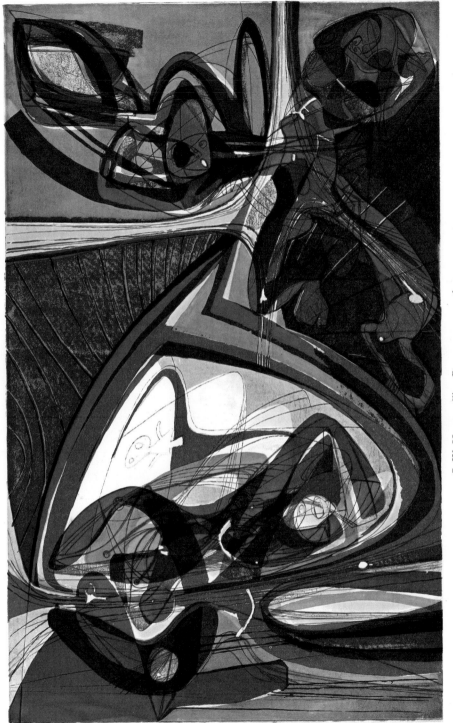

3. S. W. Hayter: Cinq Personnages, 1946.

back of the sheet with some variations, showing it as it would appear on the plate. Two detail drawings were made of the spinning figure in the loop. One showed the skeleton of the consequent figure and the other the main organization of the first figure, which was not complete at this point. The figures were only complete when they were engraved on the plate much later. The subsequent figure itself was not shown. The tracing of the main framework of the composition was made on the plate, using white transfer paper, and the work was started with the burin. All the forms actually originated with the burin, the vague white trace being used only to place and orient the composition.

First State: After about two days' work on the copper it showed only the loop: the first revolving figure (head down) was incomplete. There was no structure in the right side of the print. Two prints were made on 1 January 1946. Work with the burin was continued after the recumbent figure had been drawn in on the drawing. A previous version of this figure, in painting, was commenced early in December 1945.

Second State: This shows only the burin. The static figure and vertical separation to the left of the print, the recumbent figure and the plunging figure at the right, the whole structure of the composition, were indicated. There was further detail in the spinning figure in the loop, and the direction of the space in the lower right corner was defined. The consequent figure, complementary to the spinning figure, was slightly indicated. Two prints were made on 5 January 1946.

Third State: This was not completed until 18 January 1946. Detail was added in the head of the spinning figure; there was development of the burin work throughout, and detail was supplied to the recumbent figure on the right and the plunging figure on the upper right. Two small white reliefs were added in the spinning figure to verify the proportion of white accents.

Fourth State: After some further burin work, the copper plate was coated with soft ground, filling all the burin lines and sealing them against the action of the acid. Various fabric textures, an irregular

mesh of gauze, several different closely-woven silks, and crumpled brown paper were pressed into this ground, using the printing press with, in some cases, greater pressure applied to one margin of the plate than to the other. When the textures were removed the ground lifted, exposing the plate. About four complete grounds were used at different times. The textures were superimposed in some cases at the moment they were applied, and in other cases a second or third ground carried the texture which was to overlap that already etched into the plate. The silhouettes of the bitten elements were defined by stopping-out with a varnish composed of resin dissolved in alcohol. The biting was done in a bath of saturated solution of potassium chlorate to which had been added about 10 per cent. hydrochloric acid, that is, a more concentrated Dutch mordant. Practically every bite was varied by tilting the plate in the acid, and allowing it to creep across the surface, as well as by the variations of pressure in the transference of the textures. Spotting in certain places was produced by leaving scattered drops of acid in places during the tilting operation. Though biting follows the lines of engraving in some cases, it is most generally planned in counterpoint. The biting was controlled in view of the effect the transparent greys would have in modifying the three colours to be used. The forms of the bitten textures, although not indicated in any drawing, are consequent upon the linear forms and rhythms already established in the plate.

The Fourth State was printed on 30 January 1946. Prints A, B, and C show slight changes due to removal of overbitten tones in the lower centre with water of Ayr stone and the burnisher. At this point the distribution of the colour was worked out roughly on tracing paper, using transparent inks of orange, red–violet, and green to serve as a control in setting up the screens.

At this point, also, the composition was incomplete. The triangle in the upper centre was still empty. It was to be completed by printing green over violet, a combination producing a blue, with lines of clear colour.

The method to be used for colour printing was first considered in 1930 in Paris, when some experiments were made by applying surface

colour with a roller to an uninked plate, making one impression, then cleaning the plate and inking it, for intaglio printing, in black and reprinting on the same paper. Owing to errors in register a black/white line, apparently in relief, was given. Stencils were used to define areas of colour, which, in this case, were crude and detached. Later, in San Francisco in 1940, a print, *Maternity*, was made in which one opaque colour, orange, and two transparent colours, blue and ochre, were printed in tempera on damp paper, using silk screens to replace stencils, and finally overprinted with black in intaglio from the plate. In 1943, another colour print, *Centauresse* (Fig. 53), was made in which red, yellow, green, and blue elements of oil colour were applied to the surface of an intaglio plate previously inked with violet: this provided the only transparency to modify the four colours. Though some prints were made with two successive impressions, the first being offset from stencilled colour on the surface, the second being the intaglio impression, it was found that all the colours could be assembled on the plate without mixing, if suitable media were used, and transferred to paper in a single impression, thus avoiding all the difficulties of register.

In this *Cinq Personnages* plate, I proposed to employ silk screens instead of the stencils used in the *Centauresse* experiment. The large scale of the plate and the complicated overprinting in transparent colour which was planned made the use of stencils impracticable. The plate was to be inked in black, as for normal intaglio printing, and then, with the use of silk screens, three successive films of colour were to be deposited wet upon the surface without mixing with the black. The whole was to be transferred to damp paper by means of the roller press, in one single operation. On the print, colour would appear as offset from the plate surface and, over it, would be the intaglio impression in black, appearing slightly in relief above the surface of the paper. Relief whites—hollowed-out spaces in the plate which were uninked or cleaned out—would appear in front of the greyish whites of unworked and uncoloured plate surface.

Experiments in the additive use of colour had been made in January and February 1946 with drawings in transparent inks, using the same

four colours, orange, red-violet, blue-green, and black. The method proposed, when technical difficulties had been overcome, would permit a certain sort of effect to be produced, but it was to be in no respect a means of reproduction. Many effects obtainable in paint would not be realizable, and only a composition planned from the beginning with a full knowledge of the limitations of this method would be successful. However, as in paintings of 1944 and 1945, I had found that a closely knit series of tones, produced as the consequence of the interference of very few colours, gave a psychological unity which a more complex palette did not. Pavel Tchelichev once told me that many of his compositions were planned in this way.

As an oil medium would be used in the printing, the silk screens were prepared with glue solution, openings exactly the size of the plate being left, and colour lines were drawn in with lithographic tusche and a ruling pen. These were subsequently washed clear with turpentine in the usual fashion. Stopped lines were drawn with glue, using the same pen. Registration with the black was simplified by the fact that the plate was visible through the screens while the work was being done. Some scattering of colour, outside definite colour areas, was obtained by using a deliberately thin film of glue.

Owing to accidents and to the presence of insufficient margins on the first screens, it was, in fact, necessary to remake both the orange and the green screens before a satisfactory result was obtained.

The screens were hinged to boards to which mats, cut out to fit around the plate, were attached so that register would be automatic.

It took about two weeks of experimentation to find the appropriate medium, which would permit screening with a thin film of colour, which would not clog the surface of the paper so as to reject the black, which would not spread under pressure and would not mix with the black nor bleed when all the colours were wet on the plate. The order of succession of colours turned out to be very important when set up on the plate. Intaglio would be deepest, followed by orange, red-violet, and blue-green, so that on the paper they would appear in reverse order, the last colour applied being undermost. However, the controlling factor seemed to be that amount of colour,

previously deposited, which was lifted by the two following screenings. Finally the best succession was found to be green—violet—orange. A soft Japanese paper, Kochi, with three blankets and light pressure, was found to print best. Printing was done where possible by the artist, who handled all intaglio inking and final impressions. Three helpers, one man to each screen, printed the colours, cleaned the undersides of the screens, and kept colour mixed and ready. The colour did not add more than thirty seconds to the time needed to make each print.

The Fourth State in full colour was run successfully on 5 March 1946. Two prints were made. The colours used were cadmium orange, thalo green (chlorinated copper phthalocyanine), and alizarin violet. The latter, not being obtainable, was ground from the pigment. Hand-grinding of a quantity sufficient for fifty final prints and thirty trial prints took ten hours.

The plate was then completed by further burnishing on certain parts, by the accentuation of certain burin passages and the removal, with scorpers, of hollows to print white, or colour, in relief.

Fifth State: This work was completed on 7 March 1946, and prints in black were made. Some modifications of the screens suggested by errors in some of the trial prints were made at the last moment. Then progressive proofs were printed—black plus one colour, and black plus two colours. The final series of fifty prints was made in three periods, totalling about twenty-six hours. Although some thirty prints were lost before the correct conditions were found, in the final printing only seven prints were imperfect.

Mr. Ezio Martinelli helped in setting up the screens, and Messrs. Frederick Becker, the late James Goetz, and Karl Schrag, all of New York, assisted in the printing.

12

COLOUR PRINTING

ALTHOUGH the first successful printing in full colour from a single plate in one operation has been described in detail in the last chapter, the underlying principles are not clearly defined. In the course of subsequent development of the method it has become clear that for the operation to be successful two other elements must be clearly understood. In all methods of printing (with the exception of electronic printing) the control of the surface tension of the film of colour and of its viscosity is essential. It is clear that the surface of any liquid behaves like a membrane in tension; thus to break or interrupt such a surface will require a force greater than that tension. The viscosity of the colour, usually measured as its rate of flow, operates in the sense of the adherence of the film of colour to the plate, the adherence of one film of colour to another, and further the adherence of those films of colour to paper in printing. In the operation we shall describe there are certain limits to these two qualities. Thus to prevent the film being broken the surface tension of a film of colour must be sufficient to resist the rolling pressure of the press in the presence of water (the paper being damp). As surface tension and viscosity are interrelated this condition will serve to define the minimum: the maximum viscosity, as will be seen later, will be lower than that of intaglio ink already present in the plate.

The method we are about to describe can be considered as an amplification of the principles involved in lithographic printing. Briefly, in lithographic work, the drawing is made in wax on a stone that will absorb water; a roller coated with a viscous ink will then deposit ink on every trace of wax and fail to ink the wetted surface of

the stone. This effect, often ascribed to the antipathy between water and oil, can be described more precisely by considering the viscosities of the elements. Thus, wax, which we can consider as a liquid of very high viscosity, accepts the ink of a lower viscosity, while that ink is rejected by water which has a still lower viscosity.

To demonstrate this, suppose we put a spot of colour of low viscosity on a glass plate. We then coat a gelatine roller with a thin layer of a second colour of a definitely higher viscosity and pass this roller over the spot. The second colour will be rejected by the first, so that a spot of the first colour will be seen surrounded by the second colour. If we now prepare the second colour with a viscosity equal to or lower than that of the spot and pass a roller coated with this colour over the spot, the result will be a double colour, as the second colour has taken on the first (as in the printing of the plate described in the last chapter). In the earlier applications of this method the areas of colour were frequently defined with stencils or silk screens on the plate, with the intention of exhibiting all of the permutations of the colours used (so that three colours give seven, as RBY, RB, BY, RY, R, B, Y: four give fifteen: five give twenty-four, and so on). In this procedure the application of successive films of colour must follow a scale of equal or progressively decreasing viscosity in order that all the colours may accumulate (where intaglio ink is present in the plate, the total thickness of the layers must be such that the damp paper can still penetrate it to make contact with the intaglio).

Later, with the development of plates having several degrees of relief on their surface (see Chapter 6), it became possible, using rollers of different penetration, to produce structures of colour of great complexity without the use of either stencil or offset. Even without rollers colour can be applied to the highest points of a plate by contact with a flat surface carrying the ink (as in the printing method probably employed by William Blake, Fig. 34b), followed by other colours on hard (rubber) rollers of different diameters, and then by soft (gelatine or plastic) rollers . . . each with a different colour. Thus perhaps a hard roller will carry a film of colour of low viscosity which will deposit only on the original unetched surface of

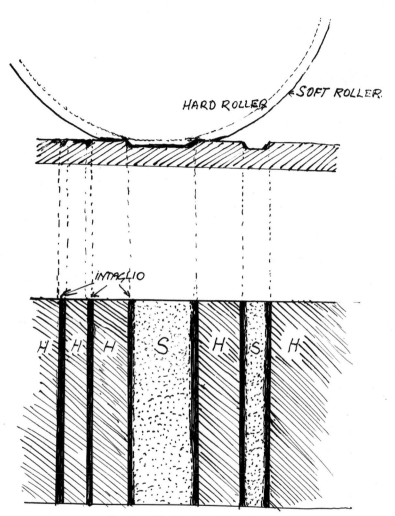

Fig. 61. Hard Roller, Soft Roller.

the plate: a soft roller, carrying a colour of higher viscosity, will then surround these forms with a second colour, neither affecting the intaglio colour originally present in the plate which might appear between the two. Recent research, using plates made by the methods described in Chapter 6, has shown still further variants in these methods of inking in colour. In the passage of a hard roller across a plate having some relief, the configuration of the plate surface is scanned by the band of contact of the roller which will be in proportion to its circumference. Furthermore, it is clear that the pattern of colour deposited when this band traverses the plate horizontally will be different from that deposited when the band moves vertically. Suppose a plate has a surface with vertical corrugations; if the roller passes horizontally there will be a maximum of colour, but if it passes vertically the striations will be narrower. With more complex structures the differences are greater although the two patterns are clearly interrelated. The use of these effects in the work of Krishna Reddy and of Sergio Gonzalez Tornero has been most revealing.

To make this more clear we might describe in detail the actual operation involving printing a plate by this method. The colours used are as concentrated as possible, completely fast to light, and ground in a medium which is not siccative. Such colours, sometimes difficult to find in commerce, have been supplied to us by Messrs. Laraignou and Edelmann of Chas. Lorilleux & Cie. and by Mr. Parle of the California Ink Co. Colours of this concentration are known in the U.S.A. as 'flush' colours. As completely transparent colours are preferable for this purpose, and also colours of great intensity with a simple absorption spectrum, we are limited to about ten colours in all. They are used pure and never mixed together.

A sufficient quantity of each colour is put out on a glass slab, the viscosity being modified by the addition of raw linseed oil. It is obviously necessary to mix to complete uniformity, otherwise the result will be uncontrollable. In one operation the hard rubber roller is then coated with a thin layer of the most liquid colour, either by rolling on to the slab or by picking up colour on a smaller gelatine roller and coating the large roller with this. The quantity involved

M

can be controlled roughly by looking at the appearance of the film of ink on the glass slab. This film will appear mat at the moment the roller has passed over it and should then become perfectly smooth within two seconds. If the film remains mat or shows a granulated surface its thickness is too great; it may even obscure the printing of the intaglio.

Another colour which has been prepared with a higher viscosity, i.e. less linseed oil has been added to it, is used similarly to coat a soft gelatine roller.

The plate is then inked with an intaglio ink which must have a higher viscosity than that on the soft roller and the plate wiped as in ordinary intaglio printing (see Chapter 7). The plate is removed from the heater, allowed to cool, and placed on a flat glass slab; the coated hard roller is next allowed to pass over the plate with its own weight without pressure on the handles. At this stage the plate will show the intaglio inking together with a structure of one colour corresponding to the highest relief of the plate. The soft roller carrying another colour is then passed over the plate, sufficient pressure being used to penetrate the hollows in the plate. This roller may then show traces of ink lifted from the highest relief of the plate, but should show no trace of the intaglio ink which, as we have said, must be of a higher viscosity than the ink on the soft roller.

The plate is placed on the bed of a press and printed like a simple intaglio plate. The resultant print will show in relief above the paper surface all of the intaglio work (which being held below the surface of the plate is embossed above the surface of the paper), while all of the variants of the two pigments used, modified by the relief and texture of the plate, will be seen passing underneath the intaglio.

This technique of colour printing does not replace the methods already known of printing colours successively from a number of plates. The results of the method furthermore cannot themselves be reproduced by multiple plate processes. The procedure of the artist in making and printing plates by the new method is completely different from that employed in the earlier processes. Our viewpoint on means of expression has been very strongly modified by the employment

of this technique. Where we at one time considered the matter of idea involved in a work to be latent in the mind of the artist, its projection in visible form being provoked by the employment of the technique, we have come to the idea that the image itself can well arise from the interaction of stages in the process. Whereas once we might have forced a plate to conform to a prearranged pattern, we would now submit ourselves to a process of development in which a totally unforeseen image could appear. At a certain stage of development the plate will be accepted as the work itself, and that result in colour that can be derived from it by the operations described is the final print. This may be totally different from what the artist had 'in mind' at the commencement. As I have often had occasion to remark, we print the plate we have and not the plate we might have had, ought to have had, but in any case have not. There is an obvious parallel in musical composition in which the score must be written for the compass and timbre of those instruments that we have and not for those that we have not.

The behaviour of colours in transparency being quite different from the behaviour of the same colours in painting on canvas, it became necessary for artists to familiarize themselves with these new conditions, and for us to formulate a theory leading to a consecutive operation by the new method. Of course no colour will remain the same under all conditions; in fact it is not 'colour' that we are using but certain specific pigments, and it is the behaviour of these pigments in thin layers which has to be understood. In practice we have found about ten colours which fulfil our requirements of intensity, transparency, and perfect resistance to light, and it is with these colours that we propose to arrive at our result, and with no others. This is far less of a limitation than it appears to be, as with any four colours it is practically possible to imply a complete saturated field. In working out this operation we made one assumption which cannot be proved: that is that for any particular plate and particular artist there exists one and only one ideal system of colour, in comparison with which any other version will appear inadequate, and that of that ideal system the artist must be convinced.

Before the first operation is undertaken it is necessary to decide once and for all on the predominant field colour of the print. To illustrate this it suffices to imagine oneself in the centre of a circle of the available colours; it is simply not feasible to explore every radius before commencing the operation. The only way in which I have been able to advise people in making their decision has been to quote from my own experience. Whenever I have not had in view a definite field of colour when starting the operation, I have put a black and white print in front of me and, making myself as stupid as possible, have stared at it until it appeared coloured. It has been my experience that, once clearly seen, this general field of colour will always appear. That is to say, the print will appear bluish, reddish, yellowish, greenish, and so on.

The plate is inked in intaglio black and prepared for printing. The hard roller is coated with the general field colour at a high saturation (otherwise it is difficult to identify the exact tone in many of the colours). This roller is passed over the inked plate without pressure. The resultant print will show black, the field colour, and a trace of the complementary colour which will appear in the greys and spaces between. At this point a definite choice is made: either to eliminate this effect of complementary colour by mixing with the intaglio ink a colour similar to the field colour, or to exaggerate it by mixing in the complementary colour. A choice of this sort between two colours that are very closely related or two colours that are very strongly contrasted (as the complementaries) determines each stage of a consecutive system.

If, at either of the two stages described, the print is completely satisfactory, it is clear that one need go no further. In fact there is an assumption in all such operations that the simplest possible means are likely to produce the most powerful result. Thus the change made in the whole position by the addition of one colour is greater than that made by the addition of a second, which is greater again than that produced by a third colour, and so on. However, supposing that the result has not yet been reached, in the third stage a colour of a higher viscosity than that on the hard roller is prepared, and a soft roller,

which will penetrate deeper into the hollows of the plate, is coated
with a thin layer of it. The choice of this next colour, although based
on the same idea of closer or more remote relation to those colours
already present, will not be quite so simple. In this choice one of the
implications of colour-space will have to be considered: the use of
closely related colours will reduce this apparent space, while the use
of complementary colours will exaggerate the relief. Thus, if we
visualize on a colour chart the two colours already to be seen in the
print (stage 2) we have two choices for the close relation, the one
close to the field colour, the other close to its complementary. A third
choice open to us will be to employ that pigment which would be
found on a chart more or less half-way between these two; or even its
complementary.

To anyone who has had practical experience of this method the
foregoing will appear oversimplified, for it would appear from this
account that once any colour is established it will remain the same
throughout all of the changes. This of course is not true, as shifts of the
field colour towards warm or cold hues will be caused by the presence
of other colours and, furthermore, the colour mixed with black in
the intaglio will constitute a screen through which all of the other
colours are seen. The character of the plate itself, according as it is
organized in simple masses in relief or in a more intricate texture,
will present either simple areas of contrasting colour or a vibration
of colour similar to a pointillist painting. It has been found that
a highly intense vibration occurs, as one might have expected,
between complementary colours and also, surprisingly, between
very closely related colours. Again, in our systematic account, we
considered only the operation in which the hard roller colour is sur-
rounded by that on the soft roller (as the latter is rejected by the lower
viscosity). Two other possibilities exist: one being to pass the soft
roller first followed by the hard roller, the viscosities being un-
changed; the other being to use the higher viscosity on the hard
roller, followed by the soft roller with a lower viscosity colour. In
both these cases a double colour will appear on the highest relief,
but the effect will not be the same. A moment's calculation will show

that with the use of black and the same three pigments, sixty-four different colour versions could be obtained. Of course it is unlikely to be necessary to make them all: the final version could appear at any stage, but it will now be clear why we consider it absolutely necessary to decide on a general colour field before starting, for otherwise the number of possibilities becomes astronomic.

NOTE TO SCHEMA

SCHEMA I

In this system black intaglio is used without or with admixed colour. Then a hard roller coated with transparent colour of *lower viscosity* (in order to reject colour of higher viscosity) is passed over the plate: it is followed by a soft roller coated with transparent colour of a *higher viscosity*. It is recommended to commence trials with the highest usable saturation of each colour.

By this operation a mosaic of pure colours will appear, all of which will be seen through the intaglio colour held in the plate.

SCHEMA II

As in Schema I black intaglio is used without or with admixed colour. Then a hard roller is first passed over the plate coated with colour of *higher viscosity*: secondly a soft roller is passed with a colour of *lower viscosity* which will take effectively on top of the first layer. (Note that this operation can be carried out with exactly similar viscosities of colour.)

By this operation no pure colours are seen: double films of colour appear again seen through the whole complex of intaglio colour held in the plate.

SCHEMA III

Again as in Schemas I and II intaglio black without or with admixed colour. But first a soft roller is passed over the plate carrying colour of *higher viscosity*: secondly a hard roller is passed carrying colour of *lower viscosity* which will adhere to the S.R. colour only on the highest relief.

Here one single and one double colour appears: double colour (again seen through the intaglio within the plate) not being identical with that seen in Schema II as the effect of two colours deposited in the order A/B is not the same as B/A.

All these schemes are oversimplified, as in reality every change made in pursuing an ideal colour system will cause a general shift in the whole field. Thus colours indicated as F or Fcp for reasons of simplicity ought really to be denoted F1, F2, F3, &c., or Fcp 1, Fcp 2, Fcp 3, &c.

Further variants described in the text may arise from the use of the hard roller in different directions, or more than one hard roller in different

directions using equal or differing viscosities, the use of contact inking on a few salient points in the plate, or the use at some stage of a clean hard or soft roller to discharge colour from salient areas. Finally, it is clear that the selection of any other colour to replace black as intaglio will initiate fresh series.

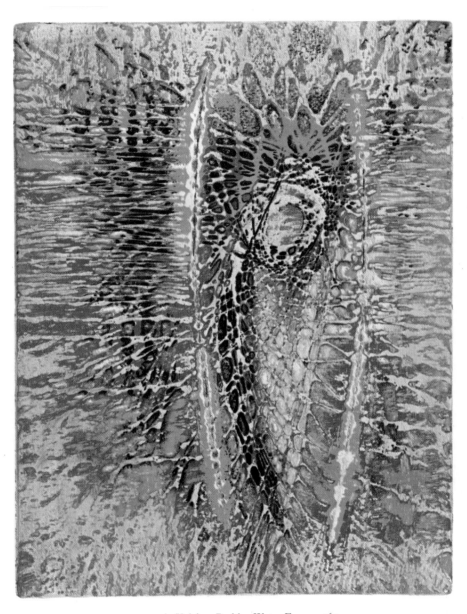

4. A. Krishna Reddy: Water Form, 1963.

HISTORY OF THE TECHNIQUE

13

GRAVURE AS ORIGINAL EXPRESSION
(FIFTEENTH AND SIXTEENTH CENTURIES)

ENGRAVING, using the word in its simplest definition, the decoration of a surface with incised lines, seems to have been one of the earliest techniques of art. As early as any of the prehistoric drawings and sculptures, perhaps even earlier than sculpture in the round, primitive man engraved designs in line on rock, slate, horn, and bone (Fig. 62). It is curious to compare these engravings with the line cut in copper by artists today. Even when the line has been made by hammering a pointed instrument held diagonally in the direction of the curve it still has the quality of the driven line of the burin, in which the artist travels with his line instead of regarding his hand executing an arabesque at arm's length.

The Sumerians, who already possessed a method of printing cuneiform characters on clay with two arrow-shaped tools, made cylindrical seals which not only printed the signature of the owner on a clay slab, but did this printing with a rotary motion (Fig. 63). Such a seal, filled with an oily black, could function like the roller of a rotogravure machine. But true printing had to wait for the invention of paper, and it is surprising that it did not appear in Egypt even before its legendary invention in China.

In Exodus xxviii. 36 there is a clear reference to engraving in gold for the decoration of the Ark of the Covenant, and by the time of Solomon and the bronze doors of the temple the craft must have been well established. As was to be expected, in Europe the workers in precious metals, the goldsmiths, were the first makers of prints from their engraved plates.

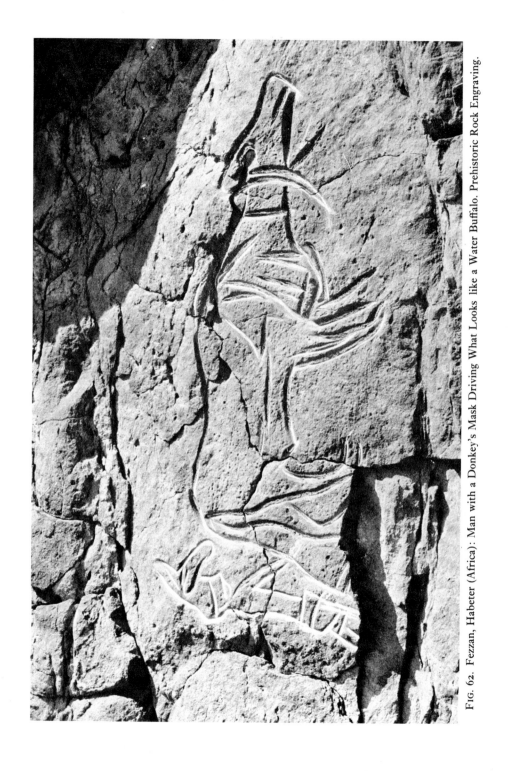

FIG. 62. Fezzan, Habeter (Africa): Man with a Donkey's Mask Driving What Looks like a Water Buffalo. Prehistoric Rock Engraving.

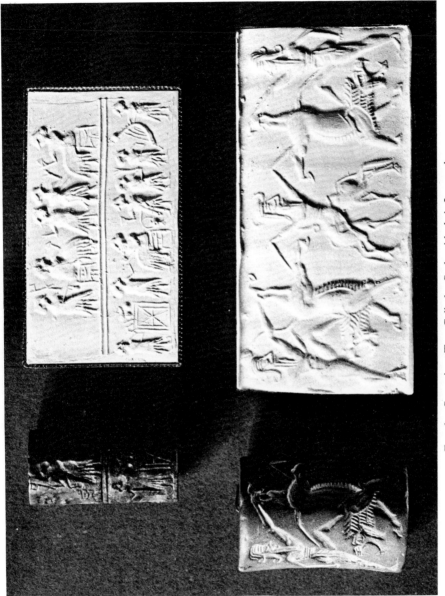

FIG. 63. Sumerian: Two Cylinder Seals with their Impressions.

Printing from the surface of wood blocks was known a century before the first intaglio prints. The small pressure needed could be more easily applied by the primitive means available. The rolling pressure required to squeeze the ink out of the grooves of an engraved plate was harder to apply. In fact, some of the earliest prints appear to have been rubbed with a burnisher from the back.

Early in the fifteenth century a method of making the hollows in the plate was current which is known as *criblé*. Points were hammered into the soft metal, and printing was sometimes done from the surface, the hollows remaining white, but often, in the same print, parts of the plate would be filled with ink and the surface wiped clean. Thus two methods of printing were employed simultaneously. It is possible that in such prints we might find the origin of intaglio printing, but, as no artist of importance employed the method, it had little development, though recently certain modern artists have re-employed *criblé*, and simultaneous printing in intaglio and relief from the same plate is used by the artists of Atelier 17. One print in this manner, to which, on what evidence I do not know, the date 1406 has been assigned, might be the earliest example of intaglio printing. A modern example is shown in Fig. 65.

The men who made those earliest prints in Italy and Germany were not, as the term is now understood, artists. They were primarily artisans and they either kept a shop in one of the free towns or were domesticated in the household of a noble or a prince of the Church. The workshops could employ men who were at the same time among the greatest artists of their day. A method much in vogue at this period was to engrave on silver or copper, filling the cuts with a paste of copper, silver, and lead filings mixed with sulphur. The plate was then heated to fuse the black sulphides in the lines, so that, when polished, they would appear black on the bright metal (Fig. 66). The name of this process is *niello*, and similar work is still being done in Iran, Iraq, and India. I have seen Syrian silversmiths in Amara filling their plates with a mixture of antimony, silver, and charcoal dust which, when reduced by heat, gives a slightly bluer colour than the black of the *nielli*.

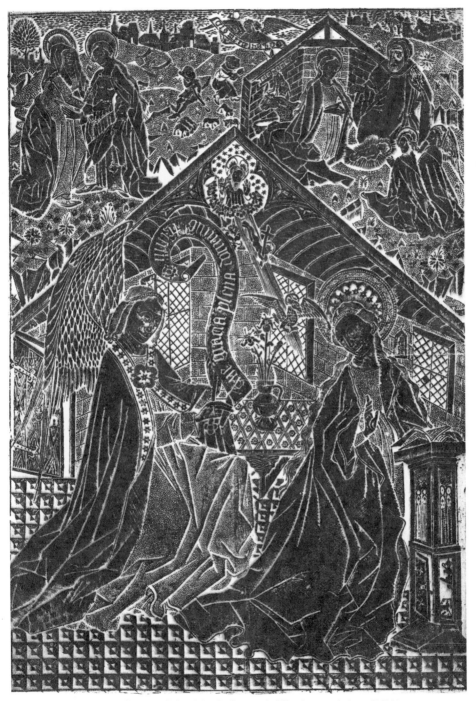

FIG. 64. German School (15th Century): The Annunciation. Criblé.

FIG. 65. Abraham Rattner: Crucifixion, 1947. Engraving, Criblé, and Aquatint.

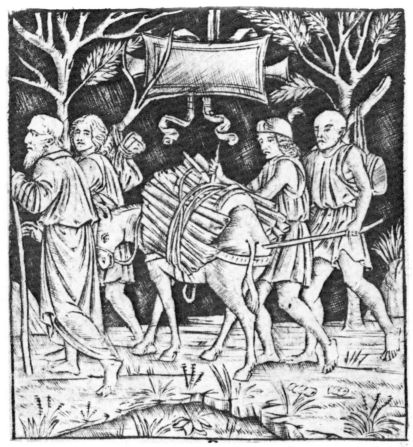

FIG. 66. Anonymous Italian (15th Century): Abraham and Isaac with Two Servants on the Way to Mount Moriah. Niello.

Giorgio Vasari states that Maso Finiguerra (1426–64), whose workshop continued in his family for three generations, was the actual discoverer of printing from an engraved plate. This claim was at one time admitted, but it now seems that printing was well known before his time in the north of Europe. Prints are known of this period which were quite obviously intended primarily for decorative purposes rather than as prints; this is shown by the presence of holes at the corners, intended for attachment, and the fact that inscriptions

N

often appear in reverse. In the workshops it was a common practice to make a pressing in clay to follow the progress of the work: sulphur was sometimes melted and a cast, even a cast of the clay pressing, was made. As engravers still rub oil and powdered charcoal into the finer parts of their work to make it more visible, this is yet another possible source for the practice of printing.

To abandon unprofitable speculation about the mechanism of the invention of printing, there is one fact that emerges clearly from the study of the prints of this earliest period. This is that, within two generations, a mere half-century after its invention, it had arrived at complete maturity and within a third generation it had become converted to another function entirely. In Italy one series of the so-called Tarocchi cards appears at about the same time as a number of masters known only from the monograms or initials on their plates, and the Master of the Hausbuch (Fig. 67) is, perhaps, even a little earlier than the cards.

There was already a very definite difference in style between the northern and the southern schools. The Italian examples show a definite line profile; modelling was then applied with fine parallel lines running diagonally from the lower left to the upper right on the print, which is the most natural direction on the plate when set before the artist. (The most natural direction of scratched or pulled lines would be the reverse.) The modelling in these early 'fine-manner' prints is weak and closely set, and in the later impressions it has often been reworked. The subject is generally a figure without any organization of the surrounding space, and the modelling describes the surface as sculpture rather than indicating lighting. In Germany and Flanders, with the Master E.S. (known only from his initials) and Martin Schongauer (1445?-95), a far more elaborate technique was already in use (Fig. 68). This employed cross-hatched passages giving variations in texture as light and colour, and dotting, generally with the flicked dot, printing as a lozenge-shaped point. The attempt to make a picture, to describe a landscape about the central figure, and the deformation of the firm curve proper to the cutting tool into the most involved arabesque of the Gothic spirit contrast with the sculptural

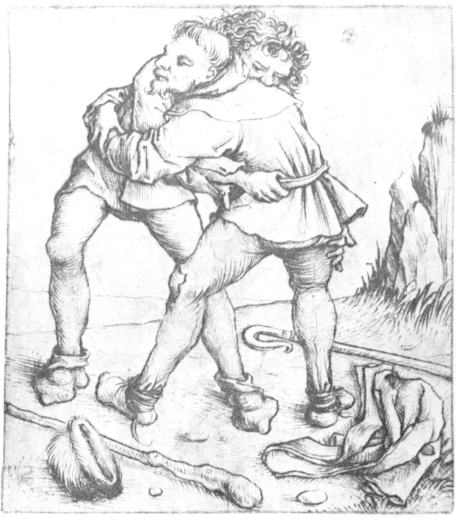

FIG. 67. Master of the Hausbuch (15th Century): Apprentices. Engraving.

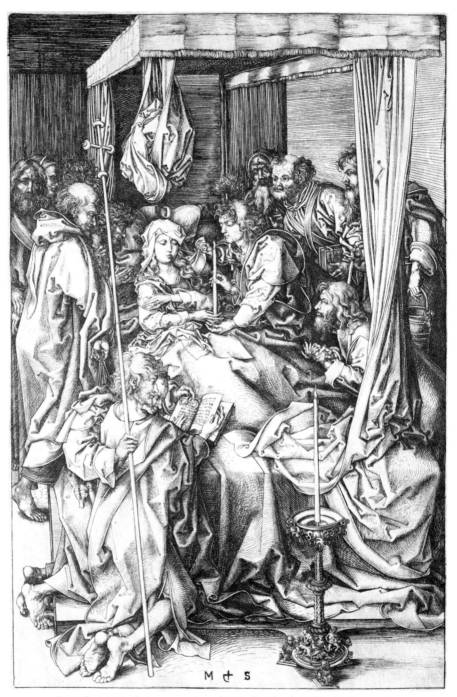

FIG. 68. Martin Schongauer (1445?-95): Death of the Virgin. Engraving.

character of the goldsmith's preoccupation with the metal. The factor that seems to distinguish the engraving of the Italians from that of the Northerners was the influence of the Renaissance. It is sometimes difficult to realize that Antonio Pollaiuolo (1429-98) and Andrea Mantegna (1431-1506) definitely thought that they were recreating the art of ancient Greece (Figs. 69, 70).

Pollaiuolo was perhaps the first great artist to use engraving in Italy. He is known to have been associated with the Finiguerra family workshop in Florence at the time when they were producing many *nielli*, and the dark background of his *Battle of Naked Men* (Fig. 69) is supposed to have been influenced by the work he must have done in that medium. The figures are described with a flexible but heavy outline, which is attached to the background. Within the space thus defined, modelling, as with Mantegna and his school (Figs. 70, 71), is carried out with diagonal parallel lines which do not often touch the outline, and between these lines a second series of finer lines are laid in the same direction at a slight angle to the first but without crossing. These *contretailles* have been explained by most museum authorities as an attempt to follow the return stroke of the pen in drawing. I doubt whether any working engraver would have thought of such a solution, for if he intended to do this it would be simple to turn the plate upside down and cut them in the reverse direction. To understand the purpose of this technique I think it is sufficient to regard the general effect which the artist has achieved. The whole plate is a sort of relief, in which the hollows in the background all return to the level of the plate at the margins. Within the hollowed space the outlines of the figures cut out spaces in which a complete volume revolves. If the hatchings were connected solidly with the outline the effect would be half-round instead of a complete solid.

We know that Italian art of this time was very preoccupied with 'the Antique', which was, in the case of Mantegna, Aretine pottery and Greco-Roman sculpture. In all of the plates of the school of Mantegna the space described is limited, as it is in bas-relief, but the sculptural effect of the cutting in metal is used to make the recession within this limited space concrete (Figs. 70, 71, and Master I. F. T.,

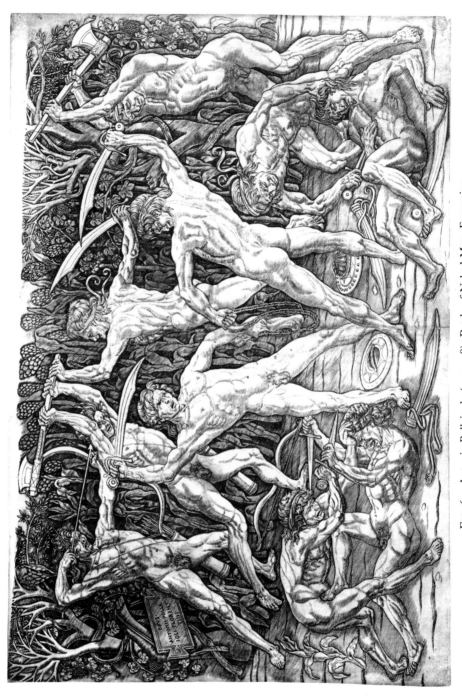

FIG. 69. Antonio Pollaiuolo (1429–98): Battle of Naked Men. Engraving.

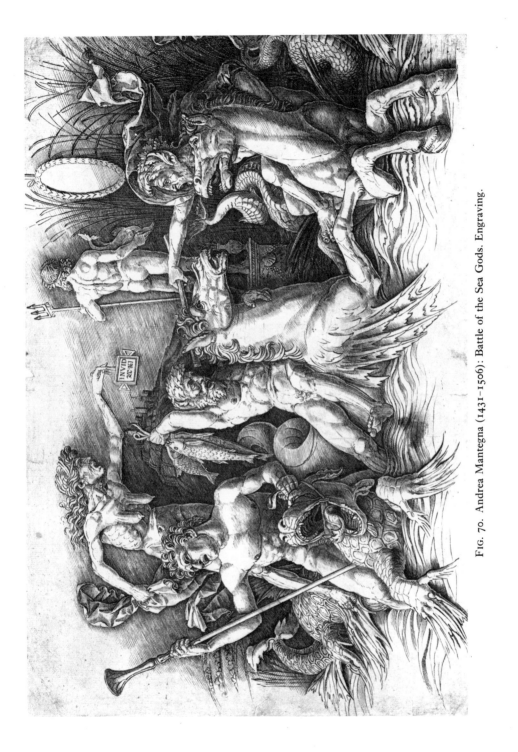

FIG. 70. Andrea Mantegna (1431-1506): Battle of the Sea Gods. Engraving.

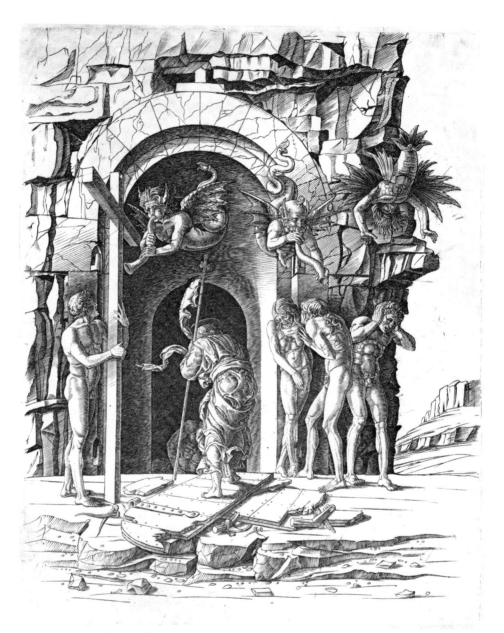

FIG. 71. School of Mantegna: Descent into Limbo. Engraving.

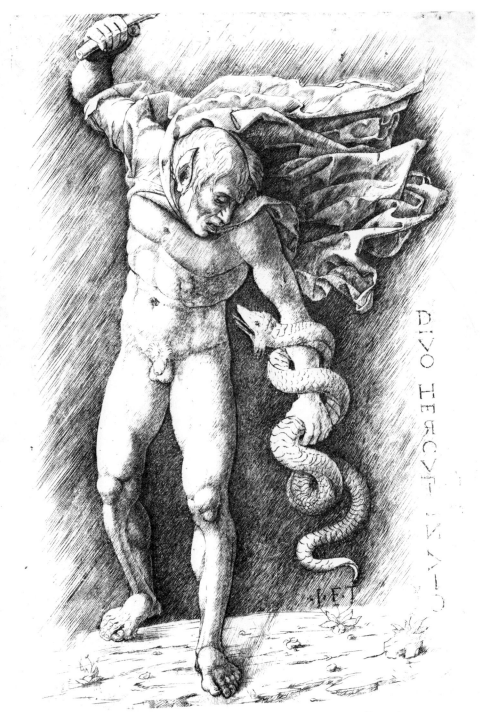

FIG. 72. Master I. F. T. (15th Century): Hercules and Hydra. Engraving.

Fig. 72). The modelling on the figures is arbitrary, and is not a matter of light and shade; progressive darkening follows the turning of a plane consistently and thus describes a volume rather than the effect of light on it. The effect is so powerful that even the definite lines which Mantegna uses to describe local modelling within the main volume do not destroy the magnificent weight and solidity of the figures.

In Germany, Martin Schongauer was followed by Albrecht Dürer (1471–1528), perhaps the most astonishing virtuoso of engraving. A great painter, he made woodcuts, probably executed by *Formschneider*, he engraved on copper, made dry points, and etched on iron. He knew Jacopo de' Barbari (1440?–?1516), the Venetian engraver; he visited Italy at least once, and copies by him of Mantegna drawings are known. Like many other very original artists he borrowed freely from his contemporaries, just as Rembrandt, Manet, and Picasso have done. But in his hands the point or the burin became different instruments from these same tools in the hands of the Italians. He is supposed to have acquired his preoccupation with proportion from de' Barbari, but in his copies of Mantegna there is more of Dürer than there is of his model. Where a strong simple fold appears in the original, Dürer cannot resist the temptation to torture the fabric into a few twisted tucks in the corners nor can he avoid the angular stiffness of the drapery (Fig. 73). His vision and conception of the plate is pictorial rather than sculptural; the massing of light and shade is not to be considered as inferior or superior to that of the Italians. It is merely completely different in aim and intention. His language is dramatic and graphic, but not plastic. In execution he employs every variation of cross-hatching, alternate dot and line, and lines of different weight to obtain texture, even to achieve an equivalent of colour. He rarely employs the violent accents in the cutting which are typical of Mantegna.

Dürer also made a number of etched plates (Fig. 74). The process must have been known as early as the thirteenth century, as armourers used to coat steel with wax, draw designs through it, and etch or corrode the trace with salt and vinegar. Printing from etched plates

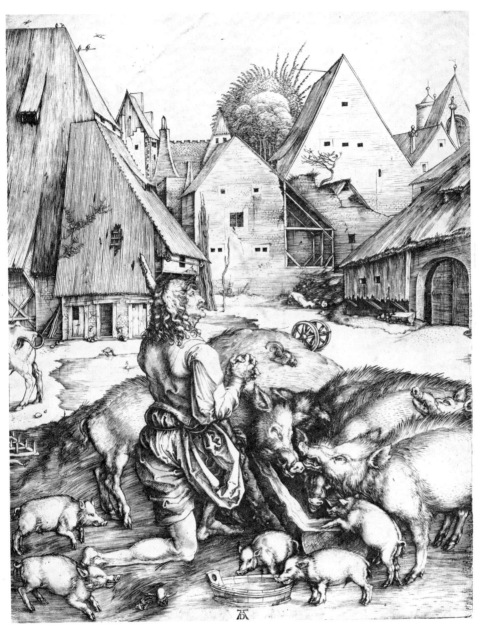

FIG. 73. Albrecht Dürer (1471-1528): The Prodigal Son. Engraving.

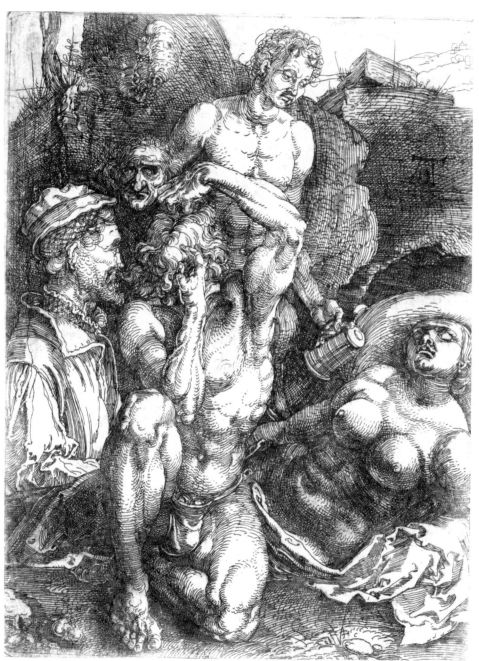

FIG. 74. Albrecht Dürer (1471-1528): Man in Despair. Etching.

does not seem to have been done until printing from engraved plates was common, and the process seems to have been regarded as a quicker, but less effective, way of repeating the effects of engraving. Although acids capable of etching copper were known in this period they do not seem to have been generally available, as all of the earlier plates were of iron, and the bitings were uniform, without variation of intensity.

Dürer travelled to many parts of Germany and to the Netherlands. His work was not only seen but copied in Italy. The technique of Giulio Campagnola (*c.* 1484–*c.* 1563) combines dotting and cross-hatching with the severe form of the school of Mantegna (Fig. 75). In the Netherlands Lucas van Leyden (1494–1533) was etching on copper and was probably the first to do so. In Switzerland Urs Graf (d. 1527) etched plates of iron. Daniel Hopfer (*fl.* 1493–1536) at the turn of the century made some of the earliest etched portraits. The process of engraving, first used by goldsmiths to decorate metal surfaces, was applied by great artists to original expression. But already engravers like Zoan Andrea of the school of Mantegna were using the method to reproduce the master's drawings, apparently without consulting the author. In fact, it is reported that Mantegna assailed Andrea and Simone de' Ardizzone in the streets of Mantua for one of those breaches of copyright, leaving them for dead.

The northern style, in which the free cut of the burin, that is the line obtained by swinging the plate against the cut of the tool, was deformed to render the calligraphic line which those masters sought, was beginning to find many imitators in Italy. As soon as the inherent quality of the work on metal was neglected in favour of pictorial representation the way was open for the conversion of an original medium of expression into a means of translation from originals into another medium. Original engraving had had less than a century of life, and, although it does not disappear entirely from this point, it was now the exception, and practitioners of original print-making in engraving were freaks.

Marcantonio Raimondi (1475?–?1534) was an engraver of extraordinary facility. He was not without considerable ability as an

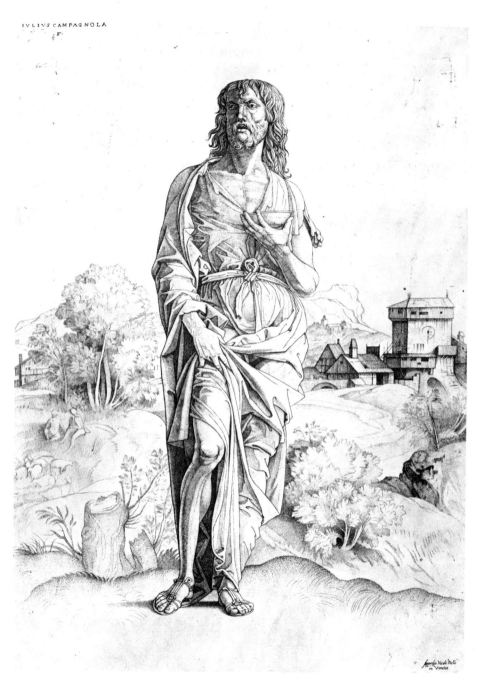

FIG. 75. Giulio Campagnola (c. 1484–c. 1563): St. John the Baptist. Engraving.

original artist, but he chose to reproduce the works of Raphael rather than his own. He had a power of acquiring techniques with such authority that they no longer belonged to his precursors. A comparison between the *Adam and Eve* of Dürer and the Raimondi plate of the same subject is interesting (Figs. 76, 77). His borrowing from Dürer is unmistakable even if we did not know that he had engraved copies on copper of Dürer's woodcuts, not omitting the monogram.

He was engaged by Raphael, who realized, with great business acumen, that the employment of such an engraver could be of enormous financial advantage. Together with others of the school of the engravers of Raphael, he engraved from the cartoons of his pictures under the direction of the master, who is supposed to have even corrected the outlines of certain of the figures. Later reproductions made by members of the school after the death of Raphael are so much inferior to those made under his direction that one realizes the importance of this factor. Raimondi, however, made many of his finest plates at this time. The perfection of these reproductions had so convinced the public of that epoch that young engravers found no incentive to revive a mode already abandoned and re-invent original expression in a medium already dedicated to the fame of the painter.

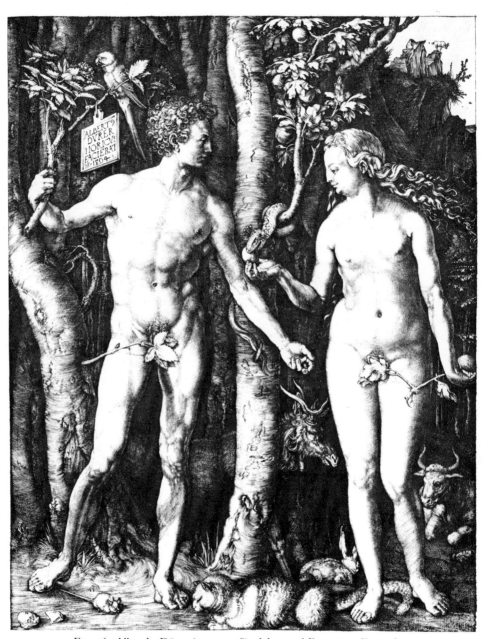

FIG. 76. Albrecht Dürer (1471-1528): Adam and Eve, 1504. Engraving.

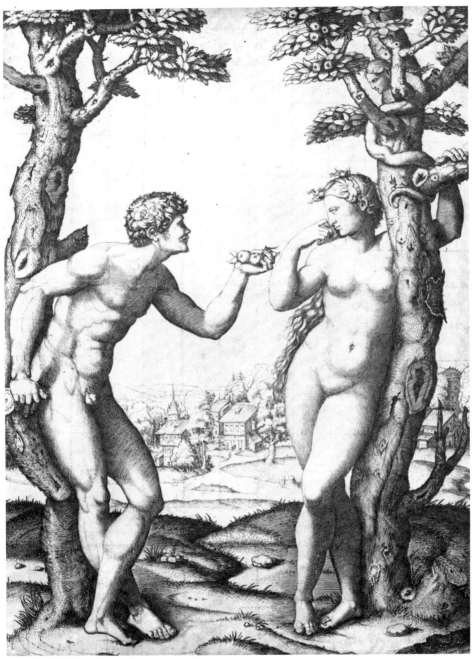

FIG. 77. Marcantonio Raimondi (1475?-?1534): Adam and Eve. Engraving.

14

CONVERSION OF GRAVURE TO REPRODUCTION

IN the consideration of the techniques developed or invented for the purpose of reproduction—for the imitation in prints made from plates of the effects proper to other media—I propose to include the study not only of the methods of those engravers, like Hendrik Goltzius (1558–1617) or Boetius Adam van Bolzwert (1580–1638) and his brother Schelte van Bolzwert (1581 ?–1659), whose work was chiefly reproduction of the originals of other artists, but also of those original artists whose methods were derived from the reproduction process, even though their use of them raised their work above the category of mere reproduction.

Most of the history of engraving from the seventeenth to the twentieth centuries falls into this category. Those exceptional artists who invented methods for original expression, even when, as in the case of William Blake, their work includes conventionally executed plates, will be referred to again in the following chapter devoted to the restoration of original expression in print-making.

In Flanders, directly following the school of the engravers of Raphael, the engravers of the school of Rubens, Lucas Vosterman (1595–c. 1675), and the Bolzwerts continued the translation of painting effects into engraving. The connexion between the schools was very intimate, as some of these men were trained in Italy by the school of Raphael. They developed imitative textures with interwoven engraved lines and dots further than the Italians, with the exception of Raimondi, whose technical virtuosity is hardly excelled until the time of Goltzius.

As we have already seen, the means by which engravings were made had become organized into the 'Schools of the Engravers of' this painter or that, but in Italy a new method of distribution appeared. A bookseller or a printseller would order prints or have prints made by various engravers. Il Baviera in Rome and, later, Hieronimus Cock in Antwerp had their stable of artists—often mere hacks—who produced works for the print-shop, generally from drawings made to order or purchased from the artists and published under the imprint of the dealer.

In France, Jean Duvet (1485-*c*. 1561), an isolated engraver, applied the characteristic methods of reproduction engraving to the representation of an Apocalyptic Vision (Fig. 78). Yet even an artist of his powerful vision could create nothing in the copper which could claim an independent existence. The mannerism in the use of parallel lines, somewhat similar to that of Jacopo de' Barbari, is not sufficient to remove his work from the interpretative category.

Francis I had imported Italian painters to make frescoes at his palace of Fontainebleau and some of these artists of the school of Raphael made engravings after their own paintings. The prints of the school of Fontainebleau, mostly by Italian hands, undoubtedly influenced later engravers in France.

The methods inherited from Raimondi and the school of Raphael were developed in France for purposes of portraiture by Claude Mellan (1598-1688), Michel Lasne (1590-1667), Antoine Masson (1636-1700), Robert Nanteuil (1623?-78), and others (Figs. 79, 80). Mellan employed a mechanical 'swelled line' to describe chiaroscuro with extraordinary fidelity; his *St. Veronica* is a single uninterrupted irregular spiral starting from the nose of the face and describing by its variations of thickness every variation of value. It is an achievement of penmanship rather than of engraving, as the copper never shows itself at any point.

The Renaissance influence seen in the rigidity of sculptured borders and décor in many of these portraits has a different function from that shown in the school of Mantegna. While the latter tried to re-create their classical model, the French engravers imitated, with great ingenuity, the surface of the object.

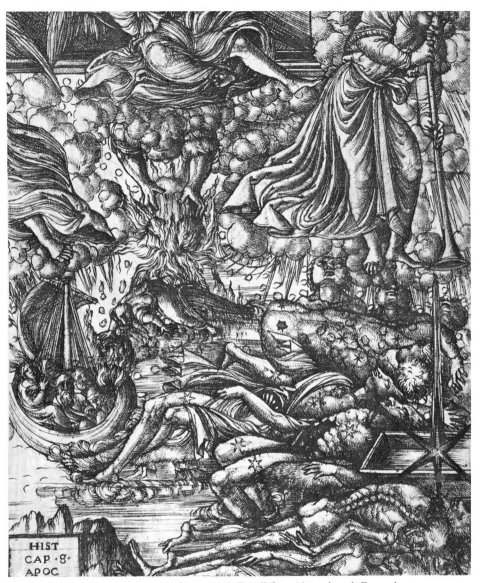

Fig. 78. Jean Duvet (1485–c. 1561): Detail from 'Apocalypse'. Engraving.

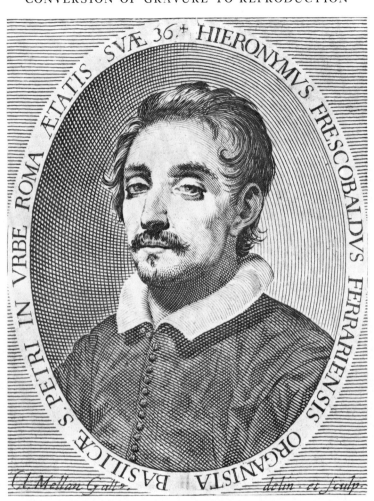

FIG. 79. Claude Mellan (1598–1688): Portrait of Girolamo Frescobaldi.
Engraving.

In England, engraving, on a basis of cruder drawing than the Italian, Flemish, or French examples, was firmly established in the sixteenth century. Rogers's portrait of Queen Elizabeth is attractive for its stiff *naïveté*, but technically it is no more than an unskilful attempt to reproduce the quality of a painting. The interest of such prints is chiefly documentary or historical. In them the function of

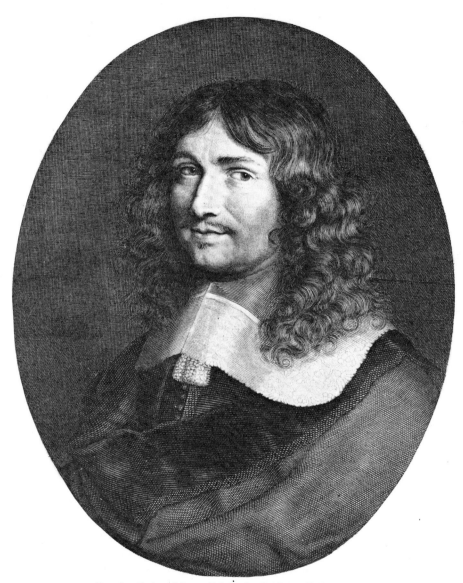

FIG. 80. Robert Nanteuil (1623?-78): Portrait. Engraving.

the technique is imitative and, when most successful, bears no trace of the copper on which it is executed.

Goltzius, in Flanders, perfected the weaving of the cross-hatched lines, the webs of alternate heavy and fine cuts, with dotting in the intervals of cross-hatched passages (Fig. 81). His ingenuity, however, serves to reproduce the surface of armour, of velvet, of flesh, of satin, and so on and never allows the metal of the goldsmith to be felt.

During this time, the art of etching, at first regarded as a rapid means of imitating the effects of engraving, had developed considerably, with copper taking the place of iron as stronger mordants became more generally available. Bitings, which had previously been uniform over the whole surface, were varied by stopping-out.

The seventeenth century found flourishing schools of gravure in France, the Netherlands, and England. Engraving was still called upon to represent the effects of painting, but in the reproduction of drawings even greater verisimilitude was required. Dotting by the use of a special tool (stipple) was developed by Francesco Bartolozzi (1725–1815), and although this method had been used by Domenico Campagnola it now became a mechanical process for the reproduction of the values of drawing (Fig. 82).

A step further in the accurate reproduction of texture and the quality of chalk and crayon was the 'crayon' method of Jean François (1717–67), in which small rollers with irregular surfaces were used to open dotted lines in a ground, the plate then being etched (Fig. 83). Printing from black and sanguine plates at this time simulated very exactly the sanguine and black drawings of Boucher, Watteau, and Lancret.

But even softer and more dense printed textures were sought, to imitate the effects of painting. These were found in aquatint, which appeared in the seventeenth century with Adriaen van de Velde (1636?–72) and others (Fig. 84), and, towards the end of the century, in mezzotint. Ludwig van Siegen (1609–after 1676) is now considered to have been the first to employ mezzotint, and Prince Rupert (1619–82) introduced it into England, where its soft dense tones were so much appreciated and employed that within a generation it became

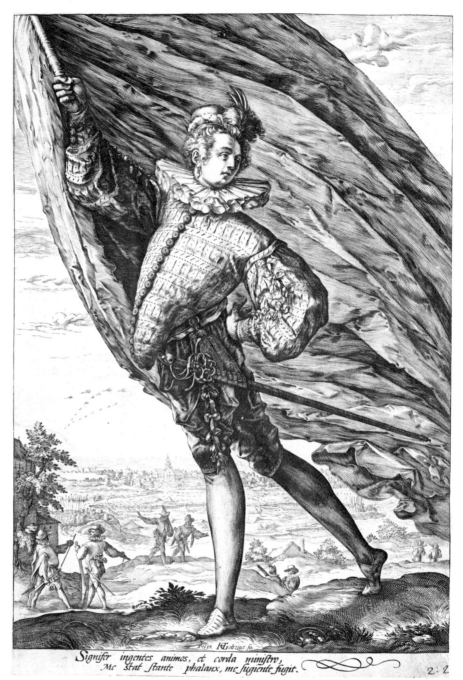

Signifer ingentes animos, et corda ministro,
Me stat stante phalanx, me fugiente fugit.

2.2

FIG. 81. Hendrik Goltzius (1558-1617): Standard Bearer. Engraving.

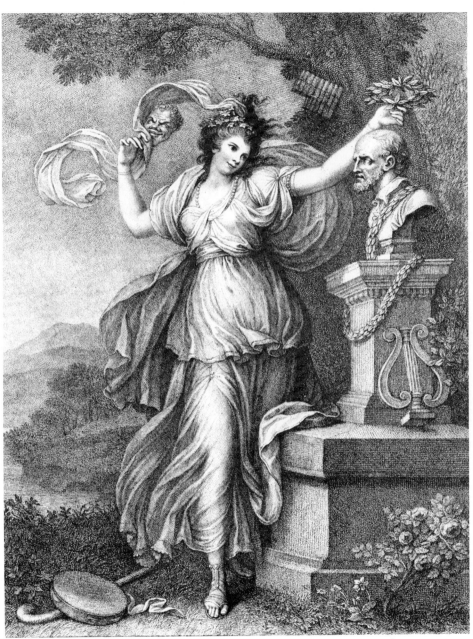

FIG. 82. Francesco Bartolozzi (1725–1815): Allegory. Stipple (Collection, Metropolitan Museum of Art, Dick Fund, 1917).

Fig. 83. Jean Charles François (1717–67): Allegory. Crayon Method.

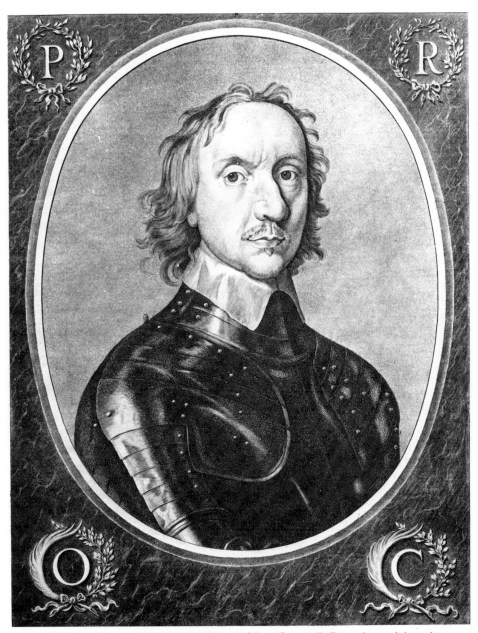

FIG. 84. Adriaen van de Velde (1636?-72): Oliver Cromwell. Engraving and Aquatint.

known as the 'English manner' (Fig. 85). Before the twentieth century, mezzotint was rarely used other than as a reproductive method; even those artists who employed it, George Stubbs, John Martin, and J. M. W. Turner in his few plates, looked upon it as a means of reproducing their drawings or paintings. (Martin, it should be noted, was one of the earliest users of soft-steel plates to allow him to print enormous editions of his works.)

Methods of translating colour into black and white values and finally of imitating even the brush strokes of painting were followed by the development of printing in colour from a series of plates, to reproduce all of the qualities of the painting. Jacques Christophe Le Blond (1670–1741), using stipple or crayon method on successively printed plates in colour, made prints which are extremely faithful. With the later application of colour aquatint to reproduction, the imitation of painted surfaces became almost as perfect as with the later photographic methods and in some cases was perhaps even more accurate.

By the eighteenth century the rules of expression by means of engraving had become completely codified. There was so little incentive to explore the expressive means of the medium that an engraver such as William Hogarth, whose first known work, executed in his teens, was an engraver's card informing clients that he would undertake engraving for gentlemen, when prosperous enough to employ hacks, commissioned them to engrave from his designs.

The nineteenth century saw the development of machine ruling, the invention of a burin with a turned-back point like an adze, intended to cut when pulled instead of driven, and of enormous steel plates in which engraving, etching, and stipple or mezzotint were combined to arrive at a facsimile reproduction of a painting by a popular artist. Such plates, executed on soft steel and later case-hardened, could be printed in editions of thousands of copies. Another method, which also became common during the century, was the 'steel-facing' of copper plates, by electrolytically depositing iron, and later nickel or chromium, on the surface, a process that gave the same resistance to wear in printing that the steel plate

FIG. 85. Prince Rupert (1619–82): Head of the Executioner. Mezzotint.

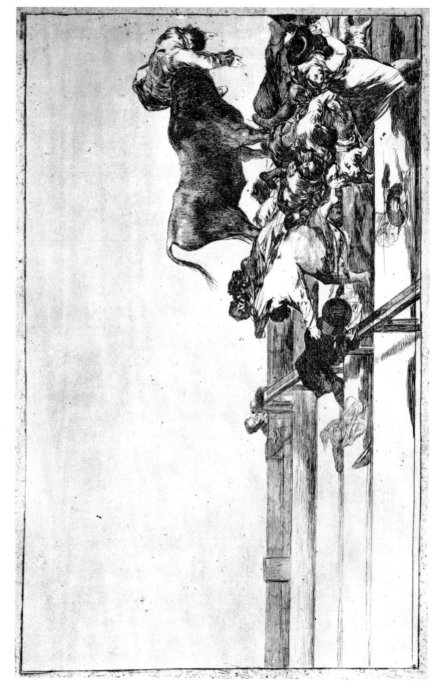

Fig. 86. Francisco Goya (1746-1828): Tauromachia. Etching and Aquatint.

possessed, but enabled the engraver to work in the softer and more sympathetic metal.

Yet, in this period, we find Goya using aquatint in a broader and more expressive fashion than the engravers of the previous century, showing what such a medium can become in the hands of an artist (Fig. 86). When I handled his plates in Madrid in 1937, they were in remarkably good condition. Steel-facing had protected them in spite of the numerous editions printed after the death of Goya. At this time a final and beautifully printed edition of some 500 plates was being made by Ruperes, one of the greatest printers I have known. (It is curious to note that Goya's plates are stamped with the mark of Wm. and Maxwell Pontifex of Longacre in London, the firm whose plates were also used by William Blake.)

15

RENEWAL AND NEW WAYS

AMONG the artists who made use of the means of reproduction but who also felt the need to go beyond that, there were five who are in some manner forerunners of the modern revival of the arts of engraving and etching. They are, as I have already indicated, freaks in their different generations: Hercules Seghers (1590-1640/5), who was apparently little esteemed in his own time, Jacques Callot (1592-1635), Rembrandt (1606-69), who is generally regarded as the greatest master of etching, Piranesi (1720-78), who was a fairly successful artisan, and William Blake (1757-1827), the poet who had comparatively little success in the England of his day.

Seghers (Fig. 87) worked with acids on curious grounds of his own invention, and may well have been trying to remake a sort of painting. A texture similar to that of many of his prints can be obtained by exposing a bitten plate for a short time to acid without any ground; the curious mottled line in another plate, by rubbing a thin film of oil over the needled plate when, owing to this film breaking down irregularly under the acid, the ground itself being weakened, the line spreads somewhat as a pen line does on wet paper. He printed in colours, sometimes in relief, in white ink on dark paper, and on canvas (Fig. 55). Though many of the prints could have been printed over paper previously coloured with watercolour and others could have been retouched with colour after printing, I do believe, in certain examples where the colour varies very exactly with the form yet is clearly under the line, that he anticipated the simultaneous intaglio and relief colour method used by Atelier 17. His well-known *Tobias and the Angel* plate, in itself the reproduction of a painting, was

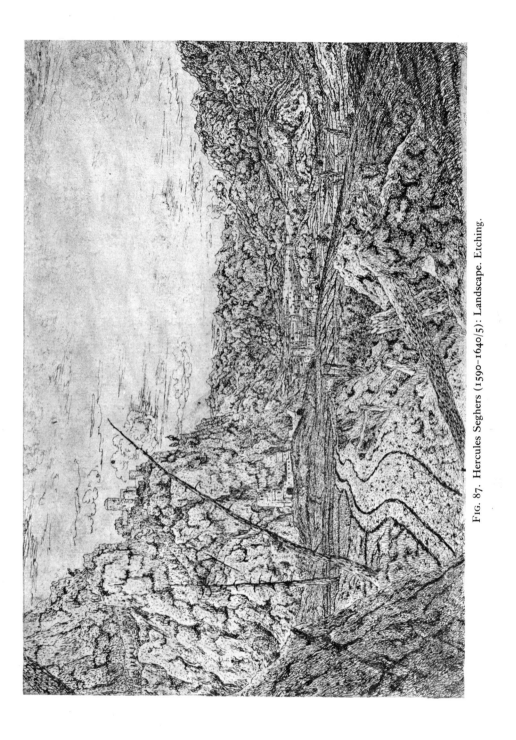

FIG. 87. Hercules Seghers (1590–1640/5): Landscape. Etching.

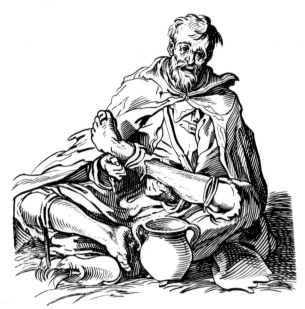

FIG. 88. Jacques Callot (1592–1635): A Suffering Beggar
Seated. Etching.

re-worked by Rembrandt, who transformed the quality and scale
of the whole composition.

Jacques Callot (Fig. 88), using the characteristic reproduction
methods of engraving of his time, but with fantastic wrongheaded-
ness, made his plates by etching. With the echoppe (Fig. 4D), a needle
with the point cut off at an angle to give an oval cutting edge, he could
cut a line through a ground which has the characteristic swelling
quality of a burin line. This quite illogical proceeding gives a curious
accent to his drawing which could not, however, have been obtained
with the burin.

Rembrandt (Fig. 89), in his most characteristic plates, uses the free
stroke of the point purely in the sense of drawing, but with an intensity
that few drawings ever attain and a power of description perhaps
never equalled in the medium. The masses of dry point which focus
light on a few salient points in later states of some of his plates seem
like the arbitrary adoption of a convention of painting and, as we

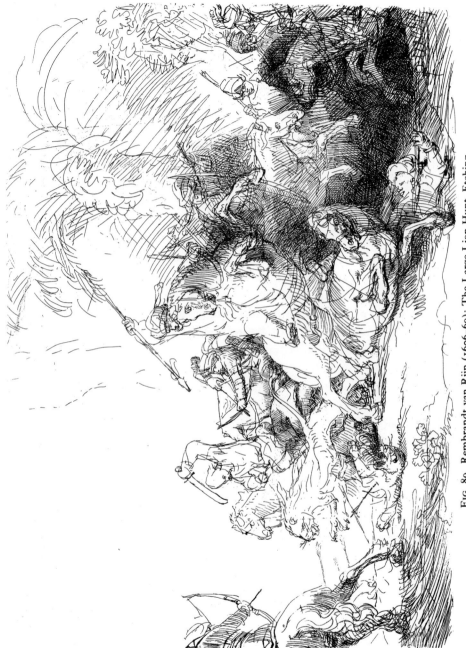

FIG. 89. Rembrandt van Rijn (1606–69): The Large Lion Hunt. Etching.

gather from accounts of the time, he applied them somewhat against his better judgement. His technical virtuosity has lamentably influenced a school of etchers, who see art merely as an exhibition of skill.

Piranesi (Fig. 90), in his later years, was an efficient engraver of archaeological and numismatic illustrations and the greatest part of his work is of this character. But as a young man he made the famous series of *Carceri*, imaginary architectural scenes in which the means of etching create a viable space in defiance of logic, and in which the imagination builds concrete spaces which it would be impossible to realize in painting.

William Blake (Fig. 91), while still almost a child, was trained in the mechanical methods of the Italian reproduction engravers; at a time when he had as yet no identity as an artist to defend, these methods of describing flesh, terrain, clouds, and water were firmly imposed upon him. In spite of a boundless imagination exceeding that of any of his contemporaries, and indisputable courage in the use of the burin, he was never able to escape the discipline—though, in some parts of the great unsuccessful *Canterbury Pilgrims*, his attempts to do so are obvious. He was finally led to reverse the whole process of etching, drawing in acid-resistant varnish on plates and etching away for relief printing (Fig. 92). His methods of printing these plates have been explained in Chapter 9. He was almost destroyed by the bad taste and hostility of the England of his day, and those who might have employed him preferred the work of the dullest of Italian hacks, like Louis Schiavonetti, as do certain collectors of the present day.

The conditions for a renewal of the arts of etching and engraving as media of original expression emerged as soon as the public demand for the work of reproduction engravers had disappeared with the introduction of photomechanical methods. Yet this in itself would not have been sufficient had the movement of the art of graphic expression not made an insistent demand for these means.

Towards the end of the nineteenth century a transformation was taking place which affected not only the modes of expression used by artists, but also the relationship between the artist and his work, and

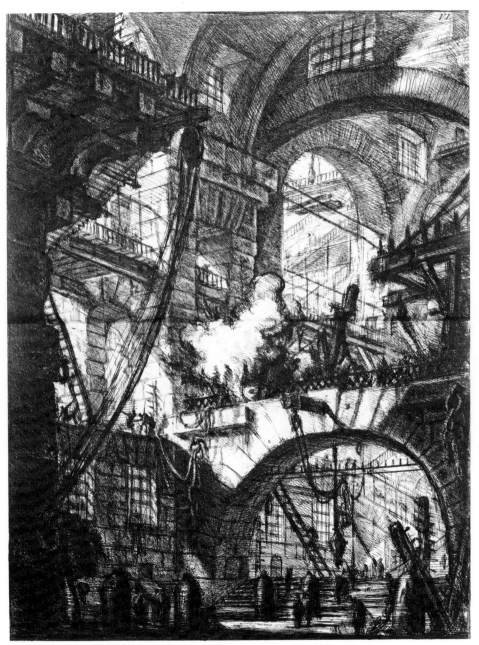

FIG. 90. Giambattista Piranesi (1720-78): Gli Carceri. Etching.

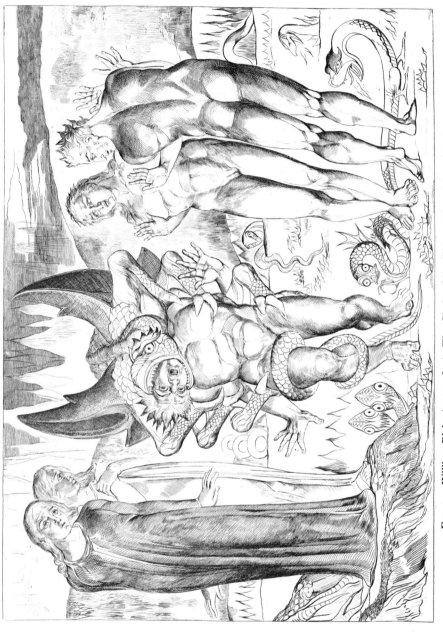

FIG. 91. William Blake (1757–1827): The Circle of the Thieves (from Dante's *Inferno*). Engraving, Trial Proof. The work still to be done is outlined in Dry Point.

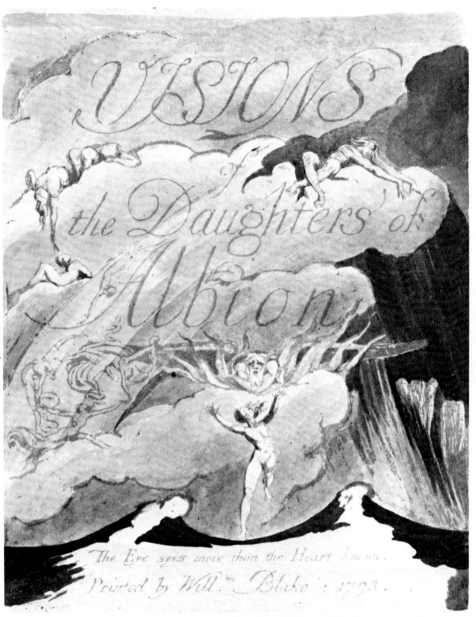

FIG. 92. William Blake (1757-1827): Title Page from *Visions of the Daughters of Albion*.
Relief Etching.

that between the work itself and the public. This change was of course dictated by a change in the conditions of living, in the relations between individuals, and in man's mental attitude to the phenomenal world. In part these shifts were due to the social changes brought about by the enormous advances in the study of natural science and their application to every moment of the individual's life.

A considerable number of people will always resent change and will frequently oppose to changed conditions a stubborn determination to ignore them. There are artists who speak for these people, just as there are artists who speak for any other minority in a community. For these artists, new means of expression have very little value, and the existing means will always prove adequate.

A valid revival of the arts of engraving could spring only from strictly contemporary artists, whose relation to the real thought of their time was as intimate as it has always been with the old masters, though it may be that they were estranged from the opinion of a public which had been kept in ignorance and fear. It was therefore to be expected that, at about the beginning of the twentieth century, a false revival would appear, more particularly in countries where the principle of reality was held in small honour by artists trying to live in another age, possibly in a golden age that never was. So in England, America, and France, as well as in other countries, a variety of 'original' print-making appears, with the purpose of representing, by the methods of drawing, scenes and objects already within the grasp of the photographer, but coloured with the atmosphere of Rembrandt, or, in some of the wittier examples, of Piranesi and of Méryon (1821-68, Fig. 93). It seems hardly necessary to insist that this atmosphere is no more convincing than a cloak-and-sword at a fancy-dress ball, but there was no lack of support for it, as there will always be enough people who are sufficiently disgusted with everyday reality to take refuge even in a fancy-dress ball.

A group in England, realizing some of the neglected possibilities of the burin, staged a sort of belated Pre-Raphaelite movement. A number of very creditable Schongauers and Dürers were produced by members of the group, some of whom arrived at a competence

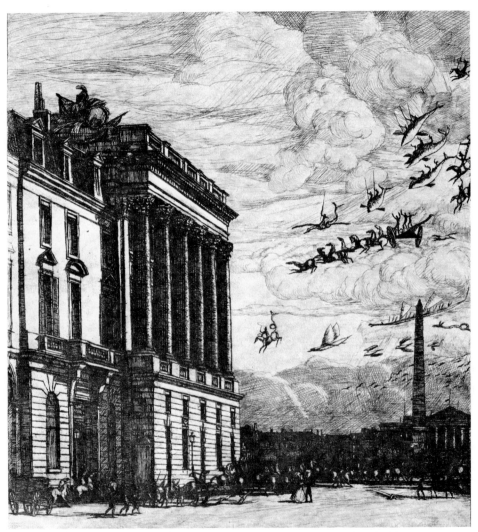

FIG. 93. Charles Méryon (1821–68): Le Ministère de la Marine. Etching.

of execution almost worthy of their models. However, the world of Dürer and Schongauer is not ours and such works, in my opinion, lack the first essential quality of valid art, an adequate motive.

The means by which modern artists arrived at a new use of the plate media are illustrated in the career of Jacques Villon (1875-1963), in my opinion one of the unacknowledged fathers of modern print-making. Before 1900 Villon was making colour aquatints of fashion-able subjects which owed perhaps something to Toulouse-Lautrec, but his use of the medium was still solely reproductive. Later, how-ever, as he was affected by the wave of Fauvism and Cubism (the realization of the initiative of Seurat and Cézanne), he started as early as 1910 to use interwoven webs of line to construct a cubist space (Fig. 94). Although during this time and for twenty years more he was employed in making some of the most accurate aquatint reproductions in colour from the works of Picasso and others, yet, in his own work, he used the medium to construct the sort of space in which artists now operate, a very different space from that seen through the classical window of Renaissance representation.

At about the same time Joseph Hecht (1891-1951), a Polish en-graver who finally settled down to work in Paris after passing through Warsaw, Berlin, and Norway, had laid the foundations for the re-newal of the use of engraving as a creative medium. Although, like Villon, he had learned the use of his tools from conventional repro-duction engravers, he commenced to analyse the action of cutting with a burin into copper, and to construct from the most elementary and simple strokes of the tool an image which should have a discrete existence of its own, not merely a vicarious existence in terms of its dependence upon some third object. At the same time he possessed an extreme sensitivity to all the qualities of a line—rigidity, flexibility, resilience—and saw the character of life in the line itself, not the description of life by means of the line. An examination of the prints of Hecht reproduced will show that there is not a limp or dead line in them (Figs. 6, 21, 97, 109, 115).

Jean Laboureur (1877-1943) was working at the same time in France, using the same tool, although with different results (Fig. 95).

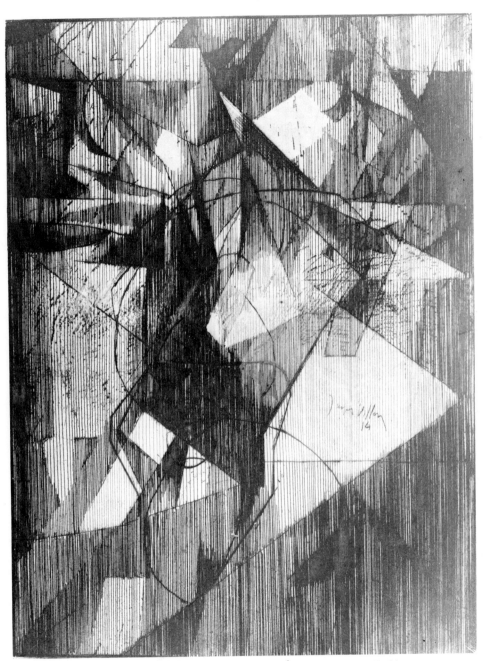

FIG. 94. Jacques Villon (1875–1963): Petit Équilibriste, 1914. Etching.

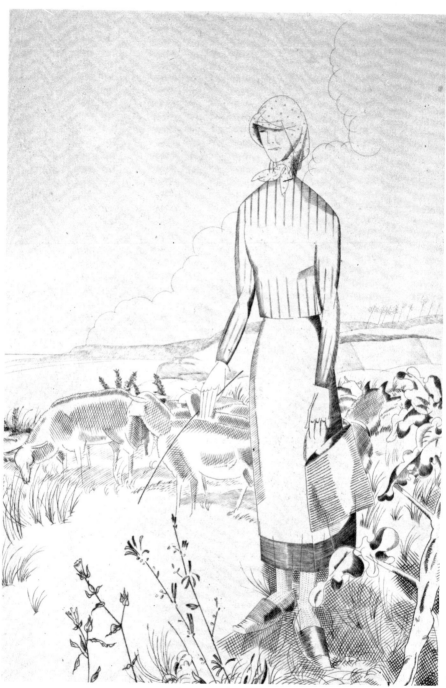

FIG. 95. Jean Laboureur (1877-1943): La Grande Bergère, 1926. Engraving.

Unable to escape entirely from the mechanical quality of reproduction engraving, he did offer an image in other terms than the English school. His successors, Louis Joseph Soulas (b. 1905) and, recently, Pierre Courtin (b. 1921), although still overpowered by the discipline of *hachures*, have made interesting works.

Picasso had been working over the same period in a large number of techniques, from the dry points of about 1900 to experiments with bitten line aquatint, line through cracking grounds, and burin engraving in the cubist period. Later, when printing himself, he experimented with colour superimposed on a sheet before taking the impression (Figs. 20, 27, 40). Although Paul Klee made few plates, they are all curious applications of etching (Fig. 107), as one would expect from his research in texture of paint and ink.

When I met Hecht in 1926 I was very strongly impressed with the latent possibilities of his manner of using a burin and later, realizing the necessity of collective work in a group in order to develop these and other possibilities, I set up a workshop where all equipment was available for artists who wished to work in those media. From drypoint and burin line, aquatint, soft-ground etching used in the conventional fashion, members of the group (later known as Atelier 17) began to elaborate the methods described in the earlier part of this book. Printing on plaster was done from about 1930, Serge Brignoni, Nina Negri, and John Ferren doing interesting work in this method. About 1933, it started to become clear that the use of the vivid line of the burin for the mechanical production of values in a plate was illogical, and the first impressions of textures on soft ground were made to produce a neutral surface when needed. The collage method of assembling different textures on a plate was employed brilliantly by Max Ernst and later other uses of the method were found.

The hollowing of the plate to print white relief was suggested by nineteenth-century Japanese woodcuts and was first used by us in 1933. Experimentation in colour printing from a single plate by simultaneous relief and intaglio was started about 1931 and is still being developed.

The printing of metal cuts in relief for illustration was done in the

Fig. 96. Anthony Gross: La Mer, 1935. Etching.

Fig. 97. Joseph Hecht (1891–1951) and S. W. Hayter (born 1901): La Noyée, 1946. Engraving.

early 'thirties, the method being an application of that practised by
William Blake. The plates were engraved or etched and later mounted
type-high on wooden blocks, set up and printed along with the type.
The method lends itself to illustration even on the most popular scale,
as the cost to the publisher need not be greater than that of ordinary
typography. Ian Hugo has illustrated several books by this means
and two books of poems by Georges Hugnet, published under the
most difficult circumstances in Paris during the German occupation,
Non Vouloir, 1942, and *La Chèvre-Feuille*, 1943, were illustrated by
Picasso using similar means (Fig. 98). The Picasso prints, however,
were done by an extremely rapid method: an ink drawing was repro-
duced as a half-tone block, and then burin cuts (which print white)
were made through the black masses represented by the original
plate surface.

FIG. 98. Pablo Picasso (born 1881): Illustration for Georges Hugnet's *La Chèvre-Feuille*, 1943. Engraving (Collection, Museum of Modern Art, New York).

16

METHODS OF TEACHING IN ATELIER 17

It must be clear from the technical section of this book that our general approach to the problems of plate-making is experimental and it may be of interest to describe how this attitude has been extended to teaching. The method we have evolved to introduce new-comers to this subject, unlike the usual system of precept, has been to involve the artist in an experiment which, although controlled, can be expected to lead to unforeseen situations. Such experiments have been in use in Atelier 17 since the late 'thirties, but have over this time been changed and elaborated. Starting from an arbitrary position, action is continued in consecutive stages, at first rational but later becoming intuitive, in the absence of a concrete project, and further continued to the destruction or physical exhaustion of the plate. The reason for this is that a plan can only be made of what is already known, but an experiment of this type can lead to matters completely unknown. The experiment now to be described must have been carried out by a thousand different artists at least, yet no two of the series have been alike, and the 'success' of the artist in discovering new means has varied from very few items to a very large number. To formulate the conditions of this sort of experiment, a point of departure had to be found which would offer almost in-definite possibilities of development and a principle which would determine the consequence between one stage and the next. Although the position of departure might be completely arbitrary, the principle on which the best results could be obtained would need to be a sort of organic consequence, real and not invented, such that while the beginner was becoming familiar with the operations on the plate,

some real transformation of the image would take place. The most convenient initial stage was found to be a line structure and the principle controlling the development by transformation that relation between forms which we have called counterpoint.

To make this clearer I shall describe the experiment as it is normally applied to the initiation of a newcomer to Atelier 17. It is often necessary in the first place to present the idea of an action undertaken experimentally without any intention of producing a work of art, as many of our associates have had no previous experience of such action. It is also sometimes necessary to point out that vague uncontrollable action on a plate is not an experiment in our sense, as the result, if any, can be neither understood nor repeated. It is sometimes difficult to present the idea of a more or less anonymous operation without a plan and having no end except to expose the subject to the possibility of discovery. This is the possibility of a real discovery, a discovery of things unknown to us and often different from the discoveries of others in similar circumstances. It is indeed my practice to warn newcomers not to believe what I tell them for the obvious reason that, if I know something, they cannot know it simply by hearing me say it. It is the subject's own knowledge which is being sought for and this can arise only from his own experience, as mine cannot be transmitted to him.

A zinc plate is prepared with soft ground as described in Chapter 4 and the newcomer is invited to make a line structure on it, using a pencil, a stub of wood, or any other instrument which does not scratch the metal. Zinc is used because it is cheaper and works faster. To obtain a satisfactory structure, the operation may need to be repeated several times, the plate being re-prepared each time. 'Structure', for our purpose, means strictly a line system, extending from edge to edge of the plate so that all of the available space is involved, in which the lines, of two different thicknesses, may represent rods, beams, cables, but never outlines, closed spaces, objects, textures, or light and shade. The object of this is to set up a skeleton or scaffolding which appears to extend beyond the plate, but leaves the potential space open for subsequent development. At this point it is desirable

that the character of the structure should be unlike the normal gesture of the artist in drawing, as this tends to provoke an unfamiliar situation in which discovery is more likely to occur than in a normal circumstance.

As soon as an adequate structure has been realized, the plate is examined in a mirror. Either from the structure itself, if sufficiently asymmetric, or from diagrams made for the purpose, the beginner is invited to verify that his eye has a tendency to follow a diagonal from south-west to north-east in the ascending direction, but that a diagonal from north-west to south-east will be followed in a descending direction. It will be pointed out that this is a normal movement of the eye which surveys a field from left to right and not from right to left. In most languages the words right, rechts, droit, dextra . . . all connote rightness, justice, goodness even, whereas left, links, gauche, sinistra . . . signify wrong, clumsy, awkward, adverse. From a semantic point of view this signifies that there is a conviction in the minds of those who use these words that a right and wrong direction is involved. However, in regarding an image we are not immediately impressed by the feeling of these two directions, whereas the sense of an image rising or falling implied in the diagonal has a very powerful psychological effect.

It is then pointed out that all work done on a plate will appear on a print as its mirror image, and in this mirror image both of these directions are wrong. Here it is interesting to invite the newcomer to try by rotating the plate to attempt to correct the inversion which he sees in the mirror. At the same time he may also consider the number of possible inversions of an image, of which he probably sees one only, although six are possible. It is important that the ideas thus suggested to him be verified by his own action, and that further implications which might occur to him be investigated. A position slightly to the left and below the centre of the plate (generally shown by an unconscious concentration in the beginner's structure) is then marked and in most cases is seen to be a focus of attention. When the image is inverted in the mirror, this focus can be seen to have shifted from what was right on the plate to what is left in the mirror image.

Whereas the rising and falling directions of the diagonals seem to be constant in all circumstances, this point of focus, which represents the point of rest of the eye in an empty rectangle, can only be observed in the absence of any strong deformation of the field.

These findings were the result of experiments undertaken with the advice of Professor Wertheimer in the early 'forties when I was a member with him of the Faculty of the New School for Social Research in New York. Our interest in this matter obviously arose from the conditions of print-making, in which we were always working with mirror images. No mathematical explanation for these findings was available at that time, but subsequent work on a possible fundamental asymmetry of time/space has been quite suggestive.

Once an adequate line structure that appears more interesting in the mirror image has been established on a soft ground a second line structure is drawn through it with a stopping varnish (Chapter 4). This will show, when the plate is bitten, as a white structure passing through the black structure which has been drawn into the ground. This black structure shows a definite third dimension, as each line is isolated from that earlier line that it crosses, while the white structure, which is only seen where it interrupts the black structure, though to the eye it will appear connected up throughout, will have no depth. The back of the plate is then covered, with extreme care, using the same colourless varnish. The plate is bitten in ten per cent. nitric acid until, against the reflection of light from its surface, all lines are seen to be black. All ground and varnish are removed from the plate with a solvent and the plate is inked and printed. This will be the First State.

A new soft ground is laid on the plate filling all earlier work. The plate is placed on the bed of the press, a texture laid over it and over this a sheet of waxed paper, and the whole is passed through the press with a light pressure (to avoid re-setting the press two old blankets often replace the four generally used for printing). When the texture is lifted its trace should be seen clearly over the whole surface. Again with the use of the colourless stopping varnish, a few forms are left open, the rest of the surface being covered.

At this point it must be explained that the design of these forms should follow a certain system which we have called 'counterpoint'. This is a simple mechanical consequence (see diagram, Fig. 99, showing the consequences of an ellipse) which the beginner is invited to study. It seems quite necessary at this point to show that this is a relation which exists in nature and can quite readily be observed; it is not artificial or of our invention. If one observes a simple object, its own form is first seen. Almost simultaneously one becomes conscious of the form of the background; and as one continues to study the object other forms appear, as if in the air, passing out of the background and through the object. Whenever two such counterpoint forms are superimposed a third image is seen which is not present in either one of the original forms. Once this effect had been observed it was seen to be an ideal link between the consecutive stages of the sort of development we proposed.

Thus a few forms in counterpoint to the line structure are left open on the plate, the back is re–covered, and the plate bitten. In order not to sacrifice too much of the surface it is wise to leave open no more than one-third of the plate. The plate is then cleaned and a print made; this constituting a Second State. The operation is repeated with different textures and different types of form which can easily be found within the possible counterpoints of the original structure. The purpose of each step is to bring about the greatest possible transformation of the whole image with the fewest and simplest forms. However, after four or five stages it will become very difficult to find adequate counterpoints, and here we introduce by means of an experiment another variety of counterpoint.

The artist is advised to take at least a dozen sheets of thin paper all of the same size (air mail letter paper, for example) and placing one sheet after another in front of him to make, without any particular thought and literally without changing his mind, a series of linear designs, one on each sheet. He will not stop at some point, observe some form that has arisen, and consciously repeat or amplify it, nor will he wilfully interrupt the succession to introduce an extraneous form. When a sufficient number of arabesques has accumulated, he will

FIG. 99. Mechanical Counterpoint.

take at random groups of three or four sheets and placing them care-
fully together so that their edges fit examine them against a window
or over a light. Our object is to permit the artist to prove to himself
that there is some operative cause connecting all of these drawings.
With this in view he is invited to look for a number of different effects
that we have found to occur in these conditions, while he is warned

that not all or any one of them is certain to be found. Very frequently each group inspected shows a similar structure which cannot be identified in any one of the drawings. Furthermore, three or more lines may intersect, not to within half a millimetre, but with such precision that a needle could be passed through them all at the point of intersection; a precision greater than that which could be realized with measuring instruments. A third sort of effect to be seen in the different layers is the mechanical counterpoint already described, with its inversions and consequent successions. Analysing these results mathematically, we could say that if one such effect only has been observed it can be a hazard, if two are found it may be no more than a coincidence; three, however, would imply a very strong coincidence, and four would demonstrate a cause beyond the laws of chance. This idea of unconscious counterpoint has been familiar to us for more than twenty-five years, but, although it can be shown to exist in almost any artist's drawings, we have found very few who have studied it consciously. To us the necessity for this study lies in the fact that, when one has acquired complete confidence in it, it can be employed without hesitation or restraint, its great value at this stage being to avoid a position in the development of a drawing where there appears to be nothing more to be done. It does not, however, provide a ready solution for all problems, as it confronts one with an enormous number of consequences among which to choose. However, the problems involved in too great a wealth of image seem to us preferable to those of poverty of image.

To return to the original experiment, the plate by this time will show the original structures and a number of overlapping forms in texture giving a position of a certain complexity. Once the idea of unconscious counterpoint has been clearly identified, use can be made of it at this point for the purpose of finding new forms. Keeping his attention on the print the beginner allows a pencil to move freely on a sheet of paper placed at one side. The trace made in this way is seen to be an irrational counterpoint to all those forms already present in the plate. It is then possible to select among the forms in the draw-ing those which appear likely to have the strongest effect on the image.

5. Sergio Gonzalez Tornero: Chaja, 1960.

The accumulation of textures is pursued until such a degree of confusion is reached that any definite action becomes impossible. The next stage will consist of ruthless elimination with opaque black obtained by means of aquatint; whereas the successive operations in texture remain transparent, all earlier work being sealed up by the soft ground, in aquatint some of the earlier work is destroyed by acid as the plate is bitten. At the same time the space represented by the image on the plate is to be inverted; that is to say it will be seen as white (or greys) on black instead of black on white as it has been up to this point. If more than half of the plate is obliterated with black this inversion is almost sure to occur; if, however, the black forms can be designed so that the inversion is obtained with no more than ten per cent. of black, the effect is much more striking. The problem of designing these blacks is a very serious one; and there are two ways of attacking it. The plate having been prepared with a resin grain (see Chapter 5), those forms which are now to appear in front are protected with colourless varnish, the spaces between becoming black. The doing of this instinctively is what we hope to realize. However, as most people have great difficulty in doing it the different principles involved need to be clearly explained. In the diagram, Fig. 100, the operation marked 1, in placing two black forms against a corner, establishes that black functions as space and not as object. The second series of operations shown has the effect of attaching those salient blacks already present to the new black space elements. Thirdly, the condition for the success of this operation is that all of the black spaces should have an interior continuity, so that the light elements in the plate will appear to float upon a continuous black space. This does not necessarily mean that all of the black forms are actually attached to one another. The black lines in the original structure are one of the difficult elements to invert, the problem being to convert what appears to be a rod or bar into a space which will be seen as a crack. The diagram shows one simple means of doing it.

The last operation on this plate involves an even more complete transformation of the space. One or two large masses within the plate (not touching the edges) are covered with black varnish and the remainder of the plate is bitten away to a perceptible depth. When

BLACK ON WHITE

WHITE ON BLACK

FIG. 100. Black and White.

printed, this last state of the plate shows the background etched away as an indefinite space in which the one or two elements of the previous state (which were protected by the varnish) seem to float. It can then be seen that a second complete inversion has taken place in the figured space, yet the result does not return to the situation before the black/white inversion. The deep etched form can generally be shown to have the ambiguity referred to in Chapter 5, i.e. some part of it can be masked off from the remainder of the print so that it is seen as object in front of the plane of the plate: yet without interruption it connects with another part which is seen as space. This demonstrates a concrete curvature of the figured space passing through the original plane of the print. Thus some points should be found to lie in both spaces: however, observation will show that no such points exist. It then becomes clear that we have before us two different orders of space which do not have co-ordinates in common.

The last operations are to print from the plate first with intaglio black and one warm colour applied with the hard roller and then with a cold colour. It is then seen that of the two alternative positions possible in a black-and-white print, the most obvious one is confirmed by the warm colour, which causes that element to come forward. The use of a cold colour (against a background which then appears colder) has a tendency to invert this space, as the surface carrying it appears to recede. It may even be possible to demonstrate a third labile situation in which an alternation of the position produces a rhythmic flickering in the image.

When all work on the experimental plate is finished the complete series of states is pinned up on a wall and analysed in detail with the newcomer. The specific character of the space of the print is pointed out and at some stage it may be possible to distinguish that operation, or that series of operations, that excites the curiosity of the person. It is then proposed that he undertake immediately another plate in which this matter alone is to be pursued; this time with a minimum of means in view of a concrete result. This has been found to be most essential to avoid the implicit conclusion that the operations of the experiment constitute an effective means of creation, whereas in reality they are only means of destroying an effective image.

IMPLICATIONS OF GRAVURE
AS A SPECIFIC MEDIUM

17

THEORY OF LINE

Expression of space

AT one time it was customary to place spheres of mirror glass in the cages of birds, perhaps with the idea that looking into them would give the bird an illusion of unbounded space and liberty. When one looks into such a mirror, after an instant's adjustment, the sensation is rather that of looking outward than inward, into a space which, though showing increasing spherical aberration towards its limits, seems very similar to external space. One very obvious difference, however, is the distorted image of the observer in the centre—in the habitual concept of space the observer is not present. In other words the distinction between that part of space occupied by the observer and the 'phenomenal world' around him is momentarily lost—at the expense of some degree of distortion. Although the space perceived is almost identical with external, egocentric space, the observer may for the moment have the illusion of being able to navigate in it outside of his own body, or with it even interpenetrating his own body.

By reason of these two details—the loss of distinction between the outward and inward direction, and the completeness of the image (the observer being included together with the space observed)—the spherical mirror seems to me an excellent point of departure for consideration of the space of the imagination and of its description by means of line.

The complexity of the human concept of space is demonstrated by the number of equivalent words that have had to be invented in all languages to characterize different aspects and functions of this idea. Physical space, that external space which is experienced directly

through the senses, is complex enough. The senses of sight, touch, and, to some extent, hearing are involved in its exploration; and one characteristic of the manner in which it is experienced immediately appears: without motion, in the sense of physical displacement in the medium, the experience of space is incomplete. Thus the recognition of space can be assimilated in this respect to movement itself— to the primary function of life. In the visual recognition of space from the scientific point of view it is found that where the dimensions of the space are not enormously greater than those of the observer a very slight change of position is sufficient to verify the relative distance of objects in space (a movement of the head, even a difference of angle between the axes of the eyes, is sufficient to situate two objects if near enough). But when interplanetary distances are involved, a movement in the space itself becomes necessary before the space itself can be described to the observer (this is the phenomenon of parallax).

From this it appears that motion is inevitably involved with the concept of space—motion either of objects situated in space or, on a smaller scale, of the observer. I wish to concentrate on the concept of space rather than on space as a thing, since the concept, being referable to human habits of thought, is more easily verifiable than space itself, and thus might be considered to belong to a higher order of reality (see Introduction).

We have noted that for the recognition of certain dimensions of space the existence in the space of objects is also necessary. One view of concrete objects in space is that they can be considered as modifications of the space which interpenetrates them (the 'ether' of the scientist)—modifications in respect to mass, rigidity, or fluidity, or in fact of objectivity. In many cases it is the properties of such modified fractions of space—their capacity for emitting or reflecting light, heat, sound, or other vibrations—which constitute the only means of observing or experiencing the space in which they are situated.

In a sense one could say that the mathematicians have explored the space of the imagination with which the artist deals. Expressions arrived at often for quite other motives can be considered as referable to space, in some cases even reprojected in concrete form to make

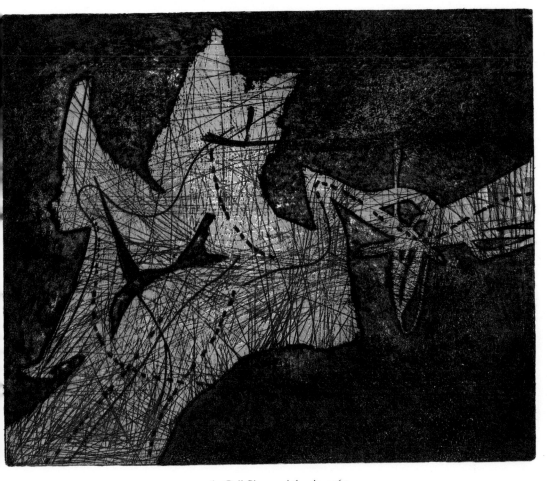

6. Gail Singer: Atlantis, 1962.

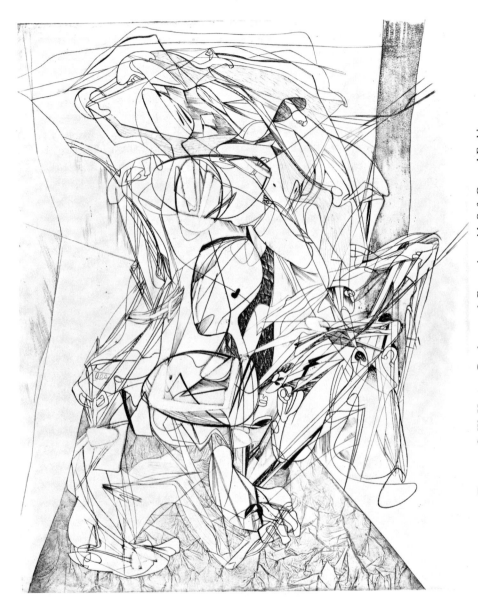

Fig. 101. S. W. Hayter: Combat, 1936. Engraving with Soft-Ground Etching.

models illustrating curious properties of line, surface, movement in space. Of course it is possible to translate the indices of x, x^2, x^3, as length, length \times breadth, length \times breadth \times height, as their usual terms square and cube indicate; but when one attempts to visualize the square root, or the cube root of x, or to follow completely reasonable operations with negative quantities, or with the square root of -1 except when employed as a versor, the difficulty of translating the dialect of mathematics into visual expression becomes obvious. In other words, if the mathematician has explored the space of the imagination he has not carried a camera, and the recording of his comptometer gives us nothing but quantities in another species. One important characteristic shown by the analogy with mathematical space is that it is not limited by duration; the time factor with which it is inevitably associated can be imagined to travel forward or backward with the change of a sign, and is not unidirectional as it is in external sensory experience. The ambiguity between the inward and outward sense can be demonstrated by the number of solutions to a problem in the mathematics of space, some of which may be 'real', others unreal or, rather, unreasonable, some negative and others positive in sign—yet from mathematical considerations there is exactly no more reason to favour one of the alternatives than another. In fact the commentary that mathematics furnishes on the problems of space, though reasonable (meaning in step with general human habits of thought) and consistent with itself, omits most of the functions of space which are of interest to the artist, just as a sine curve fails to induce all the emotional reactions of a ride on a roller coaster.

The visible space seen in the spherical mirror is completed by the space occupied by the observer himself, but the space of the imagination is *not* limited by the restricted experience of the individual in his own lifetime. In the unconscious mind one might expect to find traces of the experience of space derived from other species from which man has evolved, such as the freedom of movement in three dimensions in water reconquered, in some respects, by the conquest of the air. The space of the imagination, like that of the mathematician, is not limited in direction or duration in time, nor is it inevitably

confined to one order of time; the simultaneous realization of a num-
ber of rates of movement in time is quite possible. Apprehended space
can travel forward or backward in time as it can travel inward or
outward, or both, or into an unlimited series of dimensions. Its move-
ment, and the motion of objects in it, have less limitation and their
representation greater possibilities than such phenomena in external
space. Thus the space of the imagination contains an essential muta-
tion and ambiguity—that order of ambiguity that permits the poet
to imply an infinite series of linked consequences in a single phrase
and a score of experiences to be simultaneously present to the mind
of a child (Fig. 102).

The line

For some generations both sculptors and graphic artists have
shown an intense preoccupation with the interpretation of imaginary
space. They have not been alone for, in consequence of the increased
technical means of action in space and time, the whole world has
developed the same interest. They have operated with concrete con-
struction, employing actual motion, density, equilibrium, and colour;
but for the moment I wish to deal only with one particular means of
describing space—with line.

What is a line? If one asked this question of a thousand people
surely none of them would hesitate to reply, but it is very probable
that the replies would be as various as the individuals who made
them.

The word in everyday speech may mean *outline*: a trace describing
a margin, a limiting edge, a boundary of an area or a solid, an en-
compassing trace, a fence and, by an obvious extension, a bond, a lien,
even a link. A *base line* is a conversion of this idea to the purpose of
measurement, a step in triangulation. A *dividing line* is an applica-
tion of this category to separating the parts within a whole, a zone,
a meridian, an azimuth, or lines of latitude and longitude; these are
dividing lines applied to the surface of a sphere or to space.

A *plumb line*, however, is something different; it is a thread whose
use is to plumb, to explore as well as to measure; and as a line it is the

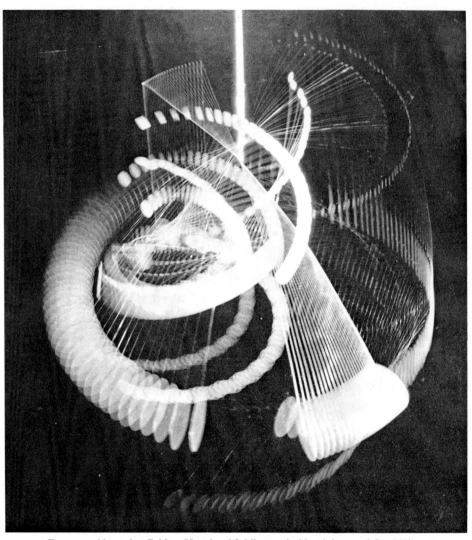

FIG. 102. Alexander Calder: Hanging Mobile, 1936. Aluminium and Steel Wire.

representation of a gravitational pull. Of such lines, the catenary curve of the chain suspended from two points, the parallelogram of forces, are extensions. In the case of the fishing line, the hand line, the life line, the cordage of a boat, the line is a strand, cord, or hawser without inevitable association with a force.

A *pipe line* is obviously a tube along which a liquid can be transferred; a railway line, a trace representing possible conveyance of passengers or goods; a line of steamers, an imaginary trace along which boats either have passed, or can be expected to pass. Thus a great number of such common uses of the word involve the existence of a path, a locus, the record of actual or potential displacement of some object in space. A line of fire, the trajectory of a bullet, an orbit, the path of a comet, are simpler versions of this sense of line.

By dictionary definition a line is a long narrow volume of a colour or value differing from that of the surface on which it is traced. Its function in expression, however, may be to represent:

(*a*) A long, narrow object, as a strand or thread, stretched, bent, or laid on a flat surface; e.g. a limp thread.

(*b*) A wire or more or less rigid strip seen edge-on, bent or twisted in three dimensions, or in a two-dimensional plane not parallel to the plane on which the line is drawn; e.g. a coiled spring.

The distinction between these two categories is, in addition to the three-dimensional character, the quality of resilience and comparative rigidity represented by (*b*).

(*c*) As the defining edge of a plane against another plane, a volume against another or against space. These functions of the line are of course quite arbitrary, as that which is represented is in no sense a line.

(*d*) As in many mathematical diagrams, the locus (path showing successive positions) of displacement of a point or an object in motion. Here again the representation may attempt to indicate a two-dimensional path or one in three dimensions.

(*e*) A direction of movement, or the direction in which a force or tension is exercised without any implied point or object in motion. Again used in mathematical illustration of mechanical problems.

(*f*) As in the original definition, a long narrow volume which may dilate to a volume of different character or may diminish to a series of isolated points.

(*g*) In combination with other lines, parallel or hatched, to describe a difference of value or illumination.

(*h*) A mesh or web of filaments or fibres as in a membrane, or a net which itself, with its torsions, inversions, and movements, can describe a surface in space, in which no one line exists independently.

(*i*) The axes of volumes; or the axes in space serving to situate objects by the relations of such objects to them (co-ordinates).

When we employ such expressions as a line of action, a line of development, a musical line, we are no longer referring to a displacement in space alone; the narrative sense of a displacement in time is involved. Even in many of those cases already quoted in which a force or a velocity is assumed, the factor of space divided by time is implied in the trace. To see how the notion of line acquired such universal significance we might try to trace it from its inception.

If we try to imagine the first instance in which any being recognizable as man made use of the concept of line, two gestures offer themselves with about the same degree of probability. Either our savage ancestor observed the trace of his passage on a sand or mud surface, looking backward from the point at which he had arrived, or from his position he pointed in a direction in which he proposed to go, to send someone, or something (Fig. 103). That aspect of the notion which interests us is, of course, its employment for the purpose of communication.

To drive or pull an object across a surface to record such an experience and to use the result to transmit it to another is an action which seems so obvious that we should expect to find it side by side with the earliest traces of human activity. The forces employed are of the simplest and the incentive is clear; but even at this stage the line shows all the characteristics of a convention, a symbolization: the representation of one thing by another rather than the quality of direct imitation. The trail or trace which the individual has drawn behind him in our first instance, though readily symbolized by a long, narrow

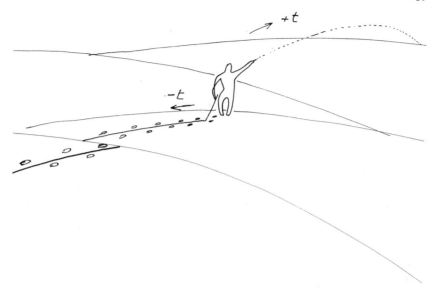

Fig. 103. Origin of Line.

mark, really is not entirely representative of what happened, as a number tells us only how many and not what kind of objects we are counting. Actually we could say that a series of discontinuous displacements with variable intervals of time between them is recorded by only one of its qualities—its direction.

This record could be taken as the description of past achievement such as the railway line where trains had passed, or the unravelled clue of Ariadne which could permit the repetition of the act already performed. In this sense the point to which this order of line tends and from which the second order of line issues, the standpoint of the reflective anthropoid at the moment of his discovery of line, is the mobile present in an unidirectional time system. Now all of the pointing sort of lines issue from this point in time; they project, advance into the future, and as the point itself can be assumed to move such lines must be considered to travel ahead of the movement of the individual experiencing them.

Once the line has been traced the imagination is freed from the time limitation inherent in the two different conceptions involved in its

execution, although it remains to be seen whether in the two traces made by a different means some implications of the conditions of execution do not remain. From the plan which the line represents or the project of movement it describes it becomes easy to retrace it from the limit of futurity back to any assumed present, or to more than one assumed present—to travel backwards in time as readily as one could retrace in space the same directions. At this point the imaginative domination of space and time by the elementary gesture of tracing a line, with its consequent liberation, becomes obvious.

If we imagine this primitive line of experience to be elaborated into a record of sufficient completeness to give a map of those means of communication available in a limited terrain, and that projected lines like the north-south indications in the margin of a map (of the fifth order of lines mentioned) could be made, then it is conceivable that primitive man would be led to orient himself in whatever position or direction he might desire by means of his chart (or, let us say, his drawing) and thus achieve from its use a very practical degree of convenience in circulating in that terrain. As we are occupied with the development of the concept of line rather than the actual moment at which a particular use of it was current, it is not important that a considerable interval of time must have elapsed between the first trace and its elaboration into a chart.

In the phenomenal world around him prehistoric man could observe relatively few examples of true line to imitate except those he made himself with such ease. Sometimes a crack could be narrow enough and long enough; a twig, a vine, a thread, or a fibre again could be long enough for its thickness to be negligible. Perhaps the lightning—the luminous trace of an electrical discharge—would be the purest example of true line in his experience.

But in examples of prehistoric art from the earliest times we find two different adaptations from the function of line as a line. In the representational form volume is described and silhouette, itself not a line, delineated by the same trace. In fact, in this type of drawing, all the lines could be said to be descriptive of things not in themselves linear (Fig. 104). It has been suggested by archaeologists that the

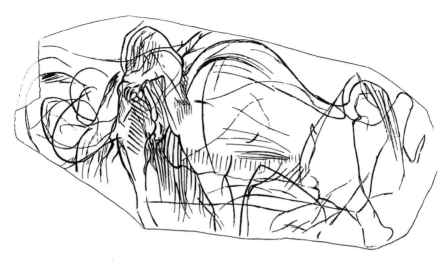

FIG. 104. Dordogne (France): Mammoth. Prehistoric Rock Engraving.

purpose of these images was of the nature of imitative magic, that
primitive man made such drawings to obtain power over the objects
he represented.

Another application of line which seems to have arisen at the same
time and to have developed alongside the representational form is
that lamely referred to as geometrical or decorative. The latter term
indicates that the use of the lines is solely to enrich the surface on
which they exist. I believe, however, that in many cases the interest
of the artist was clearly in lines as lines; perhaps their significance
to him mirrored the magical power that the concept of line gave him
over space and experience. Lines have had such a function, even
geometrical lines, in occult ritual of historic times. And it is important
for our purpose to note that the linear forms used in this sense are
not conversions of line to the imitation of objects, and thus have a
sense different from that of those employed in imitative magic.

Once these two directions in the prehistoric use of line had been
established (the development of representational drawing and of line
for its inherent significance), their adaptation to hieroglyph, symbol,

Fig. 105. Different Kinds of Line.

FIG. 106. John Buckland Wright: Nymphe Surprise II, 1936. Engraving.

syllable, and cipher does not seem abnormal. In fact, as with the perfection of many human means of communication, one feels that none of these steps demanded the boldness of imagination required of the first man who represented a world of light, of shadow, of space and volume and time with the same universal convention of line.

To leave for a moment the significance of the line when made— two orders of line have been described, distinguished from one another by a fundamental difference of attitude in the artist to their direction at the moment of their creation. Although lines made in both of these ways can finally be referred to the numerous functions which have been found for line, it is important to realize that at no point does any line completely lose any one of its original or acquired implications, though one or another may be emphasized at the expense of others.

Although certain of these functions of the line in expression are less familiar than others, all of them are used and are to be used by the artist. They are not mutually exclusive. In the process of tracing a web of lines to indicate a transparent surface which diminishes to a point or fold, the accumulation of the lines will give a difference of value suggesting an effect of light; the character of curvature of the individual lines composing the mesh will itself suggest rigidity, resilience, or tenuity; the tensions existing at the intersections of lines of unequal force may be modified by other intersections or by the addition of a point at the intersection. A single line which at one point of its trace represents an object may continue to describe the margin of a plane and may divide into a system of lines to indicate a transparent surface. A number of lines which describe movements in three dimensions will still intercept areas between them in the plane of the drawing, the effect of which will be perceived simultaneously with the movements that we intended to describe.

Where two lines are drawn to converge to a point it is entirely reasonable to imagine them to represent parallel traces upon a plane or curved surface not parallel to the plane upon which they are drawn—the familiar experience of perspective will easily cause the point to appear more distant than the open ends of the lines. But by

concentrating a moment on such an image it becomes equally reasonable to suppose the point of intersection to project in front of the plane of the drawing; in fact we find immediately that the character of the space of the imagination is clearly demonstrated by the ambiguity of significance of the two lines.

In line engraving, as in sculpture, the trace does not remain precisely in the plane of the plate (or consequently of the print made from the plate) although in engraving the departure from that plane may be only of the order of a few hundredths of an inch at its maximum. As the burin cuts into the copper, the deeper cut will be separated in space from the shallower and finer cut, so that the possibility of concrete construction of space exists (Fig. 18). When printed, the deeper cut will give a line which is physically higher in relief above the surface of the paper than the finer cut; and it would appear that in this manner all that was intended to be closer to the plane of the image could be made in stronger relief, and all that should be more remote, in lower relief. However, in seeming appearance, the difference in plane between lines of higher relief and lines of lower relief can produce the opposite effect, as very little experience will show. What is physically in front (that is, lines in higher relief) can actually appear to recede beyond what is physically behind (the lines in lower relief). It should be noted that an effect obtained in this way differs entirely from the effect achieved by the use of the conventional means of indicating perspective, which convey an illusion of distance by employing converging lines in a flat plane simulating parallels in another plane, an apparent recession by means of overlapping elements in series, or by modulating the colour to suggest the increasing density of atmosphere. The difference between the two effects is one of kind, not of degree. It is the difference between apprehending an event by actually witnessing it oneself, and apprehending it by a deduction from someone else's account. Whereas the use of the conventions of perspective presents only the evidence by means of which a rational deduction concerning the nature of space can be made, the use of a concrete physical means, such as a distinction in plane between high and low reliefs, conveys an apprehension of

FIG. 107. Paul Klee: Prickle the Clown, 1931. Etching and Aquatint (Collection, Museum of Modern Art, New York).

space as an immediate sensuous experience, modified only by a change in scale, as when a man's figure is shown an inch high, yet is instantly recognized as the image of an object known to be larger.

So we find that line, having in its function the same essential ambiguity as the image in the spherical mirror, gives us an enormous positive advantage in the description of the space of the imagination, not only because of its lucidity but rather because of its possibilities of expressive ambiguity.

It is obvious at a glance that lines such as skaters may trace on ice, or the trajectory a tracer shell describes in the air, have a quality along their length which is different from that of lines executed entirely within the control of the hand at a distance from the eye—different, because of the complete physical participation of that which creates the line in the motion it describes. Yet once the trace has been observed, if from some aspect the intervals between the trajectory and other objects should happen to constitute a local resemblance to any of the other applications of line by human agency, to graphic, hieroglyphic, representational, imitative forms present in the human memory, then all of these possibilities will immediately associate themselves with the experience of the observer.

Paul Klee, who has investigated the qualities of line perhaps more extensively than any other modern artist, says, 'the eye follows the paths prepared for it by the creation'. Line, in his sense, is then a path: but the path is prepared by the 'creation', by the activity of the imagination. I am convinced that even those artists who imagine that they are drawing from life, who imagine themselves to be transferring the retinal image of the edge of a volume to paper—even if such a deliberate sterilization of the function of line were desirable—do not in fact do this. I suspect that, even in such obstinate devotees of the immediate visual image, during the few seconds that elapse while the focus of the eye shifts from the remote object to the surface of the paper, a concept has been formed in the mind. Perhaps this is modified by a conscious or unconscious remembrance of similar objects—and that which is described on the paper is the concept and not the retinal image of the object before the artist.

18

DESCRIPTIVE DRAWING · EQUIVALENTS OF COLOUR AND VALUE AS IN PAINTING

F ROM what has been said in the last chapter it should be clear that more is implied by drawing than the very common notion that it has no wider function than graphic (that is, linear or tonal) description of an immediate visual image. Yet even within the limitations of descriptive drawing there are resources in the engraving and etching media which are not fully realized. Our conclusions about line will be directly applicable to the linear techniques where they are seen with greater precision, and applied with greater severity, than in drawing as such. At the same time the methods of engraving have been consciously or unconsciously applied to drawing by artists since the sixteenth century.

Where a line is employed to describe the silhouette of a volume there are three quite different consequences to be expected. The diagram (Fig. 108) shows three silhouettes (A, B, C) in which the same means is used—a continuous trace becoming heavier or lighter. The logic of the first (A) is obvious; apparent modelling in light and shade is indicated by a thickening of the line in shadow. It is almost like a written description of what happens. The second (B) follows a similar logic, but in reverse, that is, the apparent high lights in the volume are shown by contrast against the heavier line. Concentration on this diagram for one minute should, I think, prove them quite visible. One could call this an optical device. It is also interesting to note that in the second example the line is a part of the background assumed, and not actually part of the figure represented. Now in the third (C), the variation of strength of line is not to be explained in

7. Fred Becker: The Cage, 1946.

either of these two manners—let us consider what the effect really is by making a few comparisons. What is the apparent distance between a and a'? I think it is clear that it is small. The apparent distance between b and b', however, is obviously greater and the recession is produced by the heavier line only. This device could be called *consequent* as it depends on a conclusion of the observer.

I would suggest at this point that the consistent employment of any one of these devices is very tedious in effect. If we take Hecht's line engraving *Bison* (Fig. 109), traces of all three devices are to be found, and their use must have been instinctive. This is, however, no plea for ignorance: the artist who has become entirely familiar with these consequences to a point at which they can be forgotten has acquired the power to apply them with greater effect.

For this demonstration the line has been made continuous; interruptions and bifurcations were eliminated to present the case as simply as possible. But, when we follow more closely the use of line for the purpose of describing volume, we see that an interruption can demonstrate real disappearance of a profile against a background of exactly the same value or the recession of the surface of a volume (when it is seen as that part of an uninterrupted volume hidden by the mass and reappearing), or, as with dotted line, a change in the texture of the surface (Fig. 108D). The arrows show in which direction the overlapping volumes appear to turn. Owing to the exaggerated intensity of the engraved line, all of these consequences which have their function in drawing will have greater importance in the print.

In drawing, one of the methods of indicating change of lighting, of modelling, of position in depth, is a contrast of tone; and hatching, shading, and the massing of lines are very usual means of obtaining this contrast. When we compare the use of the same means in etching and engraving we find again that the control over them is much more severe, and that the slightest variation in direction has great effect. Study will convince most observers that, in practice, the fewest directions needed to produce the result will give the strongest effect, and that a change of direction in shading will be effective only if

s

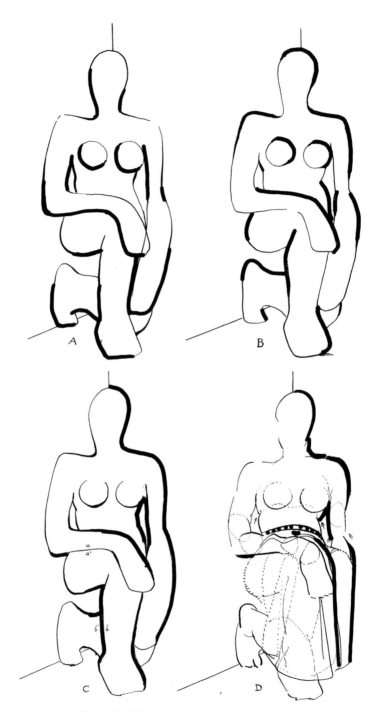

FIG. 108. Effect of a Profile on Volume and Space.

FIG. 109. Joseph Hecht: Bison, *c.* 1930. Engraving.

absolutely necessary to the expression of the design. This necessity in interpretative gravure may be conditioned by texture, volume, light value, or colour equivalent. It may even be instinctive.

The quality of colour in painting, with the powerful means of expression that it constitutes, has no direct application in etching, if we except prints in colour in which the limitations of monochrome are not accepted; these, however, form a separate subject, more closely allied to painting. In this chapter it is the equivalents of colour in black and white, or in one colour (ink) against another (paper) which interest us particularly. The two functions of colour that we shall study are: variation of hue, and indication of space by opposition of colour.

It is obvious that, as in the parallel shading of earlier reproduction engravings, cross-hatching in two or more directions will indicate a contrast comparable to that between warm and cold colour. In general, shading in which strong lines are laid horizontally, particularly if they are sufficiently spaced to count as lines, will give a maximum effect of cold colour as blue or blue-green. Where this principle is applied to small elements seen against others of similar dimension, the horizontal will correspond to lines parallel to the longest axis of the volume rather than to the horizontal direction. Vertical parallels still give a cold effect, less marked than the horizontal, diagonals even less; in fact, the latter will only appear to be cold if contrasted with cross-hatching. Where the lines are closer-set or finer, the effect is similar but less marked, and tends towards a more neutral tint; where the lines are close enough and fine enough to be no longer readily distinguishable as lines, the effect becomes almost neutral. The white dots which result from interruptions in such systems of lines are of great interest (Fig. 110).

Cross-hatching in two or more directions gives a tone which becomes definitely warmer as more directions are employed; also the effect is warmer when the angles between the components approach the right angle. Again the colour effect approaches neutral as the lines become finer and more closely set.

Curved lines used as parallels or cross-hatched are in their effect

FIG. 110. Equivalents of Colour Achieved by Hatching.

similar to straight-line systems, except that they tend to be warmer as if in a lower key. Dotting with flick dashes in burin work gives a more or less neutral effect as the total approaches a line passage, being generally rather warm than cold. The triangular dots of the burin, with burr removed, if set close enough to give a tone, give a warm effect; if smaller and closer set, a neutral one. The round dots of burin or *criblé* give neutral to warm effects if seen against the characteristic parallel shading. Burr left on burin work, or dry-point, reduces these effects; that is to say, warm tones appear less warm and cold tones less cold, rather as if mixed with a neutral tint. Combinations of dotting and line generally follow the character of the line element, again in a lower key, as if diluted with neutral tint.

The bitten textures described in Chapter 5 may be used in etching to replace the resource of colour opposition in painting to distinguish areas of similar value. They may give a cold or warm effect if definite cross-graining or striation exists in them. Open and deeply bitten parts will appear colder than those closer and more lightly etched. Again if the texture to be bitten is applied with greater pressure to the ground the effect will be warmer than if the pressure is less. The open bitten-out areas described will, of course, be warmer still— approaching the tone of dry-point. The close regular grain of resin-ground aquatint is rather neutral; it can be varied by previously executed line work seen through it, and it appears warmer when the texture becomes coarser as in sand grain (Fig. 111).

All these considerations apply more directly to reproduction where a coloured design is being translated into the terms of engraving or etching. In practice the use of such textures is applied in a much more arbitrary fashion, the difference of quality sought for depending more on a distinction between active and neutral surfaces. By an active surface is meant a texture in which the difference of value of the components is at its maximum, a neutral surface is one in which the difference of value of the components is very slight. It is obvious that unless line, construction, or composition contribute to destroy the effect, the former type of surface will appear in front of the latter. Similarly in the matter of value, in which engraving and etching

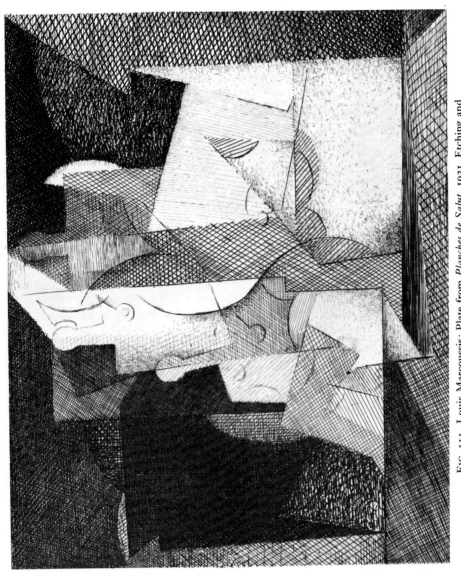

FIG. 111. Louis Marcoussis: Plate from *Planches de Salut*, 1931. Etching and Engraving (Collection, Museum of Modern Art, New York).

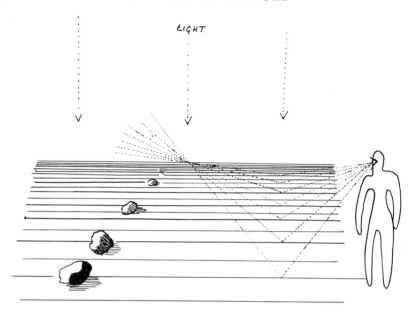

FIG. 112. Receding Plane.

have much the same resources as painting, the normal regression in
three-dimensional space represented with uniform illumination from
above will be from the greatest possible contrast of light and shade
in the foreground to a lesser degree of contrast in the middle distance.
In the extreme distance differences of value practically disappear by
the progressive lightening of shadow and darkening of illuminated
surface through atmospheric absorption. Thus the typical representa-
tion of a plane receding from the observer will show a value becom-
ing progressively darker from light to a half-tone at its further limit,
owing to atmospheric absorption and the increasingly flattened angle
of the reflected light as it arrives at the eye (Fig. 112). But on such
a surface the object in relief will throw the most definite shadow in
the foreground, and less as it becomes more remote, until at a certain
distance light and shadow become indistinguishable. Thus in the
characteristic ground plan of the *Horse* (Fig. 113) the general value
becomes darker towards the horizon. The lines and dots that express

FIG. 113. S. W. Hayter: The Big Horse, 1931. Engraving.

FIG. 114. Three Components in Water Surface.

folds or variations in it, however, are heavier in the foreground and become lighter as they recede, hence must be more closely set to obtain the darker general value. Any other succession would give the plane a sensation of flatness in the surface of the print, of reversal of direction with regard to the observer, or of transparency.

Thus in the simplest representation of a water surface two components exist. One is represented by the reflection from the surface at an angle of view too acute to allow the observer to see through it (less than the 'critical' angle for water). Under these circumstances the plane follows the same rule as that already described, i.e. light foreground—darker distance (Fig. 114A). But for that portion of the surface that is at a sufficiently wide angle from the observer to enable him to see through it, the reverse applies, that is, the water appears darker in the foreground and becomes lighter as it recedes (B). This is more conspicuous when the surface is seen from a height. Where wave or ripple markings are present, the distance to which the effect can be seen is increased; the two effects, instead of fading into one another imperceptibly, as in a perfectly still surface, will be intercalated through the diminishing patches of the wave pattern. This

is a statement of the simplest case. In practice, the source of illumination may be in front of the observer, when a total reflection will be seen where the wave surface is turned at a sufficient angle to the observer, constituting a third element (c); local reflections from objects near a margin may produce a fourth; but in each series a progression will be followed, except for the case of total reflection when almost no variation is perceptible.

Actually very successful compositions exist in which the finest work is in the foreground and the most violently contrasted blacks in the extreme distance, yet the construction and proportion of the plate keep the various elements unmistakably in their place. In such cases the values will count rather as local colour than as variations of value on one homogeneous surface. This can be seen in the snow foreground of Hecht's *Norwegian Landscape* (Fig. 115), with its very fine engraving contrasted with the violent black silhouette in the distance: mechanically, the latter should appear in front of the former, but the composition keeps it in its place. In the same plate another device common to drawing and gravure is demonstrated. The foreground, though almost unworked, has apparent solidity, while the upper part of the plate is seen just as convincingly as unlimited space. Also by one of the simplest devices in gravure the snow foreground appears lighter than the sky, although in reality the two are identical in value. An unworked surface seen against blacks will appear whiter than the same surface alone or against greys.

But variations of value (light to dark) can of course be employed in drawing without any implication of colour or texture. From the most subtle of these, the different qualities of 'white' just referred to, to the qualities of black on black, the positive fact is that any uninterrupted succession will convey a recession. But just as with the accents described above, the succession may appear to have either the darkest or the lightest extreme nearer. This seems to apply equally to a clearly defined series of flat tones and to an imperceptible gradation. Certain associations with gradations seen in everyday life cannot be divorced from a change in value shown. A tone dark above to light below, even when a horizon is not shown, leads inevitably to the

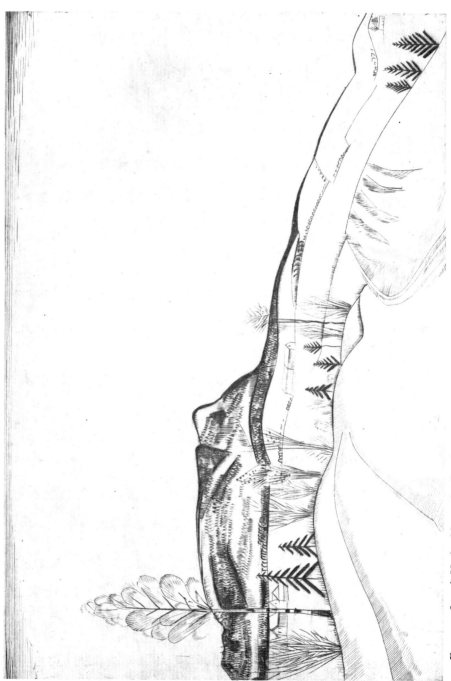

FIG. 115. Joseph Hecht: Norwegian Landscape, *c.* 1919. Engraving (Collection, Metropolitan Museum of Art, Dick Fund, 1947).

recognition of a sky, and the assumption of a horizontal earth plane below. But where, as in *Apocalypse III* (Fig. 15), the gradation is reversed, the conclusion will be that either a space is represented without the presence of the earth or of gravitation, or a movement in water (equally without gravitational consequence). If the print mentioned is turned upside down, I think this point will be clear.

Human beings stand erect, lighting is most generally from above, and vision proceeds bioptically in a horizontal plane. Thus a small volume with dark above will either be interpreted as concave, or as coloured; with light above, it will be seen as convex (Fig. 116). To all these rules there are numerous exceptions, generally where the context plays a dominant role. Although we have tried to deal in this study with concrete quantities, yet the associations with different effects that have been developed by habit in the observer will influence his interpretation of the image. In fact, unless we take into account these associations as if they were concrete physical quantities themselves, we cannot employ the means of graphic communication *en connaissance de cause*.

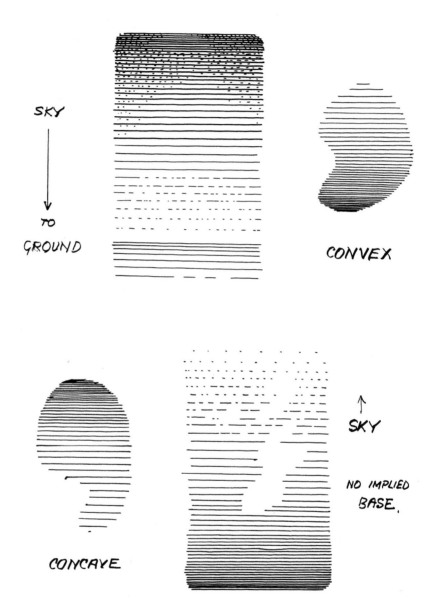

SKY

TO

GROUND

CONVEX

CONCAVE

SKY

NO IMPLIED
BASE.

Fig. 116. Convex and Concave.

19

SPECIFIC QUALITIES · TEXTURES · PLASTER

WE have seen that, by means of lines, textures, and surfaces in metal plates adapted to retain ink and transfer it to paper, the artist has at his disposal all of the expressive qualities of drawing and many of the possibilities of painting (where his textures replace the resources of colour), and of sculpture in his control over space, though with a definite limitation of scale. Together with these means—common to other forms of art—there exist a number of specific qualities realizable in the plate media, which are not completely shared with any other technique. These I will try to describe or at least indicate.

The engraved line

Those resources of expression by line described in Chapter 17 are realizable to a greater extent in the line engraved in a plate than by any means of drawing, or by any means of construction in wire filament. In the one case it is necessary for the realization of the drawn function of the line to abandon the physical displacement characteristic of the wire construction, and in the other, the drawn character— that quality of apparent velocity of execution present in drawing— will disappear from the static result. In the mobile sculpture of Calder (Fig. 102) an element of velocity, a time function, referred to displacement along an involved but ultimately closed path, is added to the concrete space and implied motion of classical sculpture. But this does not correspond exactly to the impress of the velocities involved in the curvature of the trace of the burin in copper upon the printed line as detached from the plane of the proof upon which it appears.

FIG. 117. Roger Vieillard: Espace Industriel, 1939. Engraving.

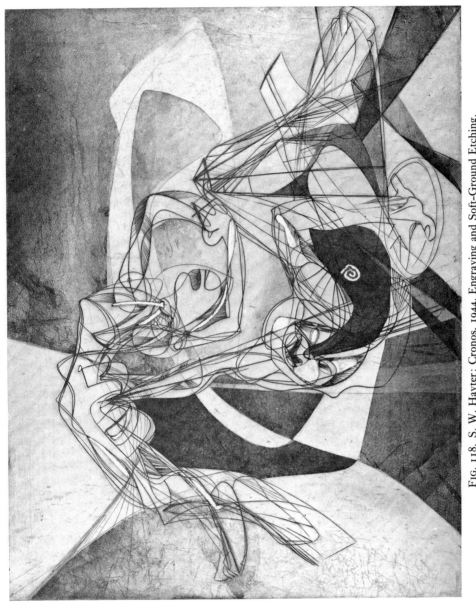

FIG. 118. S. W. Hayter: Cronos, 1944. Engraving and Soft-Ground Etching.

The change in the curvature of the engraved line registers a change of intensity of the force exerted on the tool.

But the most outstanding advantage of the engraved line is probably its function, either alone or in web-like systems of lines, of demonstrating an order of space having inherent curvature, its time function, its modification by the existence of tension and pressure, its disturbance by concrete objects, variation of density, or direction of flow—qualities which are not realizable physically in drawing or painting to anything like the same degree. With the first initiative of Hecht following the early Italian engravers, engraving is the making of a concrete object with line in the plate—an object which is connected by resemblance and association with external objects or with the experience of phenomena, but unlike the normal uses of drawing has an independent existence apart from the description of the external phenomenon.

Textures

In the demonstration of density in space and recession by the use of superposed textures (of a different, a more neutral character than the web of engraved lines) the etching methods offer certain specific qualities. The practice I have observed in students who are first introduced to the possibility of transferring the quality of a texture to wax, from which the acid will etch it into the metal, is to use such qualities in the manner of collages to decorate parts of the surface of their print. Normally they will fit such elements into a structure of lines already established in the plate. However, even at this point the overlapping of textures for the sake of using their transparency may be employed, as coloured cellophane might be used in a collage. Already a certain specific quality of the medium is used: these disparate textures have been assimilated to one single matter, the etched trace in copper; just as a photograph of disparate objects ends by being actually silver in a film, though in that case only that part of reflected light from the objects which could affect the emulsion is represented.

But the next stage in the employment of these textures is generally the realization that something has been wasted in getting profiles of textured areas to fit lines which were already there—in other words, instead of using each act of delimiting a surface for a positive constructive purpose, the act was merely made to emphasize and repeat a gesture already present in the plate. There generally follows the employment of the areas (still at this point flat and parallel to the apparent picture plane) in a sort of counterpoint. Linear elements allow the areas to function much more freely and preserve the possible ambiguity of expression inherent in line. Further amplification and vibration is permitted by the play of the margins, volume, and relative position of those areas against the linear structure. By means of etching in gradation the web of a texture may be oriented in a plane diagonal to the surface of the plate—by actual torsion in the material a torsion of the space may be demonstrated. Interpenetration of several such elements may give rise to a space which can be interpreted in two or more ways. Sue Fuller made a plate in Atelier 17 in which all the lines that appear are the impressions of threads, some being in actual tension; there are no *drawn* lines in this plate (Fig. 119).

When a space possessing perceptible density is created by this means, its interpenetration by systems of engraved line (as distinct from the etched line which shares the physical character of the texture) can produce two completely different orders of space.

Here I should add a note on our view of the probity of means in making plates. It has been a matter of 'principle' in the past to insist on completing the whole of a plate by one means, as bitten line, soft ground, aquatint, or burin engraving, probably from a dim sense of preserving the unity of the result. I have never heard that a painting in one colour, or executed with a single brush, was considered better in any respect than one done with complicated means. Integrity in the employment of the craft of etching and engraving implies that each means used shall be perfectly adequate to the function that it fulfils in the result—that under no circumstances shall the means be abused or sterilized to carry out a function for which another method is more

FIG. 119. Sue Fuller: The Sailor's Dream, 1944. Relief Print from Soft-Ground Etching.

appropriate. In fact the complexity of the means employed is completely unimportant if it is justified by the ultimate unity of the result—even should that unity arise from deliberate incongruity.

Plaster reliefs

The method of making an actual relief of the surface of the plate (and consequently a proof) described in Chapter 4, associated with the peculiar effect that ink produces in printing from such plates, constitutes a general means of expression which is unique to the medium. Fundamentally this seems to depend on a contrast of varying density of black almost inevitably interpreted by the observer as a variation of light and shade describing a solid form; this exists side by side with a construction in physical space which is frequently contradictory to the first interpretation. Without returning to the fortuitous meeting of the umbrella and the sewing machine on the operating table of the Comte de Lautréamont, dear to the Surrealist, it seems that, in a different manner, the presentation of these physical incongruities does have the shock effect of breaking through the armour of use and wont of the observer, shaking his conviction in the sureness of his powers of observation and the inevitable banality of the result they deliver to him, and exposing the sensitivity of his spirit to the ideas we have to offer him. A technique which offers the artist these possibilities will be extremely precious.

A print from an engraved or etched plate made on plaster of Paris will in effect be a low relief. When this block of plaster is sculpted to continue the work, certain specific possibilities arise which lie practically outside the normal resources of sculpture (Figs. 58, 59). Although the result could be described broadly as a species of polychrome sculptured relief, the peculiar means used to achieve it does in practice produce something which would not be conceivable if made entirely by the methods of sculpture. In the making of the plate, the cutting of the steel against copper if a burin is used, the biting of acid into metal if the plate is etched, determine a certain quality and scale. At the point where the print is made on the plaster the element of polychrome, or of black to white as light is added, arises and a

FIG. 120. S. W. Hayter: Amazon, 1945. Engraving and Soft-Ground Etching.

FIG. 121. Photograph of the Plate for the Print in Fig. 120.

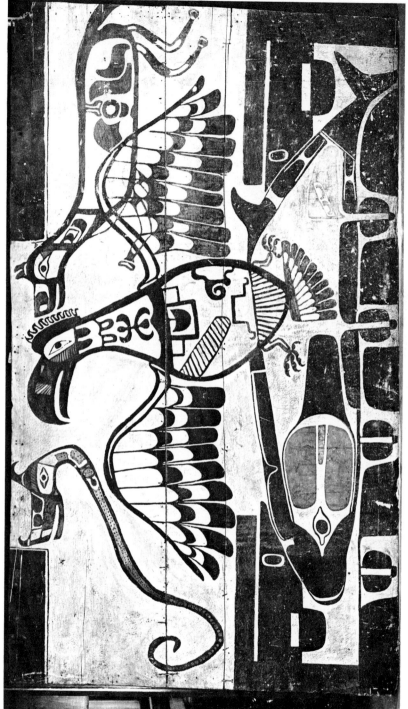

FIG. 122. Nootka: Wall Painting.

possible conflict between concrete space (in very small depth) and an apparent light/shade illusion. When the carving is commenced there is a further shift of scale (sculpture having a characteristically bigger scale than engraving), though the work will inevitably be conditioned by the result already attained. It is perhaps for this reason that the adoption of either the light/shade method or that of carving in simple relief, which have already contributed to the work—obvious physical displacement or light and shade interpreted as recession with a fixed illumination—will give a disappointing result. Actually, to a sensitive artist a certain logic will establish itself in working which depends on all those elements already established. The only existing art form in which I have seen such qualities is Alaskan and American-Indian polychrome reliefs and tissues (Fig. 122). Here the surface is divided into lenticular forms by grooves, and within these forms a concave shape leads sometimes to a deeper cavity, sometimes to a central convex form. It has been suggested that the motive in these cases was an obsession with the eye—that form being somewhat the form of an eye in an orbit—and the compulsion of these artists to make every form, which could possibly lend itself to such treatment, into an eye. We will not here go into the metaphysical implications of this theory.

CONCLUSION

THE FUTURE OF GRAVURE

I T may have occurred to the reader at this point that more importance
has been given to questions of technique—which is often considered
as a sort of mechanical process of execution of a work of art—than to
the question of idea, of content, and of significance of the final image.
The reasons for this apparent over-emphasis, apart from the fact that
technical matters are more readily described in words than graphic
ideas, and the author's view of the function of technique in contri-
buting to a result certainly do need to be defined.

It has seemed to me that the arbitrary separation of the eye and the
imagination in 'creating' the image, and of the hand and the more or
less logical processes of the mind in executing the work, is very
difficult to defend. Thus the custom of separating the different func-
tions of the individual into spiritual, emotional, physical, &c., has
a certain convenience in considering these functions, but can lead to
the most absurd error if one loses sight of the integral character of
the being exercising them. In the numerous processes of gravure
where the mechanical complexity of some of the operations and their
reputed difficulty (generally exaggerated, in my opinion) might ap-
pear to hamper the development of expression, I consider that the
very complexity of the means can be applied to provoke it. Thus the
antithesis between inspiration (imagination-unconscious) and execu-
tion, in the view of our group, has no real existence. The possession
of a means of execution has in our experience, even in the case of

mature artists whose general field of image is already developed in a definite direction, led to the stimulation or activation of further and different areas of imagination which were previously dormant.

An example might make this point clearer. In a technique elaborated by André Racz for certain of his plates, in particular in *Medusa* (Fig. 123), the artist drew automatically with a sort of viscous gesso from a container upon a sheet of smooth board. When the gesso had become completely hard, the varying relief of thicker and thinner traces was reduced with sandpaper to a minimum. A copper plate was then coated with soft ground and the board pressed into it. When the board was removed, the ground had been lifted to expose the copper along the lines and in weaker areas in the wider spaces of the background owing to the flexibility of the board; the ground remained intact only in continuous traces along the exposed lines. Certain areas, consequent upon the traces already established, were covered with stopping varnish to be white in the final result. The plate was then etched very accurately with the chlorate bath. Later, engraved passages were added with burin, opaque dark areas bitten in aquatint, again consequent upon the previous image, and some hollows removed with scorpers to print white and in relief above the remainder of the print surface.

Now it is difficult to imagine a more absurdly remote process to produce a black image on a white sheet. But the magical quality of the result depends here on the very remoteness of the method. At the first stage in the handling of the gesso the intention and choice of the artist is exercised—note that this image is in the same direction as the print, reversed in the plate; in stopping-out the transferred image a further choice is made; the action of the acid is controlled to select those accidents of pressure and intensity that could favour the latent image. In the engraving, the aquatint, and the development of the white accents, at each point, the artist exposes his image to accident—but accident that can be dominated by his intention. No consciously organized execution of a previously conceived plan could have given as powerful an emotive image, nor could it have produced its richness and completeness of quality. Yet without a planned

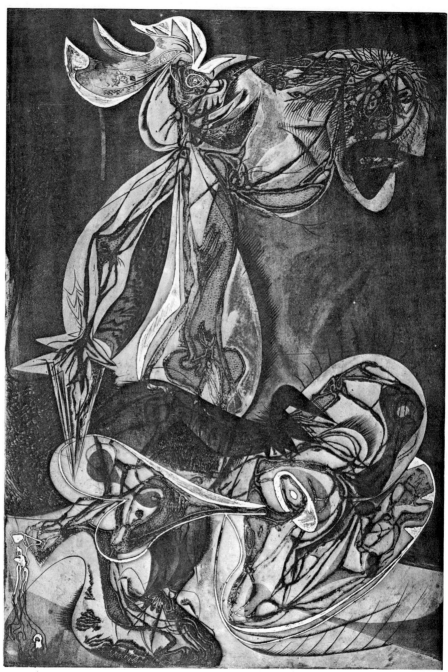

FIG. 123. André Racz: Perseus Beheading Medusa, 1945.
Engraving and Soft-Ground Etching.

succession of operations based on previous experience it could not have been done. Thus, in the mechanical use of a technique, only those qualities previously experienced by the artist can appear in the result—the making of the particular plate will not necessarily enrich his experience, nor will it provide him with means which he did not already possess. This is not art as experience, it is art as the journalism of experience.

It is in the exposure of his idea and his plate to the accidents of a method, to the imminent risk of destruction, that the greatest result may occur in the work and the most valuable experience in the artist. I would suggest that the courage needed to adventure in this manner, as much as the oft-quoted infinite capacity for taking pains, may be a component of genius, and may distinguish the valid artist from the hack.

After thirty years of contact with artists working in experimental media of gravure and my own work in this field, I consider at this point that the first essential to undertaking a plate or other work of art is a powerful urge to make a latent image visible—together with a consequent delight in the image. Beyond this, the access to the image-making faculty of the mind, the ability to free oneself during the development of an idea from considerations of mode or of profit, or of the possible effect of one's work upon the observer, a certain courage to follow the development wherever it may lead without editing, formalizing, or modifying it with respect to any but the implicit requirements of the growing design, whether absurd or not, all seem to me equally important, once the first incentive is assumed. The source of such incentive has been very much debated; it is extremely difficult to identify if one seeks the ultimate source—though the superficial circumstances may vary widely. Thus I have known artists ascribe their productive state to tactile sensation, sleep, exhaustion, ill-health, internal conflict, fury, relaxation, reading, music, stimulants, violent motion, complete passivity, among other states. From their diversity any of these would appear to be an individual idiosyncrasy leading to the functioning of a single underlying cause, which I would not attempt to define further except for the suggestion

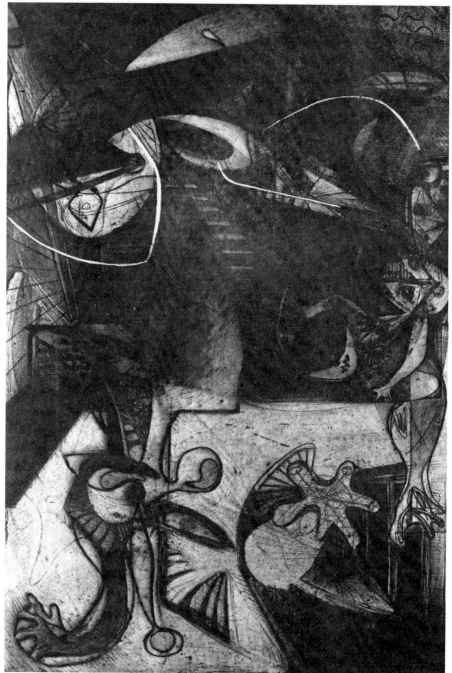

FIG. 124. Mauricio Lasansky: Dachau, 1945. Engraving and Soft-Ground Etching.

that among the main movements of the human spirit it be sought with the instinct of play rather than that of work (as struggle for subsistence). Not that I would consider such a source to be trifling or unimportant—but it is certainly in line with the gratuitous character of artistic activity.

In most of the cases I have observed, the elaboration of an idea in a plate (and in many other media of expression) follows a certain succession of stages which, whether longer or shorter, are nearly always present—somewhat like the organic elaboration of growth in a plant. The first attack in the plate is rapid and without great difficulty or hesitation up to a point when one generally needs to make a print to verify what has been achieved (First State). At this stage the result will often be spontaneous and vivid but definitely inadequate. Frequently far less appears on the plate than one anticipates, as the mind has projected more than the hand has recorded. Already the reciprocal effect of execution \leftrightarrows imagination will generally decide the next stage in the development of the design. The first strokes on the plate set up a train of consequences like the ripples from a stone dropped into a still pond, and the factor of experience in the artist determines the number and succession of possible consequences offered to his choice, just as a master of chess can visualize from an opening a great number of moves to a mate while a beginner can see only a few immediate moves. In my own manner of working I would consider the selection among these consequences rather to be unconscious than deliberately conscious, and in no case mechanical. This stage in the development of a plate may be marked by a shift in medium from, for instance, burin line to bitten surface, and in this case it would seem to me preferable to employ counterpoint rather than to conform to the linear design already established. Thus the possible mutations between profile of bitten surface and line would be at a maximum—in other words, far more consequences will offer themselves at the next stage than if biting had conformed to previous linear design. From this second state, once the definite choice of direction has been made, progress is fairly simple, though frequently it becomes necessary to make another very bold transformation when the design

seems to freeze. The last stage generally in my own plates would be the addition of white relief accents; this often needs long reflection, until their form and their position in relation to work already done and to one another become clear. Another concluding stage which often is used for the re-simplification of a design which has become over-complicated is to etch away large areas of the work, thus separating the parts to be retained from the background at a different level. Then, almost always, a very few touches will be needed to complete a plate; this may prove to be a third point of great difficulty, as it may require days of study of the image before the inevitable position of these touches establishes itself.

To work in this manner it is clear that complete familiarity with the medium and its possibilities has first to be acquired; latterly I have tried to direct students to make experimental plates which are worked to destruction. At any point when an interesting result has been achieved a few prints may be made to keep, but the plate is then continued and finally destroyed (see Chapter 16). This we have found valuable in forming an attitude to the work in which a partial or incomplete result will not be accepted for fear of destroying the plate, and a consciousness of the power to add, remove, correct, or develop elements to any degree is cultivated. This familiarity with the medium permits a reasonable succession of operations to be foreseen (practicable in the order designed) although the artificiality of the consciously planned and fabricated result is avoided. Thus a transformation which makes of a secondary or consequent structure the final theme of the plate is possible without loss of control.

Perhaps this account will make clear my point about the attitude of play in elaborating an idea as distinct from the mechanical and repetitious execution of a frozen scheme by the methods of work. As I see it there is no lack of seriousness in this attitude—what could show greater seriousness and concentration than a child playing an elaborate game? The acquisition of means in the plate media, the enriching of the artist's experience, can only occur as he plays with his processes with a certain detachment from the result; the painful and accurate execution of a preconceived plan can only involve those

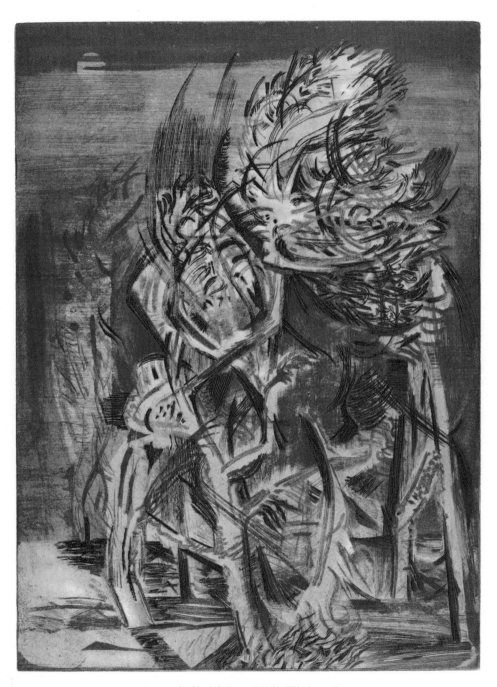

8. Karl Schrag: Night Wind, 1946.

means already familiar to him, and offer no new ones. I feel that in undertaking any graphic work the artist places himself in a position to allow miracles to happen to him, even though the position involves risk, but he must retain a certain alertness, a kind of awareness, or the miracle will happen when he is not present.

The artist uses the oldest traditional tool of the print-maker, the burin, to cut furrows through a surface of copper to different depths so that threads of ink shall stand up above the sheet in the print at different heights. The simplicity of curvature, due to the two components of the driving pressure and the resistance of the metal, and the aspect of the mind of the artist following the moving trace in a space which is continually changing with the rotation of the plate—all this might be thought to hamper the expression. But in another sense these are factors to provoke his imagination, and to free him from the banal associations of the drawn trace. Again the very indirectness of the method, the inversion of the image from left to right, of his space from depth to height, the reversal of the normal relation of the fixed observer to the line that moves, so that the artist seems to go with the burin point, can open new territory to him. In this connexion I would like to note that in my opinion even in our group no more than a very small fraction of the possibilities of these methods has been exploited. With longer acquaintance with the means artists will probably develop a much finer sensitivity to tension, rhythm, play between line and point, and drift in curved space.

I think the reader will agree that in the decorated initial of Van de Velde (Fig. 125), as in the elaborate exercises of the writing masters, no line, even by accident, has a powerful expressive or emotive function. Now from what has already been said, it seems that somewhere among these burin traces at various depths, their intersections and consequences—all those qualities leading to the most expressive use of the medium—by accident the magic quality of the work of the tool should have manifested itself. Perhaps the future will show what it is that a burin can do to an artist, or an artist to a burin, to achieve this complete sterilization. The definition of this point would be a most valuable gain in a negative sense, as of a thing to be avoided. Perhaps

U

one might suggest that the inaptitude in the engraver to recognize the miracle contributes to this result, so that the physical appearance of the phenomenon is made impossible, or perhaps that, the focus of attention of the artist being elsewhere—upon execution, virtuosity, decorative effect—its development was prevented.

From the technical point of view it is possible that in the future a much wider application of the direct engraved or etched work of the artist will be made to the methods of mass printing at low cost. By 'direct' I refer to precise mechanical methods of reproduction rather than photographic means to transfer the appearance of an engraved print to the final printing surface. The printing by ordinary typographic means of illustrations in cheap editions from the artist's own original metal cuts (rather than from line or half-tone cuts made photographically from them) could have an enormous development if enough artists with the technical competence to make the plates could be found, and if printers and photo-engravers could be persuaded to take a reasonable view of this activity. The public, given the opportunity, would learn very readily to distinguish the finer quality of such work.

With the increasing use of offset for fine work it might be interesting

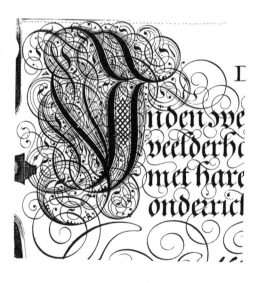

FIG. 125. Jan van de Velde (1593?–?1641): Initial 'I', 1605. Engraving (Collection, Metropolitan Museum of Art, Gift of Felix M. Warburg, 1928).

to generalize the experiment made by the Curwen Press in England in the late 'twenties in which a wet proof of an engraving was transferred without the intervention of photography to a lithographic surface, from which it could be printed either directly or by offset. The accuracy of the reproduction was perfect, except of course for the loss of relief above the print surface. However, with the increasing use of intaglio methods of printing on paper (rotogravure) and on fabrics (solid-deposit printing), it will become possible to print from the actual engraved surface of the artist's plate, formed into the roller accurately enough for the ductor blade to clear it, or possibly by means of an accurate mechanical reproduction on a cylindrical surface (electrotype method proposed in Chapter 9). It is true that the normal depth of 'etch' in a rotogravure cylinder is only a few thousandths of an inch, while the depth of the engraved line may be several hundredths, but the electrolytic re-deposition of spongy copper into these lines, the surface being protected with a 'resist', could overcome this difficulty.

For this result to be attained it would first be necessary to convince such people as the owner of the best-equipped newspaper in New York, and one of the most successful publishers (both of whom have been consulted at certain moments), that what is now being offered to the public is not, as they claim, already too good for them to appreciate. Perhaps commercial artists will free themselves from the inherent contradiction of their title and become sufficiently familiar with the elements of the printing processes, on which the reproduction of their works depends, to be able to compose directly in those processes, instead of employing the ingenuity of photographers to break down their sketches and the industry of printers to put them together again. After all, this is no more than what is demanded of the 'fine' artist working in the print media for less reward.

The relations, historical, actual, and potential, between the arts of original gravure in the hands of the artist and the numerous efficient methods of mass printing which have developed from them can hardly be dealt with here. Another work of greater size would be needed to cover this very interesting subject, but in passing one might

reflect that the knowledge, even the actual practice, of such 'primitive' crafts could be of great value to those in charge of the application of the elaborate machine printing systems. Such a study could even make for a freer and bolder use of that equipment, frequently neglected because of the conventional formation and restricted graphic education of people in such positions.

Both the present and the future of print-making are clearly associated with the general purposes of the graphic and plastic arts of this time. By this we mean that which is truly contemporary. For all that, as at other periods in art, there are probably more practising print-makers offering a simulacrum of time gone by than there are who are projecting the thought of their own time.

At one period it appeared to the author, as it had done to the artists of an earlier generation, that it would be sufficient to reproduce the immediate thing seen, although this might be an exceptional experience. But even were the experience exceptional, the result would still be an anecdote. Later a step was made to the attitude in which it was sought to recreate in the mind of the observer the emotion inspired by that which was seen. But even this will still be no more than a transfer, or a parallel to the momentary anecdote: a notation of mood, of 'colour', perhaps local; a quotation of a specific matter.

However, in this century certain artists have set out to embody a general emotion in their image—emotion as joy, fear, passion, violence, without immediate reference to its source in the experience of the individual artist. The 'Expressionist' attitude, understood perhaps as expression of the emotion of the artist, perhaps as transmission of emotion to the observer, is open to the objection that it can readily become a journalism of the emotions. Still current, this attitude seems to the writer to be of limited possible development and, as it happens, inapt for the discipline of print-making that we have been describing: or should we say that such expression and such discipline are incompatible. Emotion is of course involved in the initiation and development of a work of art, as emotion is involved in the apprehension of that work by the observer. However, it would

seem that it is not the sole or operative factor in a work, or even the most important.

Another direction in the art of this time, unfortunately referred to as 'abstract' or 'non-figurative', definitely infers the primacy of the existence of the work itself, not that of the implications and associations to which it gives rise. The term 'abstract' is unfortunate, as it suggests the abstraction or removal of a part of experience— the attempt to show less than the phenomenon and not more; the non-figurative label again suggests a pretension to deny to the observer the association or comparison of the work with latent images in his mind—a pretension which is impossible to sustain. As any closed round will at some moment suggest to all observers a human head, any bifurcated shape a figure, it is idle to ignore this. Yet a definite change in attitude is present and I suggest that to replace the opposition of 'figurative' and 'abstract' it would be wiser to employ the contrast of specific and general. Thus the artist of the present is abstracting only in the sense of generalizing experience and not of restricting his field. It is of the climate of existence and not the weather; of motion rather than of that thing there and how fast; not the momentary appearance of the stream at one place but the sense of motion in liquid or air which (to mention one of my own pre-occupations) links with the almost infinite implications of the medium in which we live. This reveals one of the resources of such a direction —that perhaps which accounts for its widespread development: from the fact that it renounces the restriction to the immediate specific observation, it opens a field of linked implications, an expressive ambiguity or polyvalence which has so far shown no limitation. A working rule for any investigation is that a direction which appears to open more and more possibilities is to be followed while that which closes and restricts progress is to be abandoned.

The general approach to print-making from plates, which is charac-teristic of Atelier 17 and is now very widespread, has become associ-ated predominantly with this attitude—not because of any deliberate choice on the part of its director or the group, but somewhat because the situation demands this sort of attitude. This attitude determines

a general choice of means of expression which is not deliberately sought for, nor could be foreseen. In colour, optically active systems are preferred which produce a reaction in the eye of the observer whether he choose or not. The contradiction of a figured space by a colour space already described is a case in point (see p. 227). In structure and composition, a concrete ambiguity involves the eye rather than acting through association or suggestion in the mind. The alternation of internal and external space in line structures and in deep-etched relief is of this type (see pp. 225, 227). Thus all of these media tend to give positive physical effects.

With a plate before him and a definite action to be undertaken, idle reflection on the beauties of nature will be of no more profit to the print-maker than estimates on the possible effect of the product on the buyer. The plate is a thing of itself, however much it may ultimately lead to a print which involves the sea, the air, the forces of nature, the emotions of man before nature, and so on. If the unconscious action of the artist on the matter of the plate is to be followed throughout all of the consequences that it may provoke, the concentration must inevitably be on the plate, the object that is coming into being—and to this extent it is abstract (or concrete).

It is as easy to underrate the courage needed to undertake the risk of such a proceeding as that needed to stand by the result when it appears. The difficulties of choice among the enormous numbers of consequences provoked by such action have also to be overcome: to us, however, this position is always preferable to the poverty of exhaustion in pursuit of a single image. The sensation of the print-maker is rather that of submitting to the evolution that the plate seems to dictate to him—which can be understood as liberation rather than as restriction. The external imposition of a preconceived plan or image restricts the print-maker to that which was already formulated in his mind. That is to say, the actual creation of some matter of idea by the reaction of the procedure on the mind of the artist has thereby been excluded.

Although we cannot foresee the form that the works of the future will take, yet it would greatly surprise me if it did not arise from some

action of the type described, where more is to be expected of the result than was already present in the mind of the artist.

I hope that this book has succeeded in demonstrating the importance and richness of the long-neglected means of expression inherent in the plate media; that its technical information will be of use to artists bold enough to undertake adventure in print-making; and that some of the speculations in the concluding section will provoke artists to experiment in directions which we have not yet foreseen.

SELECT BIBLIOGRAPHY

Compiled by Bernard Karpel, Librarian, Museum of Modern Art, New York

I. *Technical: Processes and Materials*

ARMS, JOHN T. *Handbook of Print Making and Print Makers.* N.Y., Macmillan, 1934.

BERSIER, JEAN A. *La Gravure.* Paris, La Table Ronde, 1947.

BOSSE, ABRAHAM. *Traicté des manières de graver en taille-douce.* Paris, 1645. Revised and enlarged editions, 1745, 1758.

BRUNNER, FELIX. *A Handbook of Graphic Reproduction Processes.* Teufen, Switzerland, Niggli, 1962.

BUCKLAND-WRIGHT, JOHN. *Etching and Engraving. Technique and the Modern Trend.* London, N.Y., Studio, 1953.

CAHN, JOSHUA B. *What Is an Original Print?* N.Y., Print Council of America, 1961.

CURWEN, HAROLD. *Processes of Graphic Reproduction.* Revised edition. London, Faber & Faber, 1963.

FAITHORNE, W. *The Art of Graving and Etching.* 2nd edition. London, 1702.

FLOCON, ALBERT. *Traité du burin.* Geneva, Cailler, 1954.

FURST, HERBERT. *Original Engraving and Etching.* London, Nelson, 1931.

GUSMAN, PIERRE. *La Gravure sur bois.* Paris, Roger & Chernovitz, 1916.

HADEN, FRANCIS S. *About Etching.* London, Strangeways, 1878.

HAYTER, STANLEY W. *New Ways of Gravure.* N.Y., Pantheon, 1949.

—— *About Prints.* London, Oxford University Press, 1962.

HELLER, JULES. *Printmaking Today.* N.Y., Holt, 1958.

HERBERTS, KURT. *The Complete Book of Artists' Techniques.* N.Y., Praeger, 1958.

HIND, ARTHUR M. *Guide to the Processes and Schools of Engraving.* London, British Museum, 1933.

IVINS, WILLIAM M. *How Prints Look.* N.Y., Metropolitan Museum of Art, 1943.

LABARRE, E. J. *Dictionary and Encyclopedia of Paper and Paper-making.* Amsterdam, Swets & Zeitlinger, 1952.

LALANNE, MAXIME. *A Treatise on Etching.* Boston, Page, 1880.

LEIGHTON, CLARE. *Wood-Engraving and Woodcuts.* London, Studio, 1932; N.Y., Studio, 1944.

LIPPMANN, FRIEDRICH. *Engraving and Etching: a Handbook for the Use of Students and Print Collectors.* London, Grevel, 1906.

LUMSDEN, ERNEST S. *The Art of Etching.* London, Seeley Service; Philadelphia, Lippincott, 1925.

MARTIAL, ADOLPHE P. *Nouveau Traité de la gravure à l'eau-forte.* Paris, Cadart, 1873.

MAYER, RALPH. *The Artist's Handbook of Materials and Techniques.* N.Y., Viking, 1940.

MÜLLER, HANS A. *How I Make Woodcuts and Wood-Engravings.* N.Y., American Artists Group, 1945.

PAPILLON, J. M. *Traité historique et pratique de la gravure en bois.* 3 vols. Paris, Simon, 1776.

PENNELL, JOSEPH. *Etchers and Etching.* N.Y., Macmillan, 1919.

PENROSE ANNUAL. *A Review of the Graphic Arts.* London, Lund Humphries, current.

PETERDI, GABOR. *Printmaking: Methods Old and New.* N.Y., Macmillan, 1959.

PLENDERLEITH, H. J. *Conservation of Prints, Drawings, and Manuscripts.* London, Oxford University Press, 1937.

PLOWMAN, GEORGE T. *Etching and Other Graphic Arts: an Illustrated Treatise.* London, Lane; Toronto, Bell & Cockburn, 1914.

POORTENAAR, JAN. *The Technique of Prints and Art Reproduction Processes.* London, Lane, 1933.

PRIDEAUX, S. T. *Aquatint Engraving.* London, Duckworth, 1909.

PYLE, CLIFFORD. *Etching Principles and Methods.* N.Y., London, Harper, 1941.

ROBERT, KARL. *Traité pratique de la gravure à l'eau-forte.* Paris, Laurens, 1891.

ROBINS, W. P. *Etching Craft.* London, Bookman's Journal and Print Collector, 1922.

SHORT, FRANK, and POTT, C. M. *A Descriptive Catalogue of a Collection of Tools and Materials used in Etching.* London, Victoria and Albert Museum, 1910.

SINGER, HANS W., and STRANG, WILLIAM. *Etching, Engraving and Other Methods of Printing Pictures.* London, Paul, Trench, Trubner, 1897.

STERNBERG, HARRY. *Modern Methods and Materials of Etching.* N.Y., McGraw-Hill, 1949.

STRANG, DAVID. *Printing of Etchings and Engravings.* London, Benn, 1936.

TREVELYAN, JULIAN. *Etching.* London, Studio, 1963.

WEST, LEVON. *Making an Etching.* London, N.Y., Studio, 1932.

II. *Historical and Biographical*

BARTSCH, ADAM VON. *Le Peintre-graveur.* Würzburg, Verlagsdruckerei Würzburg, 1920. Second edition, 21 vols., published 1803-21 (Vienna, Degen); reprinted 1854-76 (Leipzig, Berth). Complemented by Robert-Dumesnil (French engravers), Passavant, and Baudi di Vesme (Italian engravers).

BASLER, ADOLPHE, and KUNSTLER, CHARLES. *Le Dessin et la gravure modernes en France.* Paris, Crès, 1930.

BAUDI DI VESME, ALESSANDRO (Alexandre de Vesme). *Le Peintre-graveur italien. Ouvrage faisant suite au Peintre-graveur de Bartsch.* Milan, Hoepli, 1906.

BLISS, DOUGLAS P. *A History of Wood Engraving.* London, Dent; N.Y., Dutton, 1928.

BLUM, ANDRÉ. *The Origins of Printing and Engraving.* N.Y., Scribner, 1940.

BOCK, ELFRIED. *Geschichte der graphischen Kunst von ihren Anfangen bis zum Gegenwart.* Berlin, Propyläen, 1950.

BROOKS, ALFRED M. *From Holbein to Whistler. Notes on Drawing and Engraving.* New Haven, Yale; London, Oxford University Press, 1920.

CARRINGTON, FRITZROY, ed. *Prints and Their Makers.* N.Y., Century, 1912.

CLEAVER, JAMES. *A History of Graphic Art.* London, Owen, 1963.

COURBOIN, FRANÇOIS. *Histoire illustrée de la gravure en France.* 3 vols. Paris, Le Garrec, 1923-6.

DELTEIL, LOYS. *Le Peintre-graveur illustré.* 31 vols. Paris, Chez l'Auteur. 1906-30.

GETLEIN, FRANK. *The Bite of the Print.* N.Y., Potter, 1963.

GLAISTER, GEOFFREY A. *An Encyclopedia of the Book.* Cleveland, N.Y., World, 1960.

GLASER, CURT. *Die Graphik der Neuzeit.* Berlin, Cassirer, 1923.

GOODMAN, CALVIN J. *A Study of the Marketing of the Original Print.* Los Angeles, Cal., Tamarind Lithography Workshop, 1964.

GRAY, BASIL. *The English Print.* London, Black, 1937.

HAAS, IRVIN. *A Treasury of Great Prints.* N.Y., Yoseloff, 1956.

HAIGHT, ANNA L., ed. *Portrait of Latin America as Seen by Her Print-Makers.* N.Y., Hastings, 1946.

HIND, ARTHUR M. *A History of Engraving and Etching.* London, Constable, 1923.

—— *Catalogue of Early Italian Engravings in the British Museum.* London, British Museum, 1909-10. Also *Guide to the Collection of Early Italian Engravings,* 1923.

—— *Early Italian Engraving.* 7 vols. London, Quaritch; N.Y., Knoedler, 1938-48.

HOLMAN, LOUIS A. *The Graphic Processes: Intaglio, Relief and Planagraphic.* Boston, Goodspeed, 1929.

HOLME, CHARLES, ed. *Modern Etching and Engraving.* London, N.Y., International Studio (John Lane), 1902. Complemented by his *Modern Etchings, Mezzotints and Dry-Points.* London, N.Y., 1913.

IVINS, WILLIAM M., Jr. *Prints and Books.* Cambridge, Mass., Harvard, 1926.

—— *Prints and Visual Communication.* Cambridge, Mass., Harvard, 1953.

KONOW, JURGEN VON. *Om Grafik.* Malmö, Allhems, 1955.

KRISTELLER, PAUL. *Kupferstich und Holzschnitt in vier Jahrhunderten.* Berlin, Cassirer, 1922.

LAVER, JAMES. *A History of British and American Etching.* London, Benn, 1929.

LEIPNIK, F. L. *A History of French Etching from the Sixteenth Century to the Present Day.* London, Lane; N.Y., Dodd, Mead, 1924.

LIPPMANN, FRIEDRICH. *Engraving and Etching.* New York, Scribner, 1906.

—— *Engravings and Woodcuts by Old Masters* (Sec. XV-XIX). London, Quaritch, 1889-1900. Completed 1904.

LONGSTREET, STEPHEN. *A Treasury of the World's Great Prints.* N.Y., Simon & Schuster, 1961.

PASSAVANT, JOHANN D. *Le Peintre-graveur.* 3 vols. Leipzig, Weigel, 1860-4.

PICA, V., and MASSA, A. DEL. *Atlas de la gravure moderne.* Florence, Rinascimento del Libro, 1928.

PLATTE, HANS. *Artists' Prints in Colour.* London, Barrie & Rockcliffe, 1961.

REESE, ALBERT. *American Prize Prints of the Twentieth Century.* N.Y., American Artists Group, 1949.

REINER, IMRE. *Woodcuts—Wood Engraving.* St. Gall, Switzerland, Zollikofer, 1947.

ROBERT-DUMESNIL, A. P. F. *Le Peintre-graveur français. Ouvrage faisant suite du Peintre-graveur de M. Bartsch.* 11 vols. Paris, Huzard, 1835-71.

ROGER-MARX, CLAUDE. *French Original Engravings from Manet to the Present Time.* London, N.Y., Hyperion, 1939.

—— *Graphic Art of the 19th Century.* N.Y., McGraw-Hill, 1962.

ROSENTHAL, LÉON, and ADHEMAR, JEAN. *La Gravure.* 2nd ed. revised. Paris, Laurens, 1939.

SACHS, PAUL J. *Modern Prints and Drawings.* N.Y., Knopf, 1954.

SALAMAN, MALCOLM C. *The Charm of the Etcher's Art.* 3 vols. London, Studio, 1920.

SCHREIBER, W. L. *Manuel de l'amateur de la gravure sur bois et sur métal au XVe siècle.* Berlin and Leipzig, 1891-1910. Second edition (8 vols.) in German: *Handbuch des Holz- und Metal-Schnittes in XV Jahrhundert.* Leipzig, 1926-30.

SERVOLINI, LUIGI. *Dizionario illustrato degli incisori italiani: Moderni e contemporanei.* Milan, Gorlich, 1955.

SEVERINI, MARIA. *Grafica italiana contemporanea . . . (A-B).* Venice, Pozza, 1961—in progress.

SINGER, HANS W. *Die moderne Graphik.* 2. Aufl. Leipzig, Seemann, 1920.

SKIRA, ALBERT, ed. *Anthologie du livre illustré par les peintres et sculpteurs de l'école de Paris.* Paris, Skira, 1946. Enlarged and updated by *The Artist and the Book in Western Europe and the United States, 1860-1960.* Boston, Museum of Fine Arts; Cambridge, Mass., Harvard College Library, 1961.

STATLER, OLIVER. *Modern Japanese Prints.* Tokyo and Rutland, Vt., Tuttle, 1956.

STUBBE, WOLF. *Graphic Arts in the Twentieth Century.* N.Y., London, Praeger, 1963.

WEITENKAMPF, FRANK. *Famous Prints.* N.Y., Scribner, 1926. Complemented by *How to Appreciate Prints,* 1927.

ZIGROSSER, CARL. *The Book of Fine Prints.* N.Y., Crown, 1937.

—— *Six Centuries of Fine Prints.* N.Y., Covici-Friede, 1937.

—— *The Artist in America.* N.Y., Knopf, 1942.

—— ed. *Prints: Thirteen Illustrated Essays on the Art of the Print.* N.Y., Holt, Rinehart & Winston, 1962.

III. *General References*

ARTS COUNCIL. *S. W. Hayter Retrospective.* London, Arts Council of Great Britain, 1958.

ARTIST'S PROOF. Brooklyn, N.Y., Pratt Institute Art Center, 1962—current.

ATELIER 17. Contributions by Herbert Read, James J. Sweeney, Hyatt Mayer, Carl Zigrosser, Stanley William Hayter. N.Y., Wittenborn, Schulz, 1949. Complemented by: *Atelier 17,* London, Leicester Galleries, March 1947; *Hayter and Studio 17.* Museum of Modern Art Bulletin, v. 12, no. 1, August 1944 (for an exhibition, June–September 1944); Andrea Emiliani, *Catalogue Atelier 17.* Bologna, Galleria Foscerari, 1963.

BARR, ALFRED H., Jr. *Fantastic Art, Dada, Surrealism.* N.Y., Museum of Modern Art, 1947.

—— *Cubism and Abstract Art.* N.Y., Museum of Modern Art, 1936.

BROOKLYN MUSEUM. *Ten Years of American Prints, 1947-56.* Brooklyn, N.Y., 1956.

BRUNIDOR EDITIONS. *Portfolio Number One.* N.Y., 1947.

CAHIERS D'ART. Ed. Christian Zervos. Paris, 1926—current.

CÉLÉBONOVIC, STEVAN. *Préhistoire.* Texte du Professeur Marc-R. Sauter, Geneva, Eidos; Paris, Deux Mondes [1956?].

GOITEN, L. *Art and the Unconscious.* N.Y., United Book Guild, 1948.

GUGGENHEIM, PEGGY. *Art of This Century.* N.Y., Art Aid Corporation, 1942. For additional manifestations in England see *London Bulletin.* London Gallery, 1938-40.

HAFTMANN, WERNER. *Painting in the Twentieth Century.* 2 vols. N.Y., Praeger, 1960.

JANIS, SIDNEY. *Abstract and Surrealist Art in America.* N.Y., Reynal & Hitchcock, 1944.

JEAN, MARCEL. *The History of Surrealist Painting.* London, Weidenfeld & Nicolson, 1960.

JOHNSON, UNA E. *Ambroise Vollard, Éditeur, 1867-1939.* N.Y., Wittenborn, 1944.

KANDINSKY, WASSILY. *Concerning the Spiritual in Art.* N.Y., Wittenborn, Schultz, 1947.

KEPES, GYORGY, ed. *Vision and Value.* 3 vols. N.Y., Braziller, 1965.

—— *The Language of Vision.* Chicago, Theobald, 1944.

LAKE, CARLTON, and MAILLARD, ROBERT, eds. *Dictionary of Modern Painting.* Second revised edition. N.Y., Tudor, 1964.

MINOTAURE. Ed. Albert Skira. Paris, 1933-8.

PRINT COLLECTOR'S QUARTERLY. Ed. F. R. Carrington, C. Dodgson, J. H. Bender. N.Y., London, 1911-50.

RAYNAL, MAURICE L. (and others). *History of Modern Painting.* 3 vols. Geneva, Skira, 1949-51.

ROTHSCHILD, E. F. *The Meaning of Unintelligibility in Modern Art.* Chicago, University of Chicago, 1934. Published in the same series: James Johnson Sweeney. *Plastic Redirections in 20th Century Painting.* 1934.

SEUPHOR, MICHEL. *L'Art abstrait.* Paris, Maeght, 1949. Complemented by his *Dictionary of Abstract Painting.* N.Y., Tudor, 1957 (translated from the French).

VVV. Ed. David Hare (and others). N.Y., 1942–4. For related coverage during the same period see *Dyn.* Ed. Wolfgang Paalen (Mexico, 1942–4), and *View.* Ed. Charles Henri Ford. N.Y., 1940–7.

Walker Art Center. *A New Direction in Intaglio.* Minneapolis, 1949.

Whitechapel Art Gallery. *S. W. Hayter Retrospective.* London, 1957.

XXᵉ Siècle. Ed. G. di San Lazzaro. Paris, 1938–current.

IV. *Bibliographies: 1862–1965*

BOURCARD, GUSTAVE. *Graveurs et gravures.* Paris, Floury, 1910.

CHAMBERLIN, MARY. *Guide to Art Reference Books.* Chicago, American Library Association, 1959.

COLIN, PAUL. *La Gravure et les graveurs.* 2 vols. Brussels, Van Oest, 1916–18.

DELTEIL, LOYS. *Manuel de l'amateur d'estampes des XIXᵉ et XXᵉ siècles (1801–1924).* Paris, Dorbin-Aîné, 1925.

DUPLESSIS, GEORGES. *Essai de bibliographie de la gravure et des graveurs.* Paris, Rapilly, 1862.

KORNFELD and KLIPSTEIN. *Illustrierte Bücher des neunzehnten und zwanzigsten Jahrhunderts.* Berne, 1965.

KRAUS, H. P., & Co. *History and Art of the Printed Book.* N.Y., Kraus, 1959.

LAVER, JAMES. *History of British and American Etching.* London, 1929.

LEVIS, HOWARD C. *A Descriptive Bibliography of the Most Important Books in the English Language Relating to the Art and History of Engraving and the Collecting of Prints.* London, Ellis, 1912. Supplement and Index, 1913.

MABERLY, JOSEPH. *The Print Collector.* N.Y., Dodd, Mead, 1880.

NICAISE, LIBRAIRIE. *Cubisme, futurisme, dada, surréalisme.* Paris, 1960. Complemented by *Poésie-prose: peintres-graveurs de notre temps.* 1964.

ROBINS, W. P. *Etching Craft.* London, Bookman's Journal, 1922.

SINGER, H. W., and STRANG, W. *Etching, Engraving and Other Methods of Printing Pictures.* London, 1897.

INDEX

Figure numbers are printed in *italics*

PRINTED IN GREAT BRITAIN
AT THE UNIVERSITY PRESS, OXFORD
BY VIVIAN RIDLER
PRINTER TO THE UNIVERSITY